LUBAVITCHER WOMEN IN AMERICA

LUBAVITCHER WOMEN IN AMERICA
*Identity and Activism
in the Postwar Era*

BONNIE J. MORRIS

STATE UNIVERSITY OF NEW YORK PRESS

The author gratefully acknowledges permission to excerpt and incorporate the following previously published material:

"Female Education in the Lubavitcher Community," from *Women in Spiritual and Communitarian Societies in the United States*, edited by Wendy E. Chmielewski, Louis J. Kern, and Marilyn Klee-Hartzell. By permission of Syracuse University Press, © 1993.

"Agents or Victims of Relgious Ideology?," from *New World Hasidim: Ethnographic Studies of Hasidic Jews in America*, edited by Janet Belcove-Shalin. By permission of the State University of New York Press, © 1995.

Published by
State University of New York Press, Albany

© 1998 State University of New York

All rights reserved

Printed in the United States of America

No part of this book may be used or reproduced in any manner whatsoever without written permission. No part of this book may be stored in a retrieval system or transmitted in any form or by any means including electronic, electrostatic, magnetic tape, mechanical, photocopying, recording, or otherwise without the prior permission in writing of the publisher.

For information, address State University of New York
Press, State University Plaza, Albany, N.Y. 12246

Production by E. Moore
Marketing by Nancy Farrell

Library of Congress Cataloging-in-Publication Data

Morris, Bonnie J., 1961
 Lubavitcher women in America : identity and activism in the postwar era / Bonnie J. Morris.
 p. cm.
 Includes bibliographical references and index.
 ISBN 0-7914-3799-X (hc : alk. paper). — ISBN 0-7914-3800-7 (pbk. : alk. paper)
 1. Women in Judaism—United States. 2. Chabad—United States. 3. Jewish women—Religious life—United States. 4. Crown Heights (New York, N.Y.)—Religious life and customs. I. Title.
BM729.W6M67 1998
296.8'3322'0820973—dc21
 97-28021
 CIP
 r97

10 9 8 7 6 5 4 3 2 1

for my foremothers who could not read or write

*for the women of Herizon,
my beloved community from 1983–1991*

*for the strong women in my life who honor their Jewish roots
despite every pressure to assimilate:*

Myra Kandy Jeanne Jules Dorothy

Contents

Acknowledgments	*ix*
Introduction: A Feminist Historian's Intentions	*1*
1. A Woman of Valor, Who Can Find?	*13*
2. Educate a Child According to His Ways	*29*
3. Ingathering Those That Were Far Away: The Neshei Chabad Conventions	*55*
4. Everything Emanates from the Woman	*78*
5. Whatever Is Happening in the Gentile World Is Reflected in the Jewish World: Reactions to Feminism	*100*
6. We Must Live with the Times	*123*
Glossary of Yiddish and Hebrew Terms	*141*
Notes	*147*
Hasidic Historiography	*165*
Bibliography	*171*
Index	*183*

Acknowledgments

Many wise and loving friends, scholars, and institutions contributed to the shaping of this work. I owe a great deal to the librarians of the Levi Yitzchok Library and to the women of Neshei Chabad, particularly Rachel Altein. My friend Dr. Andrea Brown provided housing for me in Brooklyn during the years of research, and the history faculty of Binghamton University [then SUNY Binghamton] provided guidance when this work was still a doctoral dissertation. I am particularly grateful for the intellectual support of Rabbi Lance Sussman, Dr. Alice Kessler-Harris, Dr. Lynne Viola, and my friend Faith Rogow.

As a young scholar without extensive resources I received an important research grant from the Rosa Colecchio family, and a fellowship to the Dartmouth College Humanities Research Institute. The latter permitted my presentation of this research to top scholars in the genre of global religious Orthodoxy, including the esteemed Arabist Dr. Albert Hourani. Most gratifying indeed, on every level, was my appointment as a visiting research associate at Harvard Divinity School (HDS) in 1990–1991. Constance Buchanan, who brought me to the women's studies and religion program at HDS, enabled me to design and teach the first graduate seminar in Hasidic women's history ever offered at Harvard. While there, I received the feedback and critical questions on my work so necessary to its revision, and I owe much to the kind genius of Dr. Margaret Miles and to the assistance of program staff Suzanne Seger and Margie Thornton.

Acknowledgments

As this book moved through several drafts and toward publication, I found a constant ally in Debra Kaufman, who joined my first-ever panel on Hasidic women's history at the 1993 Berkshire Women's History Conference. My commitment to making Jewish women's identity visible in all feminist institutions won support from Boo Price and Lisa Vogel of the Michigan Womyn's Music Festival. Judaica scholars Paula Hyman, Doris Gold, and Janet Belcove-Shalin helped me fine-tune my research. And finally, I cannot offer sufficient words of gratitude for the caring enthusiasm of the two women's studies program directors I've worked for since 1994, Barbara Miller and Jeanne Henry. Dayenu!

INTRODUCTION:
A FEMINIST HISTORIAN'S INTENTIONS

This is a study of Hasidic women in the Lubavitcher sect. Specifically, it is an analysis of Lubavitcher women's contributions to their own American community since 1950, when outreach and education reforms supported by the late Lubavitcher Rebbe Menachem M. Schneerson began to empower his female followers. I write this history as a feminist interested in what I will term *counterfeminist* women.

At first glance, Hasidic tradition and feminism appear to share little in common. Most Western-educated feminists, myself included, bring a certain set of political interests to our interrogation of women's status in religious communities. And so the question my colleagues ask most often is not "What have you learned from your research on Hasidic women?," but "Why on earth would you choose *them*?"

This attitude reflects an expectation that feminist historians will only study the lives and work of other feminists. Ergo, there is something unexpected and puzzling in my focus on traditionally religious women. I begin this work by responding that no group of immigrant women committed to reproducing a spiritual vision of womanhood should be marginalized by the feminist historian. Indeed, the feminist historian has an obligation to acknowledge diverse contexts of ethnic and gender identity.

Women's history as an academic field is a fairly recent phenomenon. Like other innovative disciplines, women's history has

been shaped by dissent among its own scholars, in addition to time-consuming attacks from external critics. A vocal contingent of academics continues to contest greater inclusion of studies on women and minorities in the once entirely white, male, and Western canon of historical literature. The more multicultural approach to the study of history threatens that established academic canon by revealing interconnecting storylines of achievement and oppression in history. Yet the women's history and women's studies fields can, themselves, foster exclusionary research if traditionally religious women in history are not incorporated as significant voices.

The challenge for women's history and women's studies programs, some still in beginning stages on college campuses, is to unveil rather than to obscure the reality of race, class, and ethnic differences between women. During the 1980s, when I took my doctorate at SUNY-Binghamton, feminist theorists and historians grew more alert to women's ethnic identification, to conflicts between ethnic group and gender loyalties, and to ways in which ethnic and racial sterotyping might be confronted within higher education. Multicultural curricula in women's studies courses and at feminist conferences speak to this committment toward fuller representation of women in society and history.

But despite these steps toward more inclusive historical studies on women, many graduate students remain nervous about exploring the significant contributions of right-wing women in history, women whose lives and work remain rooted in a traditional ideology of divinely ordained, separate sex roles. Such women constitute no less of a dynamic group than any other community of women in history. But it is women's very involvement in the dissemination of conservative, antifeminist rhetoric that poses a unique set of questions for feminist historians.

We ask: What attracts women to movements or ideologies offering them restricted status? Why would women participate in the creation and popularization of propaganda advocating that woman's place is in the home, that her biological function naturally limits her capacity for public agency and intellectual achievement? Furthermore, what academic dialogue might ensue from the inclusion of research on antifeminist women in women's history curricula? These are the questions that sent me on my journey into the world of Hasidic womanhood.

Because my training is in history, rather than sociology or psychology of religion, I concentrate on *what* postwar Hasidic women did with their lives and their influence, rather than questioning

why Hasidic women hold views and values different from mine. It is both inaccurate and patronizing to assume that Hasidic women have merely been "brainwashed" by the males of their respective group. Such an assumption constructs women as passive recipients of ideology, and shifts all active and primary focus to male agency. While male authority and control certainly determine or circumscribe female choice, women do retain options as ideological consumers. Antifeminist ideologies may limit all women as a class, yet permit individual women to attain power and status through obedience to the prescribed female role.

In this study I place women in the primary focus as producers and agents of Hasidic ideology, and examine the possible social and self-image benefits that accrue to them through ultra-Orthodox activism. As more and more women worldwide have come to identify with conservative religious movements, it is no longer sufficient to dwell on what they are *not* allowed to do in such communities. The relevant question is, again, *what* traditionalist women *are doing* with their permitted influence as religious activists. Any separate, female sphere produces a certain and visible "women's culture," including hierarchies and (limited) authority. Because Hasidic women contend that they are "already liberated"—from Christian definitions of womanhood—and because there is good reason for them to distrust a Western feminism once based on Christian reforms, I choose to see Lubavitchers as counterfeminist, not antifeminist.

My own work on Hasidic women began in the early 1980s, before there were any published monographs on ultra-Orthodox women in either women's studies or Judaica. The enormous body of extant sources on Hasidism itself revealed almost no information on women's lives, roles, or self-image. And when I turned to new feminist texts on women's religious experience in history and community, I was again disappointed, for feminist scholarship on Jewish women's identity had yet to address the viewpoint of the Hasidic woman. I am delighted to acknowledge that all of this has changed in the decade since I began my own research. The last years of the 1980s and first years of the 1990s saw an explosion of interest in the strictly Orthodox woman's experience, culminating in the publications of books and articles by Lynn Davidman, Tamar Frankiel, Lis Harris, Debra Kaufman, Ellen Koskoff, Tamar El-Or, Jenna Weissman Joselit, and many others. There is now a plethora of research on Hasidic women's spirituality available to the interested student.

In the early 1980s, however, I began my research on Hasidic women with little guidance from the either popular or academic sources. I faced the necessity of conducting my research, for a period of several years, within the Hasidic community itself.

Working in the archives of the Lubavitcher community in Brooklyn, I found evidence of a prolific and articulate female literature by women of the postwar American Hasidic community. It was precisely this literature that I hoped would place Hasidic women on the continuum of history relevant both to Judaica and multicultural women's studies. I realized the difficulty of matchmaking a marriage between Hasidic literature and women's studies, however, as I read page after page of Lubavitcher women's polemical essays denouncing the American women's movement, its proponents, and its achievements. Any accurate historical study of Lubavitcher women in American communities would have to include this flurry of hostility to organized feminism. I was unprepared for the magnitude of feeling. The women's literature I had rejoiced in finding yielded an almost endless attack on birth control, college education, the "idiot antics of Women's Lib," career-oriented women, and so on. More intriguing still were cogent essays by women who had left feminism for Hasidism; political petitions by Lubavitcher women seeking to overturn legislation on the separation of church and state; and, most fascinating of all, essays providing Hasidic responses to feminist criticism.

My initial encounters with Hasidic women's literature placed me in the company of other graduate students and historians who experience conflicts between their own values and those of their chosen subjects. In a forum on conservative women in history, held at Rutgers University in 1987, I heard testimony from emerging scholars whose work addressed slave-owning women, women empowered by the rise of European fascism, and female leadership in fundamentalist religious movements. All participants agreed that the classification of women as an oppressed group was complicated by substantial evidence of women empowered to restrict other women, men, or both. In my case, the study of Hasidic women would have to address not only the function of male authority in suppressing women, but the role of women in promoting obedience to sacrosanct male authority.

It is hardly news that racial, religious, or ethnic loyalties may outweigh the appeal of a "women's" movement for female members of persecuted minority groups. Distrust of and distaste for non-Jewish society is behind much of the counterfeminist sentiment

informing Lubavitcher women's writing. This defensive construction of the Gentile as Other is most significant, and illustrates the tension between ethnic and gender identity for many Jewish women, not only Hasidim. Because ethnic/religious identity, not gender, was the primary obstacle to Jewish freedom throughout history, it is not surprising to find that modern Hasidic women are more concerned with ethnic survival than in liberating themselves from Hasidic men. The preference is for loyalty to Jewish tradition rather than to a primarily white, Christian feminism: after all, did not Gentile women serve as agents of anti-Semitic provocation in Eastern Europe, and as Nazi officers in women's concentration camp barracks? In short, historical and contemporary anti-Semitism has so uprooted and affected the Hasidic community that Hasidic women cannot afford to consider themselves oppressed by their own people, their male relations and leaders. These reactions are not dissimilar from African-American women's disinterest in being "liberated" by a sometimes racist white feminism. Sadly, during my research years, the black and Hasidic communities of Crown Heights reached their most acrimonious standoff, impeding further the potential for dialogue between women.

Mindful of all these tensions, in the fall of 1986 I began my historical fieldwork in Crown Heights, Brooklyn, at the age of twenty-five.

Out of respect to my host community, I temporarily adopted a Lubavitcher's-eye view of the larger world, dressing and behaving in accordance with Hasidic stipulations while I worked in Crown Heights during the 1986–1988 period. My subsequent presentation on the values and activities of Lubavitcher women is the result of many months of experience as a visitor within the female culture I sought to write back into history. This unusual research experience simply must be described, in brief, for the reading audience unfamiliar with Hasidism.

The Lubavitchers aggressively solicit guests. Outreach tactics espoused by their leader, the late Rebbe, demand that all assimilated Jews (such as myself) be treated as potential adherents to traditional Orthodox practice. A variety of schools and services, specifically aimed at *baalot teshuvah* or newly observant women, exist in the contemporary Crown Heights community. Any sincerely interested Jewish visitor may take the subway to Kingston Avenue and Eastern Parkway and walk into the Lubavitcher world.

The sight of older, female students of Judaism, awkwardly but earnestly adjusting to Hasidic norms in their pilgrimages as *baalot teshuvah*, is a source of pride rather than embarassment for Lubavitcher activists. Moreover, the highly international character of the Brooklyn Hasidic community provides a background scenery incorporating visitors, displaced students, and (until his death in 1994) clients of the Rebbe. As opposed to the more restricted Satmar and Tasher sects of Hasidism, where standards of attire, speech patterns, employment, and daily conduct are meticulously uniform, the Lubavitcher community hosts guests from myriad cultures and walks of life. French, Israeli, Iranian, Canadian, and South American Jews, as well as recent Soviet Jewish émigrés, are frequent visitors to Crown Heights on Jewish holidays (many came in pursuit of private audience with the Rebbe). In addition to this cross-cultural milieu, the spectrum of American Jewry within Crown Heights far exceeds one's immediate stereotype of Hasidic homogeneity. New, beaming, previously college-educated Hasidic adherents, elderly first-generation American Jews, and families from every state chose to settle close to the Rebbe, bringing a range of styles, accents, and dress. Against this background, I was never the most conspicuous visitor, but one of a multitude of Jews interested in learning more about Lubavitch Hasidism.

My previous experiences among the Hasidim of Jerusalem, during a year of college study in Israel, prepared me for the basic codes of conduct I was to adopt in Brooklyn. In Crown Heights, where the language spoken in the streets was more often English than Yiddish, I pursued my research with relative ease and receptivity. In order to avoid offending the community that was handsomely permitting me free rein in its libraries, I studiously observed Lubavitcher etiquette. Acceptable standards of *tznius*, or modesty, required that I wear a long skirt, white opaque stockings, feminine-styled shoes of good quality, and a blouse or sweater with a high neck and long sleeves. As an unmarried Jewish woman, I was not required to cover my head; however, in a community where most young women are married at nineteen or twenty, my uncovered head with its twenty-five-year-old face signified to all passersby that I was either new to Hasidism . . . or a pitiable out-of-towner with an unsuccessful matchmaking record.

While I was familiar with the dictum that male and female avoid one another on the street and never initiate contact or unnecessary conversation, I was apt to forget in a shop that I must not take change directly from a man's hand. I also learned that book-

sellers' brusqueness or inattention to me was merely another manifestation of avoiding excessive contact with an unknown woman. Furthermore, a woman's book order was less pressing than a man's, for the male is obligated to study, while an adult woman's learning is optional, beyond her grasp of those prayers and commandments directed at her.

However, no one thought it odd that an apparently unmarried and childless woman such as myself should browse in the famous children's toy store, Tzivos Hashem. As I stood making surreptitious notes on Lubavitcher educational toys, I was constantly approached by other women shoppers, who asked my opinion on purchases for their babies—did I think this size *yarmulke* would fit a three-year-old? As almost all Hasidic women grow up in large families, it is assumed that an unmarried or childless woman nevertheless has child-rearing expertise and interests gleaned from a lifetime of caring for siblings.

During conversations, particularly when I was excitedly interviewing new contacts and lapsed into secular glibness, I had to monitor myself carefully to avoid using crude slang expressions. One was expected to speak of the Rebbe as "the Rebbe, *shlita*" ("may he live and be well"). To omit this Yiddish acronym was a mark of ignorance and disrespect. Similarly, one rarely hears the word "God" spoken in Crown Heights; "Hashem," The Name, is the universally employed euphemism, and oaths that take the name of God in vain are unthinkable. Colorful Yiddish epithets more than suffice, but one must learn which, and when they are permissable. There are many taboos for normal conversation; it is unlucky to mention ages or numbers of children, or to overtly praise one's recent good fortune. Should such references be absolutely necessary, Hasidim (and less Orthodox Jews as well) say "*Kin ayn ahora*" against the Evil Eye. It is also customary to answer "How are you?" with "*Baruch Hashem!*" ("Blessed is the Name"), as a way of thanking the Almighty. One may say "*Baruch Hashem*" after the completion of work, the success of an event, or on any other occasion when it is appropriate to express gratitude. I heard fourth-grade girls say it after completing a difficult page of schoolwork.

I emphasize these details because my use of Lubavitcher facilities such as libraries, records offices, and book dealers depended in large part on my willingness to comply with Orthodox Jewish law. I learned that one does not bring holy books into a lavatory, even when they are inside a satchel with one's other possessions; xerox-

ing materials containing sacred literature requires that flawed reprints be left with a rabbi for appropriate religious disposal; food may not be consumed in public without the correct prayer; women may not hum, let alone sing, in public areas, lest their voices prove a temptation to men.

I dressed as a Lubavitcher not to deceive, but to observe the appropriate decorum. I explained my research interests honestly to anyone who inquired, although I seldom introduced myself up front as the radical feminist daughter of a Jewish-Gentile intermarriage. But the apparent Hasidic allegiance suggested by my dress had other repercussions. I have mentioned that my research coincided with the onset of a devastating period of racial and political tension between Hasidim and black residents of Crown Heights. In my Hasidic dress, I was an easy target for those who expressed their animus for Hasidim through verbal and physical abuse.

The primary collection from which I drew my sources is the Levi Yitzchok Library of the Lubavitcher Youth Organization, on Kingston Avenue in Crown Heights. Housing over 25,000 volumes in several languages, including a large children's selection, this library has been open since 1975 and contains bound collections of nearly every Lubavitcher periodical ever produced. While the shelves are arranged according to Hebrew or English titles, I found that the section of books pertaining to women in Judaism was labeled "Miscellaneous." Texts in this women's section include publications by the Lubavitcher Women's Organization, volumes of their Convention programs, pamphlets by rabbis on the role of women, cookbooks, marriage manuals and wedding sermons, teachers' guidelines for establishing Jewish day schools, and numerous books on the laws of *niddah* and *mikveh* (menstrual taboos and purification).

The women's section dealt almost exclusively with Jewish law and female obligations toward the preservation of *sholom bayis*, or household harmony; little could be found on the role of Jewish women in history, although the library had recently acquired *The Memoirs of Gluckel of Hameln*. Due to the library's excellent collection of periodicals such as *Di Yiddishe Heim* and other women's publications, as well as community histories and papers by the Rebbe, I spent most of my research time in the Levi Yitzchok archives.

In deference to the laws of modesty, the Library holds separate hours for men and women, and as a woman I was only permitted in the facility from noon to 4 on Sundays and from 4 to 9 P.M. on Mon-

days and Wednesdays. As I was already adjunct faculty at SUNY-Binghamton in upstate New York by then, and could only come to Brooklyn for a few days of research at a time, I found the Library's schedule quite a challenge. Xeroxing all the materials I needed was prohibitively expensive, as the ancient machine in the Library charged twenty-five cents per page and could be run only by the attending, overworked librarian. Finally I petitioned for and received a library card—no easy task for an "outsider" lacking references from community authorities, but fortunately I had a letter of introduction from a friendly Chabad rabbi. I was then permitted to check out exactly two items at a time for exactly two weeks. My own difficulty in obtaining access to materials should shed some light on the barriers to independent female learning in the community.

While "men's hours" at the library were observed somberly, for the scholarly study of community rabbis, "women's hours" were consistently loud, chaotic, and unreliable. The bulk of the visitors were children between the ages of newborn to sixteen. The noise was sometimes incredible, but efforts by hapless librarians to restore order were met with hostile responses from the children's accompanying mothers/older siblings/babysitters. The problem of discipline in the Library was compounded by the fact that the librarians were primarily young (but aging) *baalot teshuvah*, unmarried, with no social standing whatsoever, whereas the smug young patrons were the descendents of the very authors of more revered texts in the Levi Yitzchok Library itself. It was apparent that serving as a librarian to the indulged, critical brood of Lubavitcher children was a standard job assigned to *baalot teshuvah* who had left families and careers to start life anew in Crown Heights. These lonely and overworked women also supported themselves through babysitting. In both jobs they were surrounded by children not their own, surely a frustrating reminder of their own single status; often, the librarians would gossip with one another and express unhappiness that their mentors in the community had judged them unready for Lubavitcher matchmaking. Resigned to their own status on sufferance, the librarians accepted curt freshness from the children they served.

My regular appearance as a patron who genuinely wished to study caused some talk. Librarians flew to assist me and roundly scolded the many chattering schoolchildren, leading to great antipathy toward me on the behalf of the upbraided. When told by one librarian that I needed quiet for research, three nine-year-olds simply walked over to my table and announced, "We're doing

important work. Work for the *Rebbe*. Not our own research." On other occasions, older girls asked me to diaper infants, watch toddlers, or tutor a group of sixth-graders for a "little while." These were entirely natural requests in the Lubavitcher community, where sibling parenting and group learning (as opposed to individual scholarship for women) prevailed. The conditions of women's hours at the Library were such that soothing a squalling baby on top of a table was the rule rather than the exception. One memorable afternoon I used the library restroom only to return and find two toddlers eating and crayoning on my research notes. When, the next time, I tactfully scooped up all my work and brought it with me into the restroom, I was stopped by the librarian, who reminded me that Jewish law prohibits bringing any religious works into a bathroom. As an unclean place, a bathroom is the one site where one is not supposed to study Torah.

These incidents may seem entirely anecdotal to my larger research aims, but I include them here because of their significance in the question of female culture. Women's hours at the library demonstrated a living, working sphere of women and children only, that in many ways was the essence of female Lubavitcher culture. Furthermore, in spite of the chaotic background of noise and childcare, real work did take place, even at the grammar-school level—as evidenced by the fourth-grade girls' smug confrontation with me. Their work, work for the Rebbe, was of paramount importance and status. They approached it with the same dedication their fathers brought to higher Talmud study. Theirs was a nearly divinely ordained homework assignment, next to which my attempts at secular analysis of the Lubavitchers appeared crudely irrelevant. This involvement of even very young girls in community and history says a good deal about the potential for female status and satisfaction within Lubavitch priorities. There is no "self-esteem" problem among girls here.

My insistence on working in this unusual library atmosphere led to my being mentioned in one of the very journals whose history I was researching. The January 1987 issue of *Neshei Chabad Newsletter* included an article called "Something for Everyone: Levi Yitzchok Library," and the third paragraph began:

> Do you see that woman over there? She's doing research for a college term paper, writing about Orthodox Jewry in America right after WWII. I heard her talking to the librarian, very quietly, of course, who helped her to locate the table-full of books she's using right now.

While the concept of a secular doctoral dissertation was contemptible to some Lubavitchers, I represented my research intentions clearly, explaining that there were few studies on Lubavitcher women and that I was collecting historical materials to bring Neshei Chabad philosophy to interested students in the secular world. But inevitably, the first thing I was told by women of the community was that I must change my name: Bonnie did not sound Jewish. Did I have a Hebrew name? I must write to the Rebbe about it. The centrality of the Rebbe to his followers was once again demonstrated.

After I established my desire to give an honest portrait of the community, I was showered with references and assistance. I was also noticed by men in the community, for social custom still mates the male *baal teshuvah* with his female counterpart. As an obvious newcomer to Lubavitch, I was awkwardly invited to dine by several newly devout young men.

During my two years of research in Crown Heights, I attended classes at Machon Chana, group encounters with the Rebbe, holiday street festivals, women's conventions, celebration meals, synagogue services, Neshei Chabad business brunches, and other events. While my study focused on the past literature and history of the community, I was unable to detach myself from the current lively Lubavitcher scene, particularly as most of the women whose early contributions I studied were still active. It is this personal glimpse of a continuum of female activity that made my work so rewarding.

Incorporating feminist analysis was my most difficult task; not because such analysis is unnecessary, but because it placed me in the ungracious position of scrutinizing my hosts and noting their anachronisms. Their responsibility to me was more than carried out; they endeavored to bring me to full Hasidic observance and, failing to win my adherence, loaded me with texts and sources contributing to my academic, and (they hoped) spiritual, advancement. And my responsibility to them? Their astonishing generosity in the face of my uncompromising analysis cannot be fully repaid in kind, for there is nothing they seek or admire in my world. Yet I hope my efforts to note the history and activism of Lubavitcher women will be accepted by them as a gesture of cross-cultural awareness. I count myself lucky to have experienced the warmth of a world my ancestors called their own.

ONE

"AISHES CHAYIL, MI IMTZA?"
A WOMAN OF VALOR, WHO CAN FIND?

For more than 200 years, Hasidism has fascinated Jews and non-Jews alike. This ultra-Orthodox, mystical movement has been the breeding ground for some of Judaism's greatest thinkers and most poignant acts of faith. The expansion and visibility of Hasidism in late-twentieth-century America, however, baffles more assimilated American Jews. In our eyes, contemporary Hasidism seems anachronistic: a form of self-imposed ghettoization, a separatist Judaism mistrustful of alliances and opportunities in post-Holocaust society. As a fortress of traditional, Orthodox Jewish observance in the secular/Christian West, Hasidism is a standard of Jewish piety against which other institutions of American Judaism may be measured and found tepid, particularly when so many "liberal" Jews marry non-Jews and vanish into secular American culture.[1]

Whatever one's viewpoint on the survival of Hasidism into the twenty-first century, the communities established in the United States represent a spiritual movement of Jewish fundamentalism in our midst—less familiar, as a subject, than Christian or Islamic fundamentalism, which attract far more media attention and political analysis. When Hasidism is introduced to outsiders by the media, it is seldom in a flattering light: Hasidim appear as instigators, of racial conflict in Brooklyn or upheavals in Israeli government. The private world of Hasidic belief and practice remains masked during such exposés. And since it is in the private world of

belief and practice where Hasidic women have their primary influence, the outsider's image of Hasidic remains masculine: one media byte of the bearded rabbi in his distinctive garb, gesturing to his *yeshiva* students as they hurry to daily prayers with holy books in hand.

The untold story is how modern Hasidic women have made their way in the United States, and how they serve as advocates for the traditional female role in Hasidic Judaism. I will be addressing the functional Hasidic women's community, rather than the spiritual development of Hasidic philosophy, although of course Hasidic women themselves would argue that there can be no such separation. It is true that Hasidic philosophy informs women's lives; yet scores of scholars have seen fit to examine the Hasidic renewal in postwar America as though it sprang from one gender alone. I indicate here the representative studies on American Hasidic belief and socialization, such as Robert Mark Kamen's Bobover treatise *Growing Up Hasidic* or Israel Rubin's *Satmar: An Island in the City*, noting the almost total absence of material on women's lives within works that purport to represent distinctive Hasidic sects.

The Lubavitchers are an international Hasidic outreach movement, with central headquarters located at 770 Eastern Parkway in Crown Heights, Brooklyn (simply called "770" by local adherents). For over forty years the women of this Brooklyn community have organized campaigns and produced publications aimed at encouraging traditional Jewish observance among assimilated American Jews. The historic period investigated herein corresponds to the dynamic leadership of the late Lubavitcher Rebbe Menachem M. Schneerson, whose death in 1994, with no natural or designated heir, devasted the community.

Due to the relative lack of critical research on female culture within Hasidism, myths and stereotypes flourish about the Hasidic woman and her function in both social and religious contexts. Those who conflate Hasidism with rabbinical (e.g., male) tradition alone may be surprised to learn that there is a separate reality of female experience in Hasidism that includes ongoing confrontation with feminist ideology in non-Jewish society. Despite their communal isolation and ideological stance, Lubavitcher women's self-image has definitely been affected by American feminism, especially where it calls for greater female autonomy and self-determination. But by upholding the virtues of Jewish matrilineality and the Jewish home, by constructing those virtues as separate from the realm of Christian experience, Hasidic women

declare themselves already "liberated"—from Christian ideals of womanhood. Thus, when Lubavitcher women advocate traditional gender roles and domesticity for all Jewish women, they deny that they are unintentionally reproducing their own oppression. They contend that they are, intentionally, reproducing difference: the difference between a Jewish and non-Jewish home.

Gender and ethnicity construct different, occasionally competing, realities. The historic condition of the female as Other, as subject, separates the Hasidic woman from the Hasidic man; but the historic condition of the Jew as Other, as outcast, separates the Hasidic woman from the "white" womanhood of Western, Christian society. And the role of the Hasidic woman differs from that of the woman in modern Orthodox Judaism to the extent that Hasidism has a unique spiritual agenda with specific roles for both male and female adherents. Three times removed, by gender, ethnicity, and sect, the Hasidic woman until recently had yet to be located on the continuum of either Judaica or women's studies. Thankfully, this is changing. A new plethora of articles and monographs on women in specific Hasidic communities testifies to awakened interest in the function of the religious woman and, by extension, the attraction of formerly unaffiliated Jewish women to Hasidism.

HASIDISM

Despite the unspeakable atrocities of the Nazi Holocaust, which eliminated the greater portion of Eastern Europe's pious Jewish villages, rejuvenated Hasidic communities are a global phenomenon today. The largest and most active communities are presently located in New York and in Israel.[2]

Contemporary Hasidism is based on a Jewish pietistic movement founded in eighteenth-century Poland by Israel ben Eliezer; Hasidim refer to him as the Baal Shem Tov (Master of the Good Name), or Besht, the more familiar acronym. The teachings of the Besht included joyous piety and strict observance of Jewish law, during an era that saw the simultaneous onset of European Jewry's modernization and secularization. The early Hasidim, or "pious ones," expressed their faith through dancing, exuberant prayer, and the application of religious devotion to all aspects of daily life, no matter how mundane. This break from the elitist scholarship of existing Orthodox rabbinical academies initially attracted poor and

working-class Jews, who, lacking the leisure time for prolonged immersion in study, felt alienated from the intellectual strata of Judaism.[3] With the rise of the Hasidic movement, the poor but pious Jew could become actively engaged in redemptive processes regardless of his or her limited scholarship opportunity.

Of course, eighteenth century Polish Hasidism did not begin in a vacuum, but drew on earlier mystical theosophy that influenced Hasidic belief. The kabbalism of Isaac Luria and his students in sixteenth-century Tzefat (northern Palestine) posited that earthly suffering derived in part from heavenly discord—the initial contraction of God's light into divine vessels, which subsequently exploded and dispersed God's light throughout the material (and fallible) world. More important, the idea that divine "sparks" were scattered throughout the world led to the development of Hasidic emphasis on *tikkun*, repair or redemption. By redeeming the holy spark contained in each person, each action, each aspect of Judaism, the Hasidim believed they could reconstruct the shattered vessels of divine light—thus bringing about the coming of the Messiah and the end to Jewish suffering in a world of evils.[4]

The concept of *tikkun* held understandable appeal for poor Jews, excluded from elite *yeshivos*, who grasped at the possibility of an individualized role in the process of Messianic redemption. But the Hasidic departure from *yeshiva* domination in the late eighteenth and early nineteenth centuries was interpreted as rebellion and heresy by the established rabbinical leaders at Jewish intellectual centers such as Vilna in Lithuania. These *mitnagdim*, or opponents, arrested, excommunicated, and otherwise ostracized the first practitioners of Hasidism.[5] Although this fierce opposition gradually abated as both Hasidic dynasties and the traditional *yeshiva* meritocracy confronted the threats of assimilation, modernity, and pogroms in Eastern Europe, class and culture biases dating from early clashes continue to prevent unity between Orthodox Jews and Hasidim in many Jewish communities today.[6]

What differentiated one Hasidic group from another? The basic distinction was the Rebbe. One of the most significant developments in Hasidic community life was the function of specific charismatic leaders, known as *Rebbes* or *tzaddikim*—individuals credited with mystical and spiritual powers by their devoted followers. The Rebbe served as community mentor and link to Heaven. He also intervened as judge in matters pertaining to Jewish law or legal procedure, resolved disputes between his Hasidim, and negotiated with authorities in the non-Jewish world that

always surrounded and threatened existing Jewish communities. The structure of this leadership role was practical in that Hasidism continued to be a working-class movement within Judaism, and adherents were seldom able to devote the desired long hours to daily study of religious law. Instead, they trusted in the intellect and insight of their chosen Rebbe, while combining their own religious studies with the demands of earning a livelihood.[7]

As the original disciples of the Besht evolved into disparate Rebbes, each with their own followers in different Eastern European *shtetlach* (villages), each Hasidic group became a dynastic court, or *hoyf*, with leadership passed down through the Rebbe's heirs. Specific traditions, modes of dress, and even personal holidays inspired by the Rebbes of a particular village were also passed down through subsequent generations of Hasidim. Groups of Hasidim and their leaders typically used the name of their original village as a reference point for identification, so that the Hasidim from Satu Mare in Hungary became known as the Satmar, the Hasidim of Belz as the Belzer, the Hasidim of Bobov as the Bobover, and so forth. Although surviving Hasidic groups have today resettled outside of Eastern Europe, the regional names are still used, particularly with regard to the reigning Rebbe.[8] This continued deference indicates the enormous power leaders wielded, and continue to wield, over sect politics, actions, and beliefs.

The Lubavitcher movement, one sect of Hasidism, assumed a significant role in the last two decades of the eighteenth century for its efforts to redeem other Jews through outreach and proselytizing. This unique form of Jewish activism brought both penalty and success to the Lubavitcher communities in Russia and Poland, results that in turn guaranteed the Lubavitchers' high visibility among other Hasidic sects. Seven generations of Lubavitcher Rebbes committed themselves to the outreach movement known as Chabad; as a result one finds "Chabad Hasidism" and "Lubavitcher Hasidism" used interchangeably in both religious and academic literature.[9]

Chabad Hasidism is the philosophical brainchild of the "Rav" (or first Rebbe) of Lubavitch, Rabbi Shneur Zalman. In the late eighteenth and early nineteenth centuries, the Rav responded to the plight of Russian Jewry by emphasizing an active (rather than unquestioningly obedient) faith centering on the qualities of *chochmah*, *binah*, and *daat*, or wisdom, knowledge, and understanding. "The mind understands, the heart feels and the hand performs," became the credo elucidated in the Rav's magnum opus, *Likutei Amarim* (popularly called *Tanya*, after the opening phrase,

"It is taught . . .") Central to Chabad ideology is the fusion of intellect and emotion, or mind and heart. Rabbi Shneur Zalman expected more from his followers than adherence. Chabad Hasidim were to play an active role in educating and transforming a Jewish community which, at the time, had few advocates. Because the first adherents committed to this program settled in the town of Lubavitch, or "city of love," the Russian moniker quickly became a reference to the Chabad movement's (and the Rav's) center of activity.

Due to their dedication and activism on behalf of Russian Jewry, the Lubavitchers attracted considerable attention and support in the West, including diplomatic connections sufficient to ensure the safety of several Rebbes threatened with imprisonment and exile by Tsarist and Soviet authorities. These connections ultimately permitted the sixth Lubavitcher Rebbe and his followers to resettle in Brooklyn, New York, on the eve of World War II. But the establishment of a Hasidic proselytizing headquarters in the postwar United States created new conflicts. Although the continuum of Lubavitcher leadership and activism was assured, tensions escalated between the Lubavitchers and nonproselytizing Hasidic groups, and between the Lubavitchers and those assimilated American Jews targeted by Lubavitcher outreach campaigns.

The Hasidic Woman in History

I have noted that the role of the Hasidic woman throughout the controversial history of Jewish sectarianization has been all but ignored by historians and theologians. The male world of Hasidic religious study and leadership receives a great deal of scrutiny in both mainstream-academic and Jewish literature, but the female world of home and child rearing is often bypassed by scholars whose primary interests center on Hasidic study methods.[10] Until the fall of 1985, when journalist Lis Harris began a three-part report on a contemporary Lubavitcher family for *The New Yorker*, no text about Hasidic women in America available for a general, non-Hasidic audience.[11]

This invisibility of Hasidic women in Jewish historiography must be seen in proper historical context; until the late 1960s and early 1970s few texts addressed women in religion, period. A starting point for the emergence of critical work on both academic and social suppression of women by religious institutions is Mary Daly's explosive publication of *The Church and the Second Sex* in

1968, followed by *Beyond God the Father* in 1973. Combined with new work coming from feminist scholars at the Harvard Divinity School, such as the 1974 anthology *Sexist Religion and Women in the Church*, Daly's brilliant analysis of Church-sanctioned sexism paved the way for a new discipline of studies on women's subjugated role in religious communities. The 1970s also saw the introduction of academic women's studies as a permanent, if controversial, curriculum at most American universities, encouraging research on women and the application of such research in the academy (where tolerated). On the heels of feminist critique of Christianity came similar research on Jewish women's status.

A wide variety of cultural and academic anthologies on Jewish womanhood appeared during the 1970s and 1980s as a result of increasing feminist dialogue on both ethnicity and female spirituality.[12] Many of these texts criticized the sex-role limitations inherent in traditional Judaism, offering modern alternatives while affirming the importance of religious ritual in women's lives. Scholarship such as Rachel Biale's *Women and Jewish Law* (1984) provided concise new guides to the origins of rabbinical directives on women's roles, expanding the limitations proposed by Orthodox rabbi Moshe Meiselman in his 1978 work *Jewish Woman in Jewish Law* (which attacked feminist critique of Judaism as "hysterical"). The success of some women and their male allies in overcoming first Reform and then Conservative Judaism's resistance to female rabbis and cantors led a new generation of American Jewish women, in positions of religious authority and status, to challenge sexism in Jewish liturgy, hierarchy, and religious education.

Texts on the role of the Jewish woman thus expanded to include analyses of this new genre of female participation in the contemporary American synagogue, particularly after Sally Priesand was ordained as the first woman (Reform) rabbi in the United States, in 1972. Yet the ongoing dialogue between feminists and male Jewish leadership, however necessary and welcome, continued to marginalize the Hasidic woman, because the questions raised were often inappropriate to her situation.[13]

Texts raising serious questions about the *positive appeal* of the contemporary Hasidic lifestyle for many women would not appear outside of the Hasidic press until Lis Harris's *Holy Days* in 1985. This popular glimpse into Lubavitch lives was followed by two 1991 studies on Jewish women choosing Hasidism as a lifestyle: Lynn Davidman's *Tradition in a Rootless World* and Debra Kaufman's *Rachel's Daughters*. It is significant that both

Davidman and Kaufman, sociologists and women's studies scholars of the *baalot teshuvah* phenomenon, uncovered substantial evidence of American Jewish women who found Hasidism more rewarding than feminist critique.

In short, feminist research has caught up with a vast politics of Jewish identity, opening debate on the female role in Jewish spirituality. And thus the present range of publications by Jewish women scholars writing about Jewish women is wide enough to include both Tamar El-Or's *Educated and Ignorant*, a 1994 translation of her study on women of Israel's Gur Hasidic community, and Judith Plaskow's 1990 *Standing Again At Sinai: Judaism from a Feminist Perspective*.

A few male scholars interested in Hasidism have addressed the female experience. But their pages, from the older academic canon of Hasidic studies, are limited, occasionally inconsistent. Has the Hasidic emphasis on woman's *tznius*, or modesty, helped to obscure centuries of female influence?—or is it the configuration of the Hasidic community itself that defies outsiders' pursuit of accurate data?

Central to the lives of Hasidic women and men is the authority of the particular sect's Rebbe. His leadership, guidance, and moral platform are the impetus for his adherents' actions. All Hasidim are equal in their attachment and obedience to their Rebbe; both male and female receive religious and political interpretation from the Rebbe's addresses to his followers. The feminist question of women's equal access to congregational leadership, for example, is moot for Hasidim, as neither male nor female adults seek to displace or succeed the Rebbe. Hasidic women are not interested in attaining religious authority or congregational power on an individual basis; they consider themselves to be guided, protected, and represented by their Rebbe, whose role as spiritual leader is absolute. The follower's disinterest in sect leadership does not, however, alter the consistently male gender of the *tzaddik*. Thus most historiography about women in Hasidism appears when individual women distinguish themselves as the result of relationships (mother, wife, daughter) to even more distinguished males.

Historically, the role of the Rebetzin—the Rebbe's wife—provided a Hasidic model of female dignity and status not found in the non-Orthodox community.[14] And the title "Rebetzin" was not always limited to wives of specific dynastic leaders; in many cases it applied to those women whose husbands were recognized scholars of merit. These secondary Rebetzins were also revered as

women of stature who frequently taught other women. In some circumstances of the early Chabad movement, it was the Jewish woman who became attracted to Hasidism and convinced her husband to participate; she received recognition and approbation for her part in transforming the religious home, and was not forgotten if and when her husband achieved a measure of scholarly success. The historic participation of women in disseminating Hasidic ideals is at present a scholarly controversy. One previous view is that Hasidism made room for a minority of spiritually extroverted female adherents. In his 1970 article "Lady Rabbis and Rabbinic Daughters," Harry Rabinowicz reconsidered the impact of wives and daughters in the realm of Hasidic teaching. The Besht himself believed in the power of female prayer and declared in an address to one community "Through a woman have I seen the light."[15] In the eighteenth century, women played an important role in spreading the Besht's teachings in East European communities; according to Rabinowicz, some women were designated as prophetesses, received male seekers, wrote manuscripts or led discourses on the nature of the Hasidic path. One Hasidic rabbi, Leib Sarah, carried the name of his mother in honor of her uprightness.[16] In general, women who assumed the role of rabbi were wives and daughters of prominent scholars, who became literate in their homes and had access to a way of life based on parables, charity work, and missionary travel.

Those Hasidic women who functioned as authorities during the nineteenth century differed from one another in terms of whom they received to counsel and the arrangements for such audience. Eidele, a female Belzer Hasid who married Rabbi Isaac Rubin of Sokolov, took the role of Rebbe that her husband did not desire and addressed Belzer followers in the manner of a rabbinic authority. This prompted her father to comment that "All Eidele needs is a rabbi's hat."[17] Yet Hannah Havah, daughter of Rabbi Mordecai Twersky of Chernobyl, preferred to use her celebrated scholarship and piety to counsel women. And still another devout woman, Tamarel Bergson, used her influence to employ young men, enabling them to become Rebbes themselves.

Rabinowicz draws on the much earlier research of S. A. Horodezky in promoting the spectacular history of Hannah Rachel, the one Hasidic woman alleged to have achieved fame and recognition through both masculine achievement and feminine modesty. Hannah Rachel, born in 1805, became "The Maid of Ludmir," who studied Jewish law, put on *tefillin* (ritual phylacteries) and *tallis* (a

prayer shawl) and recited *kaddish* (prayer of mourning)—all male activities and symbols. While these acts resulted in the annullment of her marital engagement, her piety and moods of alternating exaltation and melancholy designated her as a personage of traditional Hasidic learning and mysticism. Her father built her a synagogue with living quarters attached, and through the partly opened door of her room the Maid of Ludmir spoke to the Hasidim who heard but did not look at her. Hannah Rachel thus maintained a modest separation from her attentive male congregation, while permitting them to reap the benefits of her knowledge. She ended her life in partnership with a kabbalist bent on hastening the coming of the Messiah.[18]

Ada Rapoport-Albert has challenged this version with her 1988 article "On Women in Hasidism, S.A. Horodecky and The Maid of Ludmir Tradition."[19] Rapoport-Albert points out that Horodezky (whose surname is spelled variously and from whose pre-1925 works most subsequent popularizations of the Maid of Ludmir have been adapted), actually provided no written sources. Instead he claimed, as oral sources, the testimony of old women who had personally known Hannah Rachel. Subsequent writers such as M. Klaczko drew on Horodezky and added their own "evidence" from women who allegedly interacted with Hannah Rachel. Rapoport-Albert comments, "Interestingly, this report of the Maid conflicts with her reclusive image as it emerges from Horodecky's tradition, as well as suggesting, in contrast to Horodecky, that her leadership was directed primarily toward a female, not a male, following."[20]

While the oral tradition of tales and Hasidic narrative tradition should not be underestimated, the lack of written accounts in praise of Hannah Rachel suggest at the very least that other (male) Hasidim did not find her actions worthy of praise, and her status as a *tzaddik* is thus questionable. Furthermore, Rapoport-Albert points out that Hannah Rachel's story is not one of success, as she remained unmarried (unthinkable for a Hasidic woman) and thus is identified as a "Maid" and not a Rebetzin. Hasidism did not offer an option of celibate female sainthood as did Christianity. What is remembered about Hannah Rachel is her abandonment of the prescribed sexual role, not the content of her preaching. If she did affect local women, who became sources for Horodezky and Klaczko, clearly for local men this was not the equivalent of having a full Hasidic circle.

And this is the frustrating dilemma of women's history in general: Do women become significant only when male observers pro-

nounce them so? How do we locate—and reconstruct—women's impact on *women* in community histories with a tradition of female illiteracy?

Thus, for the most part, we find a focus on woman-as-male or woman-as-support-to-male in past scholarship on women in Hasidic history. Where a woman lacked access to learning and status herself, she might nonetheless encounter a Rebetzin who served as a model of activism and piety. Within the Lubavitcher sect, the precedent set by the first Rebbe's scholarly daughter, Freida, permitted the gradual incorporation of women into the religious activism for which Lubavitch became infamous.

As this is a study of women in Lubavitch, it must be acknowledged that in the case of Chabad, male activism placed women in both endangered and empowered roles. The risks of Jewish proselytizing under both Tsarist and Soviet rule meant that Lubavitcher activists in Russia were frequently imprisoned, banished, or forced to flee from region to region. These threats, combined with the normally extensive travels of the Lubavitch Hasid, produced communities where the male was away for long periods of time, leaving the Lubavitcher woman in the role of breadwinner and head of the household. Consequently, Lubavitch literature frequently praises the faithful wife who arranged for her husband's bail, advised his followers of his whereabouts, lied to the police, smuggled religious accouterments to prisons, and similarly maintained an expanded role in the family.[21] These conditions, while certainly not pleasant, nevertheless gave women an important function that critics of the female role in Hasidism have overlooked and underestimated.[22] At the same time, Ada Rapoport-Albert suggests, "*Mitnaggedim* and *Maskilim* alike accused Hasidism, with considerable justification, of undermining the institution of Jewish marriage and aggravating the condition of women by drawing young married men—the main recruits to the movement in its formative years—away from their wives and children for periods ranging from several weeks to several months and more."[23]

And so the alternative framework of Chabad Hasidism within Judaism produced an alternative framework of male and female roles as well. Despite prevalent stereotypes about the rigidity of Hasidic womanhood, the role of the woman in the Lubavitcher sect really encompassed a wide range of possibilities. The Chabad proselytizing ethic permitted women, as well as men, to expand their vocational opportunities into outreach work, travel, visibility, publication, and authority. And service to the Rebbe also engaged

women in projects beyond the limitations of house and home. However, the public service aspect of Hasidic women's spirituality came late. Unlike their Protestant counterparts in the United States—women whose moral and religious frameworks dovetailed with emerging reform movements, creating a feminist missionary activism throughout the nineteenth century—Hasidic women did not blossom as activists until after World War I. The watershed for Lubavitcher women's service was the transplantation of Lubavitch to North America.

Old and New Roles in America

Traditionally, the primary role for the Hasidic woman was to fulfill her own obligations in Jewish law—not more, not less—and to oversee her family's scrupulous Jewish observance. Raised to be the wife of a scholar and the mother of as many children as possible, her daily life revolved around caring for others within the context of Torah. She prepared kosher meals, readied her home for the Sabbath and festivals, enrolled her sons in religious schools under Hasidic auspices wherever possible, and participated in charitable volunteer work and giving *tzedaka* (charity). The pious woman also served her Rebbe by responding to his guidelines for female behavior in the community; regardless of the secular styles of the day, she dressed modestly, covered her cropped hair with a *sheitel* (wig), and avoided the vulgar temptations of film and popular music (and, later, television). Central to her schedule was regular attendance at the *mikveh*, ritual baths used after menstruation or childbirth. During her menstrual period and for seven days afterward she refrained from sexual intimacy with her husband; during normal times of contact she did not employ any means of birth control, but awaited each child with faith that God would provide for the new addition to the family.[24] Above all, the Hasidic woman was exhorted to be an *aishes chayil*, or a "woman of valor," as outlined in Proverbs 31: namely, an example to other Jewish women through her modest ways, kosher home, well-instructed children, and devotion to Jewish laws and customs.

While the male Hasid devoted much of his life to religious discourse and prayer, the Hasidic woman, like all observant Jewish women, was exempt from time-bound religious obligations in order to oversee the home, thus severely circumscribing her participation in central rituals and scholarship.[25] The Hasidic woman enjoyed

certain female-only rituals, such as the *forshpil* celebration of song and dance on the evening before a young woman's marriage, but this in no way competed with the *farbrengen* experience of the male who joined his peers to eat and dance with the Rebbe himself.[26] Intellectually, the Hasidic woman remained isolated from and dependent on the legal interpretations of Rebbe and husband, both of whom who dictated the meaning of her role to her. Yet the religious knowledge of the Hasidic woman had to be sufficient to meet her domestic and communal responsibilities, such as keeping a kosher home and preparing for holidays.

In both Eastern Europe and the United States, many Hasidic women worked to support their families or to assist their husbands in furthering religious studies. Solomon Poll's research on the Hasidim of postwar Williamsburg, Brooklyn, demonstrated that Hasidic businesswomen used religious acumen to their advantage in sales work, advertising to the Jewish consumer the ritual appropriateness of commodities. Poll found that women cleverly utilized biblical quotations and Hasidic parables in retail graphics or ads, thus transforming household wares into religious necessities. Despite the strict segregation of the sexes in social activities, worship, and education, both male and female participated in wage earning and religious functions. And, because the Hasidim relied on their own goods and services, each member of the community eventually became both a producer and a consumer within the Hasidic economy. It should be noted that the very customs based on gender segregation and definition also provide economic roles. For example, within the Hasidic community women may find work as wig fitters, *mikveh* attendants, clothing saleswomen, or teachers; they also work as caterers for the many banquets surrounding religious holidays, births, and weddings.

Women in the Lubavitcher sect faced a double task in twentieth-century America: they were expected to strengthen and rebuild their community through isolation from secular ideals, yet to foray into the secular world to inform other Jews about the Hasidic alternative. The concept of "woman of valor" expanded to encompass both the traditional responsibilities of motherhood and piety through example, and the public role of Jewish missionary to wayward Jews. This change not only placed the Hasidic woman in the secular world, but reintroduced the secular world to the vibrancy of Hasidism.

In her dissertation on Ukrainian Hasidism, scholar Yaffa Eliach criticized the predominance of studies on Hasidism that exam-

ined Hasidic life "only against the background of Judaic ideas and Jewish society of Eastern Europe. The research is entirely inwardly directed.... This approach, by its very nature, presents Hasidism as a unique Jewish experience and a phenomenon not shared or influenced by any other society in the immediate vicinity or elsewhere."[27] One may interpret Eliach's words as a hint that the coexistence or intersection of Hasidic communities with secular institutions and phenomena deserves much more scrutiny. The history of Lubavitcher women in the United States is one example of an ongoing Hasidic relationship with non-Hasidic society. Lubavitch Hasidism differs from other branches of Hasidism because it is outwardly as well as inwardly directed—one scholar called it "a comparatively cosmic orientation."[28] The entire Chabad movement is based not on withdrawal from society but on engaging and transforming that society. The Lubavitcher woman in postwar America found her position as a religious minority in a secular Western setting to be a challenge that informed her identity and her agency as a Jew.

The following chapters examine the secular and religious influences—the "inner" and "outer" influences—that transformed Lubavitcher women's activism in the postwar era. Specifically, I look at the social institutions of girls' and women's schools, the annual conventions of Lubavitcher women outreach activists, the quarterly periodical *Di Yiddishe Heim*, and responses to feminism in Lubavitch rhetoric. In each chapter, we may see how the agenda of the late postwar Rebbe Menachem M. Schneerson shaped female participation and female interaction in Lubavitch, against an American background where changing ideas of gender offered women possibilities diametrically opposed to Hasidic sex-role definitions.

As the centrality of the Rebbe to his followers is a vital aspect of community life, his writings, speeches, and directions to female followers are evident in nearly all sources. Thus the materials written by Lubavitcher women are highly self-conscious, due to their combined inward and outward purpose. While the women's periodicals permit women already committed to Hasidism to share ideas and anecdotes, all Lubavitch writing has the general goal of convincing outsiders to become observant Jews. As fundamentalist Christian missionaries seek the conversion of nonbelievers in order to "save" the latter before the anticipated Day of Judgment, so Lubavitchers seek the increased observance of assimilated Jews in order to prepare for and expedite the arrival of the Moshiach. Therefore Lubavitch periodicals are careful to present positive images of

their community, and this self-consciousness in the name of effective proselytizing occasionally edits out women's complaints and critiques of their lot.

I deliberately spotlight those forceful missionary campaigns by Lubavitcher women that seem most clearly to be a response to American feminism. While recognizing the new options for young American Jewish women in the wake of the feminist movement, Lubavitcher publications nevertheless argue against the temptations of "liberation" and "careerism." Lubavitcher women do not pretend that their path is a particularly easy one, but remind listeners of the folk parable wherein no man complains of carrying the weight of a diamond-filled sack (the diamonds, of course, here represent Torah and *mitzvos*). The sources offer an ironic glimpse of Hasidic mothers who, like Phyllis Schlafly and other contemporary spokeswomen for "traditional" family values, are frequently away from home in order to conduct workshops and speeches on the importance of female domesticity. But the writings by Lubavitch women are not limited to discussion of womanhood in its varying frameworks. Lubavitcher women are committed to bringing Moshiach as soon as possible, and urge other Jews to accept the responsibility of a role in redemption. Thus Lubavitcher women's work is not only religious recruitment for the present, but part of an entire redemption process with eyes on the prophesied future.

It is, in part, this intense belief in the coming of the Messiah that distinguishes the Lubavitcher woman from other Jews. Lubavitcher women, on the one hand, are able to resist the allure of secular society because that society is limited, for them, to the United States and to the present. Torah Judaism, on the other hand, uses an eternal, otherworldly framework; and the Lubavitch movement is international, reaching far beyond the Crown Heights community where the late Rebbe made his home for so many years. This sense of the eternal, and the international character of the Hasidic community, is also evident in the sources, although the scope of this study is limited to a forty-year span in the American Lubavitcher movement.

Using the sources of the Crown Heights Lubavitch community to examine changes in outreach policy and female organizational work since 1950, I pursue several key questions. How did Lubavitcher women's literature keep pace with the tone of the times, as more and more changes in gender roles occurred in secular society? Has the American feminist movement created new conflicts between gender and ethnic identity for Lubavitcher

women, or merely intensified existing conflicts? Did Lubavitcher attitudes change as the community admitted *baalot teshuvah*—new adherents—with secular or feminist backgrounds? Did the women's publications notably improve in scholarship or political awareness throughout the years, and was this due to corresponding changes in the educational curriculum for Lubavitcher women? Finally, how do these findings fit into the current and ever-growing historiography of Jewish feminist criticism, which has primarily addressed the transformation of liturgy and ritual?

In studying Lubavitcher women through personal interviews, public forums, and their own writings, one finds much to disprove the popular stereotype that they are passive particles in Hasidic dynamism who merely acquiesce to their prescribed roles. Rather, they are active teachers and passionate speakers, fueled by their Rebbe's expectations that they serve as models of Jewish womenhood. This devotion to the Rebbe, however, meant that the primary activism of Lubavitcher women was both limited and made possible by service to a male idealogue.

The limited dialogue between Hasidic and non-Hasidic women since the 1950s has tended to focus on keenly personal issues: dress and Jewish ideals of modesty, the laws of *niddah* (menstruation), separation from men in religious ritual, and, more recently, feminist approaches to women's spirituality. In confronting feminist criticism of patriarchal Judaism head on, Lubavitcher women, as we shall see, respond with clarity and conviction to those who might categorize them as voiceless. And their battle cry of outreach, to less observant Jewish women in America (and around the world), is that the inner (spiritual) and outer (communal) frameworks of Hasidism offer the most appropriate pathways and rewards for an active and meaningful Jewish womanhood.

TWO

"CHANOCH LANAAR AL PI DARKO"
EDUCATE A CHILD ACCORDING TO HIS WAYS

> *I suppose that I, too, could have jumped enthusiastically into the world of academia and then immersed myself in an exciting career. Instead, I chose to develop my whole self as a Jewish woman.... The Jewish woman needs no fancy titles or letters at the end of her name to prove that she is a worthwhile human being. Our sick American society glorifies the types of achievements previously mentioned: professional status, higher secular education, and so forth.[1]*
>
> —Tzippora Muchnik
> The 24th Annual Convention of the
> Lubavitch Women's Organization, May 1979

FEMALE EDUCATION

One may be born a Jew, heir to an ethnic lineage. But one must *learn hasidus*, or Hasidism.

Roman Vishniac's classic photographs of Eastern European Hasidic schoolboys in their distinctive dress, bent over yellowed pages of Jewish law, are symbolic artifacts of religious communities eradicated during the Holocaust. Such images serve as a silent rebuke to non-Jews (witness the legacies of Jewish learning that Gentiles destroyed!) and as a different sort of rebuke to assimilated Jews (witness the meticulous piety of your ancestors!). But the photographs make yet another point through what they omit. There are no girls in these portraits of Talmudic learning.

Education and instruction in *yiddishkeit*, or Jewishness, form the core of Lubavitcher philosophy. Learning is a way of life in the

Lubavitcher movement—whether through the indoctrination of children in Hasidic ways, higher religious study in a *yeshiva*, or outreach to assimilated Jews unfamiliar with traditional observance. In one of the few Western subcultures where male status and achievement are measured by the yardstick of scholarship, Hasidic education includes the entire range of individual and group behaviors its students will practice throughout youth and adulthood. Despite the incorporation of mandatory secular subjects into school curricula, Hasidic education in the United States has always upheld the goal of producing Hasidim, rather than graduates intending to enter the American social mainstream of college and career. Although the Rebbe himself studied at the Sorbonne, the vast majority of his followers experience a typical university campus only as Chabad House *shluchim* (outreach missionaries).[2]

Within the strictly regulated world of Hasidic education, schooling for women remains separate from and less intensive than male learning. Traditionally, the Jewish woman learned only the religious obligations governing family life, as all "higher" education was considered superfluous to her preparation for marriage and her direction of a religious household. Throughout Hasidic history, we find evidence of pious women but not of women scholars: religious erudition was a male responsibility and privilege, and an extremely learned woman such as Hannah Rachel, "The Maid of Ludmir," was an abnormality. Women in the Lubavitch communities of Eastern Europe freely consulted male authorities for advice on religious, domestic, and community issues, but remained outside of the scope of *yeshiva* activity themselves.

Despite the circumscribed appearance of female learning in early Lubavitch Hasidism, new avenues of educational opportunity opened for women in the twentieth century. During the Lubavitcher immigration waves between the 1920s and 1940s, education reforms originating in the European Hasidic communities made their way to the United States. Lubavitcher women found new roles as teachers and students in America, due in part to the introduction of modern secular studies and certainly due to the educational programs fostered by the sixth and seventh Lubavitcher Rebbes. Innovations in women's education created possibilities for female study and mentoring on a scale unthinkable before World War II. These innovations included the founding of the Beth Rivkah school system for girls and the development of continuing education institutions for adult women interested in becoming *baalot teshuvah*, newly observant members of the Orthodox Jewish community.

To understand the significance of women's involvement in these modern educational changes, one must first consider the stark history of female education in Orthodox and Hasidic Judaism.

SCHOOLING FOR GIRLS

Scant attention has been devoted to female education in Jewish historical literature, although the schooling of the Orthodox boy has been the subject of much research, commentary, and nostalgic writing. In the Eastern European Ashkenazic tradition, the Jewish boy began school shortly after his first haircut at age three. On his first day of school, a teacher, parent, or Rebbe placed drops of honey on his tongue as he learned the first letters of the Hebrew alphabet—to equate sweetness with Torah study.[3] From then on he studied in a *cheder*, a religious elementary school, learning Bible and Hebrew through rote memorization, until he evidenced sufficient maturity to begin learning Talmud. Even before his *bar mitzvah* at thirteen, he might graduate to study in a *yeshiva*, where he remained for years or decades, studying Talmudic discourses on the intricacies of Jewish law. The young man's seminars were often led by scholars of advanced knowledge and venerable reputation, who decided when the youth was ready to receive *smicha* (rabbinical ordination).

As an adult, the Jewish male ideally continued his studies indefinitely, and his reputation as a scholar often determined his marriageability. To support his family, depending on his talents and predilections, he might find employment as a teacher, resident scholar, translator, or scribe. Since the Hasidic community economy was based on those religious goods and services generated by Jewish law, the male scholar could also find work in the trades of bookselling, bookbinding, ritual slaughter of animals, the manufacture and sale of religious ornaments and utensils, and other fields where knowledge of *halacha* was necessary. From the first day of school at age three, therefore, the Hasidic boy was surrounded by the study of laws he would adhere to and implement until his death. For him it was a personally relevant curriculum of learning.

This structure did not change with the transplantation of Hasidic sects to the United States. In America as in Europe, boys used their scholarship in daily Orthodox Jewish life, and thus the smallest male child imitated the motions of his male adult counterparts through initiation into religious ritual and Torah learning. For

girls, however, there was no parallel. The ultimate status conferred on the mature Hasidic woman was her role as wife and mother, a role that could hardly be assumed by a first-grader. Although girls certainly assisted their mothers at home and in candle-lighting on the Sabbath, this private instruction and preparation was separate, structurally and environmentally, from schoolday lessons.

The history of Hasidic education for girls is fraught with this ambivalence. In a culture that revered learning, female scholarship was suspect, irrelevant; bright girls were caught in a curriculum that did not reward brilliant women. In the United States, as we will see, frustration with these limitations led Lubavitcher girls through apathy, petty rebellion—and change.

What is the basis for this disparity between male and female study in Judaism? Beginning in the Middle Ages, Jewish women were exempted from the positive commandment to study Torah because of their general exemption from all time-bound commandments. Jewish law is composed of 613 commandments, of which 248 are positive ("Be fruitful and multiply") and 365 are negative ("Thou shalt not kill"). The exemption of women from all time-bound obligations such as daily prayer, regular study, and assorted rituals stems from the rationalization that women are responsible for home, children, and husband, and cannot simultaneously fulfill the schedule of observance required of men.[4] Hence, the daily prayer recited by all Jewish males—"I thank you, God, who hast not made me a woman"—presumably stems from the fact that men have a greater religious obligation in Judaism. The male has more opportunity to fulfill God's commandments on a regular schedule, and expresses gratitude in his prayers for this ability to serve.[5] In the actual Torah there is no basic proscription against female participation in study, for the obvious reason that Talmudic studies postdated Torah. Thus it is in the Talmudic discussions and the *minhag*, or community religious customs, that we find arguments against female study. Regrettably, these arguments reflect a misogynistic contempt for female rational ability more often than they provide a "religious" basis for female exclusion from learning.

Countless rabbis throughout the history of Jewish legal commentary debated the point of female exemption from study, some commending women for the effort of learning, some condemning the exposure of women to Talmud as heresy, and still others noting officiously that without the initial legal obligation women would receive no "reward" for study as far as the Almighty was concerned. The famous hard-liner on this subject was the second-

century Rabbi Eliezer ben Hyrcanus, who proclaimed "If a man teaches his daughter Torah, it is as though he taught her obscenity."[6] Rashi's commentary on this declaration suggests that those who objected to female Torah learning feared that an educated woman might become clever enough "to conduct immoral affairs without being found out."[7] But Rabbi Eliezer also declared, "Let the words of the Torah be burnt before being handed over to women."[8] These remarks, coming from a reverent sage to whom Torah burning would be an unspeakable horror, seem indicative of real hostility toward female learning, far beyond any fine legal point.

In the twelfth century, Maimonides more generously ruled that "A woman who studies Torah will be recompensed, but not in the same measure as a man, for study was not imposed upon her as duty and one who performs a meritorious act which is not obligatory will not receive the same reward as one upon whom it is incumbent and who fulfills it as a duty."[9] However, Maimonides also stated, "Yet even though she has a reward, the Sages commanded that a man not teach his daughter Torah, for the mind of the majority of women is not adapted to be taught; rather they turn the words of the Torah into words of nonsense according to the poorness of their mind."[10] Here the legal and ideological position become one. Presumably, the exemption of women from study renders even their pious voluntary efforts inconsequential, rather than laudatory. This interpretation, perhaps derived to discourage women from competing with men, suggests that it is the fulfillment of one's assigned commandment, not going the extra mile, which generates Heavenly approval. (Centuries of Christian theologians have critiqued this "legalistic" focus in Judaism.)

As they were not obligated in the first place, no amount of study could earn women the approval or mentoring reserved for the lowliest of male students. Beyond this legal point, we find the opinion that women mocked Torah with their poor grasp of its depths. The theme of male embarrassment by both female academic ability and inability is present in many forms in traditional Jewish literature. While a foolish woman embarrassed her teacher, a learned woman embarrassed the entire community; to have a woman recite from the Torah at public services implied that no man present was equal to the task, for which he, not she, had been groomed since infancy. Since women were all but prohibited from receiving an education, the argument that they were too ignorant to understand Torah seems contestable; but it is the male preference for female ignorance that was swiftly institutionalized.[11]

David ben Yoseph Abudraham, fourteenth-century author of the *Sefer Abudraham*, postulated still another interpretation of female exemption from time-bound *mitzvot*. His view was ideological, even social in context: he reduced the issue to one of female deference to the will of the husband in marriage. Rachel Biale, in *Women and Jewish Law*, offers this translation:

> The reason women are exempt from time-bound positive mitzvot is that a woman is bound to her husband to fulfill his needs. Were she obligated in time-bound positive mitzvot, it would be possible that while she is performing a mitzvah, her husband would order her to do his commandment. If she would perform the commandment of the Creator and leave aside his commandment, woe to her from her husband! If she does her husband's commandment and leaves aside the Creator's commandment, woe to her from her Maker! Therefore, the Creator has exempted her from His commandments, so that she may have peace with her husband.[12]

Here a husband is equated with God. A righteous woman confronts the dilemma of serving two masters simultaneously. "Exemption" came to mean that the husband cared for the Almighty's commandments, and the woman cared for the husband.

As a result of these sentiments from Judaism's most respected sages, very few Jewish women became known scholars. The few exceptions, as noted in chapter 1, were daughters or wives of prominent rabbis, who had access to texts and who overheard a broad range of legal discussions in their own homes. Throughout the Diaspora, Jewish women received no Torah education beyond household basics, and few women were literate in Hebrew. By the time of Hasidism's emergence in the late eighteenth century, religious education for Jewish women had reached its nadir, with most women and girls of Eastern Europe conversant only in Yiddish and unable to read the Jewish legal works that affected their own status.

In his 1978 article "May Women Be Taught Bible, Mishnah and Talmud?," Rabbi Arthur M. Silver claimed rather dramatically that "Historically, during other periods, religious education for girls was never as bad as in the dismal situation which existed in Eastern Europe in the nineteenth and early twentieth centuries. During the First Commonwealth, in the time of King Hezekiah, the Gemara Sanhedrin 94b relates that there was universal religious education not only for boys but for girls as well, which included

even the most difficult halakhic subjects."¹³ The lack of religious education for girls in nineteenth-century European Jewish communities was compounded by the growing access some women had to secular schools. While young Orthodox and Hasidic men were educated in a *yeshiva* system devoid of secular subjects, girls had no educational options other than attending state-run (Gentile) public schools. The Lubavitcher Rebbe Menachem M. Schneerson's own mother, the Rebetzin Chana, recalled that Jewish girls in her youth attended Russian public schools and absorbed a curriculum diametrically opposed to that which their religious brothers received in the Hasidic academies. As a result, not a few marriages failed due to the lack of a common basis; religious husbands found that their restless wives were attracted to "the theatre, opera, or even underground political movements."¹⁴

In other regions of Eastern and Central Europe, Hasidic girls attended secular Polish *gymnasia* or Western-influenced schools designed to introduce mainstream culture to Jews. This access to liberal and humanistic studies led some women away from Judaism entirely, despite the efforts by the Hasidic community to prevent assimilation and intermarriage. By World War I, the crisis in education incited one Hasidic woman to action, resulting in the birth of Bais Yaakov schools movement—a controversial new educational system for Hasidic girls.

Sarah Schenierer was born in 1883 and grew up in Cracow, "a simple seamstress who spent every evening poring over the Bible, the Mishnah, and books of Jewish ethical literature. She envied her father and brothers who were permitted to study Talmud. Her friends mocked her and as children called her 'the little pious one.'"¹⁵ In 1918 Schenierer, inspired by a wartime lecture on Jewish heroines that she had heard in Vienna, founded both a Jewish women's library and a study group in Cracow. The women's study session began with forty students and met in the auditorium of an orphanage.

Because of the strong onus on female education that pervaded the Hasidic community, Schenierer decided to solicit support from rabbinical leaders, and went to Marienbad to get the blessing of the Belzer Rebbe. She was also successful in gaining the permission of Lithuanian Orthodox leader Israel Meir Kahan, otherwise known as the Chafetz Hayyim, a halachic authority much respected by the Lubavitcher Hasidim and other sects. The Chafetz Hayyim refuted the Rambam's ban on teaching women, using the following justification:

As the Sages say, "Ask your father and he will tell you." In this situation we can say that women may not be taught Torah and she will learn how to conduct herself by emulating her righteous father. But today, when our father's tradition has become very weak and it is common that we do not have the same living traditions as our fathers did and women learn to read and write a secular language, it is an especially great mitzvah to teach them Bible and the traditions and ethics of our Sages . . . for if we do not do this they might, Heaven forbid, leave the way of the Lord and become apostate.[16]

With the approval of these esteemed Rabbis, Sarah returned home and began the first official Bais Yaakov (House of Jacob) school in 1918, with an enrollment of twenty-five girls. The number doubled inside of three months and by 1919 the school had over 300 pupils. For the first time with Hasidic sanction, young girls studied Bible, *Pirke Avot* (Ethics of the Fathers), the *Shulchan Aruch* (code of Jewish law), prayers, commentaries, and Hebrew grammar.[17] Intitially, the schools were supplementary, hardly comparable to boys' *yeshivos*; yet they represented a significant break with taboo.

The majority of the Bais Yaakov schools were located in Cracow, Vienna, and Lodz. The administrators were Polish Hasidim, notably of the Gur sect.[18] While Sarah Schenierer eventually answered to and obeyed these authorities, it was her initiative alone that expanded the Bais Yaakov system to encompass teachers' seminaries, summer camps, youth group activities, a regularly published journal, a training farm for potential émigres to Palestine, and other alternatives to the secular state schools. By 1937 Bais Yaakov boasted 260 separate schools and 38,000 students throughout Eastern Europe, Austria, and Palestine.[19]

Deborah Weissman's research on Schenerier raises the question of whether the Bais Yaakov schools initially represented a feminist innovation. The schools attracted many restless Hasidic girls who had become followers of underground political movements. In her study of the Bais Yaakov journals from the 1920s and 1930s, Weissman found student writings scornful of the European feminist movement; yet a poll taken among Bais Yaakov students and published in 1932 revealed that almost all were in favor of the emancipation of women.[20] It is unclear whether this disparity reflects conflict between Jewish and feminist identity, or conflict

between Orthodox and secular factions among the students.

There is no question that Schenierer herself fostered a unique following that, in its heyday, literally identified as a sisterhood. Weissman found that the women students romanticized Sarah Schenierer and referred to her as "our Mother"; some students referred to one another as "sisters." Weissman believed that if the development of the Bais Yaakov had not been interrupted by the devastation of the Holocaust, Bais Yaakov might have been a breeding ground for Jewish feminism in Eastern Europe; she called the Hasidic community's postwar conservatism an "atypical" move to the right.[21]

As the Bais Yaakov system was under the jurisdiction of a different Hasidic sect and located in Poland, it was slow to influence Lubavitcher families in Russia. The ideas behind Bais Yaakov, however, prompted the sixth Lubavitcher Rebbe, Joseph Yitzchak Schneerson, to reappraise Lubavitcher education for women and girls. He began first to publish his discourses in Yiddish translation for women of his own following. By the late 1930s, three Lubavitcher study groups for girls were meeting in Riga, Latvia. On learning that fifty-eight young women were studying with Rabbis Mordecai Cheifetz, Avroham Elye Osherov, and Tzvi Gore—all reknowned scholars—a visitor to the Rebbe exclaimed "Girls learning Chassidus?! Women are obliged, of course, to study and know accurately whatever pertains to the mitzvos they must observe, and that in itself is a considerable amount of Torah . . . But women learning Chassidus, the deepest facets of Torah, the mysteries of Kabbalah . . ." Whereupon the Rebbe replied, "Lubavitch approaches everything with reason. I do not mean that they learn the deep, esoteric teachings of Chabad."[22] It is likely that the Rebbe, witnessing the growing modernization of work and home and the resultant free time of some women, found it prudent to fill that time with Torah.

While the Rebbe had journeyed to the United States in 1929, he elected to remain in Warsaw and Otvock throughout the 1930s, directing the establishment of the American Lubavitcher community through emissaries. As the threat of war approached, the Rebbe sent one of his Riga instructors, Rabbi Mordecai Cheifetz, to the United States to assist with the formation of a girls' study group in Brooklyn. The young women in the American counterpart to the Riga group called themselves "Achos Tmimim," or "sisters" of the first Lubavitcher *yeshiva* students in the American Hasidic community. After Rabbi Cheifetz reported the girls' enthusiasm to the Rebbe, three Lubavitcher rabbis living in Brooklyn were appointed

to instruct the ongoing Achos Tmimim group. One of these men, Rabbi Israel Jacobson, recalled that the sixth Rebbe referred to the male instructors as *roim*, or shepherds: "The first and chief objective should be leading the girls into the right atmosphere—the Rebbe used the expression b'halah shell Torah, into the tent of Torah."[23]

We can see that this regimen in no way matched the intellectual demands placed on men, but rather stressed the preservation of virtue. Still, the Rebbe took a considerable interest in the girls' curriculum, suggesting not only which texts the girls should study alone or in group, but also providing Jacobson with discussion plans to test the level of absorption of the material.

BETH RIVKAH

In 1940 the sixth Lubavitcher Rebbe, Joseph Yitzchak Schneerson, left behind Nazi-ravaged Europe to settle permanently in Crown Heights, Brooklyn. At this time he called for Rabbi Jacobson and declared "Yisroel, organize Beth Rivkah schools, one or two, for girls. Our mutual concern has always been the study of Torah and Chassidus with boys in Yeshivos, but here in America, we have to do everything."[24]

This concession to the needs of female education acknowledged several trends. The extensive secular curriculum required in all schools in the United States, and the accessibility of college for young women, gave the Hasidic community the final push to provide parochial schools for its young girls. Furthermore, the eagerness with which young Hasidic women were independently studying Torah necessitated a formal Hasidic institution for ongoing instruction. On this point Arthur Silver has declared, "It would seem ludicrous and a mockery of the law to have her learn Oral Law from translations, often by non-Jews or irreligious Jews, and not permit its study from religious instructors in the holy atmosphere of a Yeshiva."[25]

The Lubavitcher girls' schools thus began not from any recognition of female academic ability, but to strike a balance against the onslaught of secular forces in American education. The name Beth Rivkah, or House of Rebecca, sufficed to distinguish the Lubavitcher school from the Bais Yaakov system founded by Sarah Schenierer and operated by Gur Hasidim.[26] However, the transplantation of female schooling to the postwar Lubavitcher community in America and the postwar Gur community in Israel had a common incentive.

Tamar El-Or notes: "Haredi (ultra-Orthodox) society had to give its attention to the cultural state of their women, because of the growing contact between it and its surroundings, which made change possible. The institutionalization of study for women came about after the fact, as a response to the declining status of orthodoxy."[27]

While American Jewish supporters of the Rebbe and of the Lubavitch movement appreciated the concept of insulating religious girls from the vernacular of urban public schoolyards, Rabbi Israel Jacobson found that very few Jewish congregations or philanthropists were interested in pledging financial support to a female academy. Since no congregation would allocate space for such an unheard-of institution, the first Beth Rivkah elementary school, with an enrollment of thirty students, began meeting in a Brooklyn store front in 1942. One thinks of Sara Schenierer's first students, convening in the auditorium of a World War I orphanage, twenty-four years earlier.

The female education movement was for the most part a conservative revolution, seeking not the Talmudic empowerment of girls, but rather their protection from secular indoctrination. How the actual schoolgirls selected for this watershed in Lubavitch learning saw themselves, however, was a different story. There is no question that many experienced an exuberant self-importance, coupled with genuine commitment to furthering Hasidic growth in the United States. Yet their enthusiasm often met with apathy and skepticism from a postwar community reluctant to squander precious *yeshiva* dollars on schoolgirl facilities.

No member of the Lubavitcher community paints a more vivid portrait of those early years than Sudy Rosengarten, a graduate of Beth Rivkah's first class. In seven different short stories written for *Di Yiddishe Heim* between 1973 and 1980, Mrs. Rosengarten describes the poor conditions, ill-equipped teachers, and haphazard curriculum endured by the frustrated pioneer students of Beth Rivkah in the 1940s. Her writing encompasses a range of competing emotions: the sense of high spirit and adventure among the members of Beth Rivkah's first class, and the physical hazards and neglect endemic to an institution perceived as superfluous or aberrant by many Hasidim.

> By some strange miracle, thirty children had been recruited and Girls' Yeshiva was launched. Teachers ran from group to group in classes that were doubled up for warmth and economy. Often we sat in darkness, the electricity turned off

because of non-payment. The desks were broken, the plaster was peeled, a puddle was always forming where some pipe had suddenly burst; entire floors roped off till some charitable plumber would fix it gratis.... All thirty of us, though looked upon with pity by all our former school-mates and teachers as being the sacrificial lambs for the nation, were fired and fused with Rabbi Newman's enthusiasm. For it was not merely a school that we would build; we were rebuilding a nation.[28]

"Rebuilding a nation," a cry that echoed the goal of the sixth Lubavitcher Rebbe, demonstrates how strongly even small girls identified with Chabad's vision for expansion in the United States. Certainly they could overlook poor facilities, as their male peers had in the cluttered *chederim* of Poland or Russia. No Hasidic child grows up ignorant of the poignant history of European *yeshiva* students, poor boys who had a schedule of rotating "eating days" in local homes. But despite their fervor for continuing unique Hasidic traditions while the Nazi Holocaust devasted Jewish communities abroad, the American-born girls keenly felt the inferiority of Beth Rivkah's first curriculum.[29] After all, as American citizens entitled to quality *free* education in well-equipped public schools, their choice to attend a Hasidic institution included assumptions of superior, in-depth Jewish instruction.

One problem was that while the elementary school continued from 1942 on, a Beth Rivkah High School was not founded until 1955, and the Beth Rivkah Teachers Seminary for women held its first class in 1960—twenty years, an entire generation, after the sixth Rebbe arrived to establish a permanent headquarters in Crown Heights! Due to this acute shortage of trained women teachers throughout the 1940s and 1950s, Beth Rivkah hired young religious girls who were recent public-school graduates to do the lion's share of instruction. This pattern in the postwar Lubavitch community, of assigning eighteen-year-old girls to teach fourteen-year-old girls, created predictable discipline problems.

Rosengarten's writing shows clearly the rapid mood swing from commitment to disappointment among the first Beth Rivkah students: "Feelings of being cheated were defined in disobedience: playing pranks on teachers, organizing the class into situations that made it impossible to teach what might have been attempted."[30] Throughout the growth of the Lubavitcher community in postwar America, students' lack of respectful attention to teachers remained the number-one morale problem in the Beth Rivkah sys-

tem. At boys' *yeshivos*, where rabbinical scholars taught seminars on the intricacies of Jewish law, a harsh scolding from a learned sage quickly restored order in the classroom. But at Beth Rivkah, students were only too aware that their teachers lacked qualifications and status. Contempt, rebellion, and intellectual lassitude created a host of self-esteem problems at Beth Rivkah that were unheard of in the prestigious male academies.

With the passing of sixth Rebbe Joseph Schneerson and the succession of his dynamic son-in-law to Lubavitch leadership in 1950, the Crown Heights community began a new era of adjustment to postwar American culture. One result was the formation of the Lubavitcher women's quarterly periodical, *Di Yiddishe Heim* (*The Jewish Home*). From 1958 on, this journal gave women in the Crown Heights community a forum for addressing the needs of Beth Rivkah. Countless articles, often contributed by timid or angry novice teachers, lamented the lack of support for female education and called for changes in the Beth Rivkah system. By 1963, community educator Chana Heilbrun felt sufficiently disillusioned to write a controversial three-part series, "Can We Improve Our Schools?," for *Di Yiddishe Heim*.

In her first article, Heilbrun critiqued the level of scholarship in teacher-preparatory courses, the inability of the Hasidic school system to compensate for special-needs students, and the shocking lack of *derech eretz* (respect and good manners) in a student population representing Lubavitch Hasidism's oldest families. While she upheld the positive influence of Hasidic ideology in the Beth Rivkah program, Heilbrun felt that Torah for girls in America was taught tepidly and ineffectively. She recalled the Bais Yaakov schools of prewar Europe, where women teachers, usually rabbis' wives, were respected, beloved role models for girls.

Heilbrun's own memories of her student days informed her views as a parent and teacher. She placed considerable blame on the male instructors intermittently assigned to Beth Rivkah, whom she accused of disparaging female learning even while acting as mentors to girls:

> Theoretically, the need for formal Torah schooling for Jewish girls has been established and encouraged. At the same time, there still exists that negative feeling about "too much learning." Many a time has that little chuckle and a joking "What do you girls have to learn so much for anyway" on the part of a teacher, revealed his true attitude.[31]

Having laid the groundwork for fundamental criticism of the attitudes and agenda impairing Beth Rivkah, Heilbrun turned to the students' own irresponsibility. In Part Two of her series, she called for "discipline without apology" as a necessary solution in the era of progressive educational ideals. Heilbrun's striking anecdotes revealed how student awareness of teacher inadequacy greatly undermined the structure of authority on which scholarly progress depended.

> A novice teacher enters her first class assignment—a third grade of yeshiva girls. All goes smoothly until she reprimands one of the more talkative students, who answers in tones of furious rage, "You're a new teacher and you won't last a week here. Just wait until I tell my father you pick on me and you'll get fired like this," and the eight-year-old rebel snaps her finger in the air.[32]

The problem of misbehavior led one Lubavitcher mother to recommend that all children attend annual seminars on *derech eretz*. A more pressing concern, however, was the low status and low self-esteem of Beth Rivkah teachers. Heilbrun had opened a Pandora's box with her articles, and *Di Yiddishe Heim* continued to publish a painful dialogue of other letters—from teachers forced to resign after a few weeks, teachers afraid of their own students, teachers bitter over their minimal Seminary training (one year of additional study after high school), which in no way prepared them for a roomful of hostile adolescents.

Despite the unresolved issues of student-teacher friction and irregular coursework, Beth Rivkah continued to grow as an institution. Its expansion between the late 1950s and late 1970s reflected both the high birth rate of the Hasidic population and the additional arrival of refugee children from Jewish communities in Iran and the Soviet Union. By the early 1980s, the school in Crown Heights included three buildings, over 600 students, and 81 teachers. Financial support still lagged far behind space and equipment needs, and the Beth Rivkah schools brochure apologized, "The expansion has been primarily due to the influx of many formerly non-religious students and to the appearance, as of late, of Russian immigrants and students from other Iron Curtain countries.... At the present growth rate, the pinch of inadequate classroom and recreation space becomes inevitable."[33]

In 1986, after years of campaigns by concerned mothers, the

Lubavitcher community purchased the old Lefferts General Hospital and two adjoining properties, totalling nearly one square block, for a new Beth Rivkah site. The *Neshei Chabad Newsletter* announced in December of that year that "Architectural plans have been drawn to, G-d willing, completely renovate the building to house a modern yeshiva for 1000 girls in kindergarten through eighth grade and to level the adjacent properties to build a playground."[34] The projected cost for this new facility was three million dollars. In spring 1987, another article in the *Newsletter* mentioned that Beth Rivkah's next step must surely be an improvement in the teachers' salaries, which were hardly competitive with metropolitan standards. Why was Beth Rivkah still unrecognized as a priority charity cause in its own community? This article's anonymous author did not hesitate to blame men in the community, and suggested that it was the responsibility of the male population to work as fundraisers; certainly fathers should actively support the school where their daughters were instructed in Hasidic ways. The author hinted, "And you know the 'they' we're all waiting for? You know: '*they* should do something about Bais Rivkah'? Well, these gentlemen are the 'they.'"[35]

Today, Beth Rivkah students learn Bible, Midrash, Hebrew, Hasidic philosophy, Jewish history, Shulchan Aruch (the code of Jewish law), the works of the Rebbe and his predecessors, and secular studies in mathematics, English, geography, science, American history, French, and business. The girls attend school six days a week, Sunday through Friday; the latter is a half-day, for the Sabbath begins at sundown after several hours of intense and meticulous preparation. Despite the community's distrust of secular academic influences, I discovered (during a permitted visit) that Beth Rivkah's high school library contained volumes by Austen, Dickens, Mann, Steinbeck, Stevenson, Swift, Tolstoy, and Twain. While Hasidic literature dominates the shelves, students may also browse through recent texts on civil rights history, women's studies, urban sociology, psychology, Greek philosophy, and logic—and even overtly Christian novels, such as the children's classic *Prince Caspian* by C. S. Lewis. Despite some official censorship (the alteration of nude and semiclad images in art and photography texts), inquisitive students at Beth Rivkah today do not lack access to the tools of a secular liberal arts education.

As the first and second waves of Beth Rivkah High School graduates married and raised children in the period between 1965–1975, a

change occurred in Lubavitcher women's writing. Articles on female education in *Di Yiddishe Heim* no longer focused on Beth Rivkah's limitations, but expressed nostalgia and gratitude toward the school. Young mothers, isolated and overwhelmed by the demands of housework and childcare, wrote wistful essays about the climate of academic challenge they had enjoyed (or failed to enjoy) in their school days. Such articles praised Beth Rivkah for sharpening young women's intellectual skills; for all its setbacks and financial limitations, Beth Rivkah had consistently demanded that its students work and learn. But where were the educational outlets for Lubavitcher mothers? Women whose artistic or literary talents had found sanction at Beth Rivkah now wrote to *Di Yiddishe Heim* in despair: Were there no roles for intellectual women in the Lubavitch community?

In response to this new genre of writing, *Di Yiddishe Heim*'s editor Rachel Altein and male authorities urged "unfulfilled" women to become activists for Neshei Chabad, the Lubavitcher Women's Organization. Those Lubavitcher women who expressed dissatisfaction with their limited roles as wives and mothers were warned that, as adults, they had a moral obligation to foster learning in others. Learning for its own sake was still permissable, but more important was its use in the attraction of other women to the Lubavitcher ethic.

The Rebbe's campaign to incorporate articulate women into the outreach cause partially resolved the dilemma of the alienated homemaker. Ideally, the "selfish" desire of many women for more learning could be justified as necessary for their "unselfish" vocations as Hasidic representatives. This argument was sufficiently flexible and expedient for one *Di Yiddishe Heim* writer to acknowledge the vision of American feminism:

> A Jewish wife and mother, a Woman of Valor, knows of and discharges the moral obligation to her husband and children inherent in her role. . . . Yet, what about her moral obligation to herself? Since the end of her formal schooling, has she made a similar attempt to increase her own knowledge? . . . Furthermore, even with the cries of Women's Libbers comes this quiet voice with the same message—what of the G-d-given talents that were so evident in your younger years?[36]

While the Lubavitcher woman's Jewish education could not match that of the adult male *yeshiva* graduate, she still possessed

far more Torah knowledge than the typically nonobservant American Jewish woman. The obligation to mentor drew many Hasidic housewives into the public eye as teachers of the *baalot teshuvah*, women newly committed to Orthodoxy.

As female education at Beth Rivkah had created an army of women sufficiently conversant in Lubavitcher philosophy to proselytize, so the resultant flow of incoming pilgrims created the need for more adult education in the Lubavitcher community. Barely had the Beth Rivkah graduate asked for continuing education for herself and her peers when she found herself pressed into service, helping to start school facilities for Jewish women just arriving in Crown Heights.

Education for Baalot Teshuvah: Machon Chana

> Every day was a challenge to me, to conquer my old ways and live by the Torah . . . I had an amazing thirst to learn more of Yiddishkeit, and I can remember my angry frustration over the cancellation of a class (this was before Machon Chana, the new school for women from backgrounds like mine), for it seemed that I would never be able to fill the void of the twenty-one years in which I didn't know an *alef* from a *bais*.[37]

The intense outreach efforts organized by the seventh Lubavitcher Rebbe after his takeover in 1950 spawned a new generation of observant American Jews. Attracted to, or affected by, the Chabad Houses established on their college campuses by young Lubavitcher representatives, some Jewish students throughout the 1960s turned to Judaism to find the answers secular society had failed to provide. To assure the swift matriculation of interested young men in Lubavitcher-sponsored *yeshivos*, the Rebbe established Yeshiva Hadar Hatorah in 1962. This institution was the first *baal teshuvah* school designed for American Jewish men who lacked an Orthodox background.[38] After several years of intensive remedial study at Hadar Hatorah, young men could go on to participate in classes at more sophisticated *yeshivos*, with the assurance that study was a lifelong process and that there would always be a place for them in the continuum of Hasidic learning.

After the 1967 Six-Day War victory in Israel, culminating in the occupation of Jerusalem, a strong sense of Jewish pride and identity led other young American men to examine their religious

roots. To serve the needs of this group, the Rebbe created a second *baal teshuvah* school, Yeshiva Tiferes Bachurim, in the Lubavitcher complex at Morristown, New Jersey. Jewish men who needed intensive, basic preparation in Talmud and Hasidic philosophy were rewarded for their newfound dedication with instruction and counsel from some of the most prestigious scholars in Lubavitch Hasidism.

During the 1960s, therefore, newly observant men enjoyed a variety of specially created facilities and support programs, but the plight of the female penitent was ignored by most Crown Heights educational administrators. Women, too, were attracted to Hasidic traditions and came to Crown Heights to seek instruction, but the female experience of adjustment to a new life in Lubavitch differed strikingly from that of the male *baalei teshuvah*. The young male, generally recruited from college, transferred from one academic situation to another. The familiar routine of going to classes, engaging in seminar discussions, and receiving feedback from well-informed teachers resembled the secular college experience—but at *yeshiva*, male students also found a paternal and highly structured environment, conducive to self-discipline and the reinforcement of new values. Rewards were plentiful for diligent *yeshiva* students; in the Hasidic world male status was synonymous with scholarship. And the learning regimen was hardly dry and pedagogical. Young men who had participated in the alternative political or spiritual movements of the 1960s found that Jewish scholars and philosophers in every century had also been obsessed by questions of justice, oppression, fulfillment, and mysticism. This sense of fresh identification with Jewish forebears also helped to integrate the "radical" male *baal teshuvah* into his new family of Hasidic scholars.

For women, however, the transition to *baalot teshuvah* status meant isolation and struggle. The group learning experience and institutional reinforcement of shared values could not occur without a school or, at the very least, regular meetings of students and mentors. While young men who entered Lubavitcher academies were fed and housed by their institutions and became eligible for scholarships, young women who moved to Crown Heights undertook a self-imposed regime of individual study while simultaneously struggling to support themselves financially. In the small community, crowded with both wealthy and impoverished Lubavitcher families, affordable housing for the unknown single woman was nearly impossible to find. Adult *baalot teshuvah* were not permitted to room with unmarried Lubavitcher women at the dormi-

tory of the Beth Rivkah Teachers Seminary, for the Rebbe felt the more worldly outsiders might have a questionable influence on the sheltered and vulnerable Beth Rivkah graduates.

Forced to pay expensive Brooklyn rent from the typical working woman's income of the late 1960s, the female newcomer to Crown Heights was often poor, exhausted, and lonely. If her decision to embrace Hasidism baffled or angered her family and old friends, she lost the emotional and financial support of those relationships. Lacking husband and children, the focal points for all mature Lubavitcher women, the newcomer's goal was to marry and begin a family as soon as possible. But even formally arranged matchmaking was forbidden unless the Rebbe, or a close mentor, pronounced her "ready." Until she mastered basic Hasidic legal and social codes, she remained single, an oddity in her age group in the Crown Heights community.

The Lubavitcher women's journal *Di Yiddishe Heim* provided an outlet for the confusion and alienation felt by some *baalot teshuvah*. Their poems and stories were modest rather than plaintive: tactfully, these new writers did not use the magazine to criticize lack of community resources for *baalot teshuvah*. Instead, authors reflected on their former lives in secular society and praised the Rebbe for rescuing them from drug abuse or spiritual conflict. A variety of women contributed confessional essays with lurid descriptions of bad experiences in cults, abusive relationships, or bureaucratic universities.

The pattern of *baalot teshuvah* articles published in *Di Yiddishe Heim* perhaps reflected editorial decisions rather than the actual spectrum of submissions. Letters suggesting hardship in Crown Heights embarrassed the community, whereas grateful, confessional essays depicting the evils of secular culture upheld the image of Lubavitcher superiority and morality. It was clear, however, that most *baalot teshuvah* did share a common experience of disillusionment, search, and rebirth, and these similarities created the potential for solidarity and mutual support among the underclass of newcomers. But because of the secular, feminist, and pop-psychological connotations of that new American innovation—the support group—no such format was sanctioned or organized by Lubavitcher authorities as an aid to incoming women.

Despite the obvious problems facing *baalot teshuvah*, the impact Chabad had on some former drug abusers created interesting publicity for the community. In 1973 a writer named Anne Lowenkopf published a small book entitled *The Hasidim: Mystical*

Adventurers and Ecstatics. The back cover blurb shrieked, "Hasidic techniques have proved extraordinarily successful in developing mystical and occult powers. . . . Now, in America, they are taking young men and women out of the drug culture and showing them the realm of God-seekers. These boisterous, joyous holy people have been shaking Sabbath-goers since their inception!" As Sherbourne Press (based in Los Angeles) elected to list this book in its "For the Millions" series alongside titles such as *Out of Body Experiences, UFOs, ESP, Haunted Houses,* and works on werewolves and witchcraft, *The Hasidim* undoubtedly reached some young people who were searching for extraordinary answers to extraordinary questions. Although the Lubavitch community had no interest in being affiliated with "occult powers," it accepted many seekers who had been led to believe that Lubavitch was a somewhat "hip" movement, open to all (Jewish) kinds.

By 1972, the conflict between an escalating outreach agenda and a total lack of facilities for incoming *baalot teshuvah* forced the issue of adult women's study groups. One Lubavitcher matron, Mrs. Sara Labkowsky, opened her home to an informal group of new Lubavitchers interested in regular Torah study. According to another Lubavitcher spokeswoman, Nechama Greisman, "There was no school yet available to satisfy their needs. Without a command of Hebrew, all doors of existing schools were closed to them. And then someone said, 'if Lubavitch has a Yeshiva for boys beginning Torah, why not one for women?'"[39]

Thus, over ten years after the establishment of Yeshiva Hadar Hatorah, *baalot teshuvah* women began their own study meetings in the basement of a private home—a beginning just as humble as that of the first Bais Yaakov school in Cracow in 1918, or that of the first Beth Rivkah school in 1942. From 1972–1975, Torah classes for women operated without a budget. All teaching was done on a volunteer basis, by mothers, rabbis, wives of rabbis, and young Beth Rivkah Teachers' Seminary students. The lack of formally appointed faculty compounded the irregularity of the academic program. Because the majority of the students were self-supporting and worked full time, classes met on week nights and on Sundays. This arrangement quickly depleted the reserve of noncompensated instructors, who as mothers of large families needed evenings and Sundays for themselves. Teachers also expressed frustration when enthusiastic students brought friends to classes, requiring a continual review process for each guest unfamiliar with the preceding lesson. Despite these setbacks to the academic process, the student

body grew apace, until the Rebbe authorized the purchase of two buildings for an official Lubavitcher *baalot teshuvah* school in 1974. The new facility was named Machon Chana Women's Institute for the Study of Judaism, in honor of the Rebbe's late mother, the Rebbetzin Chana.

Machon Chana included a classroom building on Eastern Parkway and a dormitory residence on President Street, one block from the Rebbe's own home. Having dedicated himself to the task of developing a women's school, the Rebbe warmed to his role, ensuring that the dormitory for unmarried students became a comforting temporary home. During the Sabbath, students ate meals with neighborhood families and enjoyed Lubavitcher hospitality.

By 1975, the Rebbe also began to arrange meetings between the families of Machon Chana students and representatives from the Lubavitcher community. Nechama Greisman, who presented a brief history of Machon Chana at the 20th Annual Convention of Neshei Chabad in 1975, explained: "It's not enough to reach the students—we must reach their families, too. And so, to date, three 'farbrengens' have been held. . . . These 'farbrengens' have done much to promote a feeling of acceptance and friendship where there might have been resentment and bitterness."[40] Of course, the preceding statement reveals that resentment and bitterness did, in fact, exist in many families. Experts at public relations, Lubavitcher authorities seized on the outreach potential inherent in family gatherings held under the auspices of Machon Chana. With family orientation as the primary value taught to all Lubavitcher adherents, Machon Chana could not appear to approve the estrangement of young women from their less religious parents. Unfortunately, the dismay of some families over the defection of a daughter to an ultra-Orthodox religious sect was not always pacified by one or two outreach teas.[41]

With the establishment of the official women's school, *baalot teshuvah* who had previously brooded in isolation now restructured their time around rigorous group study. Classes at the new Machon Chana Institute burgeoned into full-time curricula, often lasting from eight-thirty in the morning until nine-thirty at night. Brochures advertised the Machon Chana programs with the promise, "Financial aid is available. No one will be turned down from studying Judaism for lack of funds," and evening and Sunday courses were offered at a reduced rate for women who worked during the day.[42] Beginning, intermediate, and advanced classes covered the following topics: Hebrew, Yiddish, Tanya, Chassidus,

Halacha, Mishna, Midrash, Talmud, Prayer, Chumash (Bible), Tehillim (psalms), Megillos Esther and Ruth, Jewish History, and the Role of the Jewish Woman. Students could also receive scholarships to programs that led to the Teacher's Certificate in Higher Jewish Studies; this curriculum prepared *baalot teshuvah* for academic jobs relevant to the needs of the Crown Heights community. The 1983 brochure advertised Machon Chana in glowing, mystical terms:

> Direct total immersion into the depths and intricacies of the eternal Torah, in the original, leads to the discovery of the greatness of woman and . . . her destiny.
>
> Machon Chana provides exactly this opportunity. An intensive women's Yeshiva, it was founded by the Lubavitcher Rebbe Shlita, on the premise that Torah education for women may be more significantly important than for men. Machon Chana, through the teachings of Chabad Chassidus, fuses the Revealed and the Mystical into a vital, living Judaism enabling each woman to become knowledgeable in her heritage and secure in her place and purpose in the cosmic entity.[43]

This dramatic passage contains an obvious reference to the *mikveh*, the ritual bath required of adult Jewish women after menstruation or childbirth. By offering "direct total immersion" in Torah, Machon Chana hinted that a student just completing a cycle of secular contamination might well need purification. It is impossible to ignore the inflammatory assertion that "Torah education for women may be more significantly important than for men!" When this unusual line is juxtaposed with the final guarantee of feeling "secure in her place and purpose," the brochure appears to offer quite contradictory messages.

The same brochure provided extraordinary course descriptions, designed to excite those women who were interested in learning more about their stalwart foremothers. One course, devoted entirely to the scrolls of Ruth and Esther, promised: "Dramatic testimonies to the unique power and greatness of woman. They (the scrolls) are studies with a view to understanding the prototypical roles of these two outstanding female figures, in the context of the larger religious themes." Another seminar, on Jewish faith, had this note: "Special emphasis will be placed on developing

the student's capacity for learning a Maamor in conjunction with a study partner," offering to women the ancient system of pair-studying fostered among male *yeshiva* students (although women did not study the same texts men read). This combination of access to Jewish women's history, original text study, and academic techniques once reserved for men gave Machon Chana's curriculum a look that was both innovative and traditional.

In reality, however, the financial status of the Institute and the social status of the unmarried women students dovetailed to distract most *baalot teshuvah* away from study and into volunteer work. Service projects, fundraising, babysitting, and other noncompensated responsibilities occupied whatever spare time *baalot teshuvah* might claim after work and classes. The community justified its exploitation of a free labor pool on the grounds that such involvement was the best way to integrate, and endear, newcomers into Crown Heights social structure. In 1986, one brochure declared,

> But Machon Chana is more than academic studies. It is part and parcel of the thriving Lubavitch community in Crown Heights—community that welcomes and integrates the merely curious as well as the avid seeker. Machon Chana students are embraced by the community and, during their course of study, become a vibrant force in every aspect of community life. This coupling of classroom study and community interaction results in a deeper understanding of what being a Jewish woman means.[44]

Because of their single status, Machon Chana students were made responsible for many of the projects and preparations deemed beneath the already overcommitted Rebbetzins of Crown Heights. When the community needed eye-catching banners for a children's religious parade, Machon Chana students stayed up until 3 A.M. to cut and paste. This would be an unheard-of frivolity in a male *yeshiva; bittul Torah,* or waste of time better spent in Torah study. As future mothers, however, Machon Chana "girls" (as they were called by all) viewed such job assignments as evidence of the Rebbe's trust and favor. Work-study students eagerly accepted jobs as babysitters and librarians for the community's children; this contact substituted for the family life enjoyed by established Lubavitchers.

All classes at Machon Chana focused on the relevance of the subject matter to woman's role in *halachic* Judaism. Despite the

captive audience's obvious interest in discussion, little time was reserved for student opinion. The larger frame of reference was reduced to that content women were required to know to fulfill the simplest religious obligations. Thus, the provocative give-and-take of the male *yeshiva* seminar was missing, and student queries became a waste of valuable faculty time rather than evidence of lively intellectual curiosity. The male student would use his intellectual skills throughout his life in the culture of rabbinical study; but for women at Machon Chana, the task at hand was to accumulate as rapidly as possible the basics of Hasidic belief and practice—in order to proceed with marriage and childbearing.

This trend away from the joy of learning per se became apparent when Machon Chana discontinued the earlier brochures, which stressed the school's intellectually intensive curriculum. The new promotion campaign of the mid-1980s capitalized on traditionally feminine themes from the non-Jewish world: fashion and cosmetics. Machon Chana advertisements began to borrow concepts from secular American women's magazines as a way of packaging Jewish subjects. One flyer for a Summer Session coaxed, "Get to know your true Jewish colors!" and listed courses under such headings as "Makeup," "Tone," "Balance," and "Color." The combination of these studies promised to "Increase your face value."[45] The workshop titles in this brochure continued the metaphor with "The Spiritual Beauty of the Jewish Woman," "Color Your World With Kosher Cuisine," and "Professional Wares and Personal Cares." For the 1986 season, Machon Chana's brochure (entitled "Where Women Who Are Jewish Learn to Be Jewish Women") also included references to *Vogue, Cosmopolitan,* and *Mademoiselle* magazines. Whether such approaches were intended as a satire of 1980s consumerism, or as reassurance that Hasidic authorities were in touch with modern pastimes, the shift away from academic rhetoric was stark. In fairness to Machon Chana, this shift was hardly limited to the Lubavitcher community; during 1985 even *Ms.* magazine, the voice of mainstream American feminism, included fashion columns and dress-for-success tips from career feminists.

It is no accident that both Machon Chana and its sister school in Minneapolis, Bais Chana, were established in the early 1970s.[46] The Rebbe was well aware of the emerging feminist movement, and this threat to Hasidic values, coupled with the glaring absence of educational alternatives for Lubavitcher women, hastened the development of *baalot teshuvah* schools. The entire Crown Heights community capitalized on the waning youth movement

and the rising divorce rate to attract disoriented single women in search of a home base. Machon Chana's ads declared, "Give yourself the opportunity to think Jewish, feel Jewish, be Jewish—and put an end to spiritual and emotional chaos forever!"[47]

Unfortunately, this promise was deceptive. After the crash course in Hasidism, *baalot teshuvah* confronted the larger problem of integration into Crown Heights and acceptance by the community. They discovered the catch-22 preventing their immediate assimilation: to gain acceptance and approval they needed to marry and begin families, but few men would consider a match with a *baalas teshuvah*, no matter how devoted she was to newly learned Hasidic norms. Her choices were limited to the male *baalei teshuvah* of the community, who were similarly second class and transitional.

Female education became a vital part of Lubavitcher culture at all age levels in the postwar United States. The development of both the Beth Rivkah and Machon Chana school systems in the Crown Heights community also created a spectrum of employment opportunities for Lubavitcher women. *Baalot teshuvah* who entered the community as adults with advanced professional degrees or expertise were welcome assets. Beth Rivkah graduates, too, found a wider range of options as outreach activists sent by the Rebbe to promote Hasidic values on campuses around the globe. These changes in female opportunity corresponded significantly to the leadership of Rebbe Menachem Schneerson after his father-in-law's death in 1950. The reigning Rebbe assured a place for intellectual women in Lubavitch, while defining and maintaining the limits of their intellectual ambition.

As a result of these changes, some Lubavitcher women became politically involved in campaigns for federal aid to parochial schools. This cause was appealing for the very good reason that Beth Rivkah remained in a continual state of disrepair. Without a regular philanthropic base, Beth Rivkah depended on community fundraising efforts; the concept of federal funding delighted Lubavitcher women, for it suggested gender-blind support of vital student services.

One minor publication literally illustrated the unresolved tension over the existence of female schools in Lubavitch. The financial plight of female education became a satirical melodrama in a 1982 comic book by Lubavitcher artists. This children's series called *Mendy and the Golem* featured a little girl named Rivke

Klein, whose school, "Bais Challah," was unable to meet its mortgage payments. A nonobservant Jewish businessman threatened to buy out the school and turn it into a dog kennel. When Rivke and her schoolmates attempted to save their school through a series of bake sales, the corporate apostate was moved by the scent of their freshly baked *challah* and wept, "You girls remind me of my dear old mother! Please accept my heartfelt apologies and my check for *tsedokah*!"[48] This theme of the hard-hearted modern Jew, moved to reclaim his Orthodox heritage by finding young women who remind him of his religious mother, occurs constantly in Lubavitcher literature. Yet, in the comic strip, it was food that softened the wayward Jew's resistance; he was not really moved toward philanthropy by the sight of young girls studying Torah in the academic hall at the start of the story. Tradition and domesticity, not higher learning, are the hallmarks of feminine power and success, and therein lies the ambivalence responsible for Beth Rivkah's financial standing in the Crown Heights community.

While Lubavitcher women do not question the authority of the Rebbe and his policy decisions on female education, open periodicals such as *Di Yiddishe Heim* permit a broad range of opinions to flourish in print. This ongoing dialogue among Lubavitcher women reflects both acceptance of and dissatisfaction with the spectrum of female schooling. It remains to be seen whether the growing *baal teshuvah* population of college-educated and career-oriented women will alter the Lubavitcher prohibition against college for Beth Rivkah graduates. The present strategy within Crown Heights of publishing those *baal teshuvah* essays most critical of the secular university suggests that incoming women have a conservative, not liberal, function. The great irony in the postwar Hasidic community is that having overcome centuries of male disapproval in order to gain access to classroom, print, and lecture podium, many Lubavitcher women must use their limited opportunities as scholars to uphold the traditional male interpretation of female status in Judaism.

THREE

"HAKHEL, KIRUV R'CHOKIM"
INGATHERING THOSE THAT WERE FAR AWAY:
THE NESHEI CHABAD CONVENTIONS

Gatherings of Hasidic men, with their distinctive dress and ecstatic *davening*, can look like medieval pageants to more assimilated Jews. Outsiders, erroneously assuming that Hasidic women are excluded from all public functions, are often surprised to learn that Lubavitcher women lead modern business conferences. In fact, Lubavitcher women have held organized speakouts since 1956. The formation of Agudas Neshei Ubnos Chabad (Council of the Women and Daughters of Chabad) in 1955 redefined all Lubavitcher women as an educational action group—with an agenda that went far beyond personal religious observance. The new Rebbe's emphasis on *uforatzto*, or outreach, incorporated both male and female Lubavitchers into the sphere of Hasidic activism. And so, far from lagging behind secular American women, Lubavitcher women experienced a rebirth of agency in the mid-1950s, a full decade before most other American women picked up *The Feminine Mystique* or joined the second wave of the feminist movement.

During the ten years between 1955 and 1964, the Crown Heights community saw Lubavitcher women energetically taking on new roles in the Rebbe's national headquarters. From the onset of his leadership, the seventh Rebbe provided new recognition and involvement for the women who were rebuilding a Hasidic community in the United States. Small wonder, then, that these women sought to repay the Rebbe's confidence and support by pro-

moting his agenda. In all ways, female *leaders* in Lubavitch were mindful of their identity as *followers*.

In the next two chapters, we will see that Rebbe Menachem Mendel Schneerson's religious and social priorities fueled all of his female followers' projects. *Di Yiddishe Heim*, a quarterly journal by, for and about Lubavitcher women, focused on the role of women in Chabad, but also on the history of male Lubavitcher Hasidism from Tsarist Russia to the United States. Through this new medium, introduced in 1958, Neshei Chabad circulated news and essays from the central Crown Heights community to Jewish women far from the Rebbe's immediate jurisdiction and influence. Women with literary talent or personal stories to share gained a reliable outlet for expression and feedback. Although we will see, in chapter 4, that *Di Yiddishe Heim* was a highly successful outreach project, continuing throughout four decades, it limited the Lubavitcher women's exchange forum to paper. Lubavitcher women first needed a way to meet and exchange ideas face to face.

Beginning in 1956, Neshei Ubnos Chabad held its first Annual Convention, inaugurating a tradition that would bring together Lubavitcher women from around the world every year.

The Appeal of the Conventions

The Conventions, as live events rather than written testimonials, offered women living in remote outposts of Lubavitch Hasidism the opportunity to hear Neshei Chabad speakers, to organize, and to experience the particular fervor of Crown Heights. At each Convention, women delegates from every Lubavitcher community in the United States issued resolutions for future outreach projects, based on suggested themes and goals from the Rebbe.

With the Rebbe's personal blessing and encouragement, the newly formed Neshei Chabad held its first Convention to discuss the difficult but exciting challenges ahead. The first few Annual Conventions generated so much enthusiasm in Crown Heights that they quickly spawned an additional "Mid-Winter" Convention, thereafter held annually in rotating host communities far outside the Brooklyn home territory. From 1963 on, Lubavitcher women could choose between these two regularly held Conventions each year. Neshei members who were truly dedicated, affluent, or both, and who could arrange to leave their families for a few days, often chose to attend both Conventions. Over time, the Annual Conven-

tion in Crown Heights burgeoned into a lavishly catered affair, attended by as many as 3,500 Lubavitcher women from eight countries and most U.S. states. Professional speakers, local performing artists, brisk business meetings, and multilingual brunch groups were the order of the day when I attended the Annual Convention of 1987, demonstrating the substantial gains made by Neshei Chabad since its first gathering thirty-some years before.

How does the development of the Conventions' agenda over three decades reflect both Neshei Chabad initiative and the direction of the Rebbe? As we will see, while the content of Jewish law and Lubavitcher philosophy did not change in the decades after 1956, the packaging of the message underwent considerable alteration. Much of that alteration could be traced to trends and events occurring in secular American society.

The formal intention of each Convention was threefold: to appraise the success of the previous year's outreach campaigns, to draft new resolutions based on the Rebbe's recommendations, and to reaffirm dedication to the Chabad movement through personal anecdotes that were analagous to Christian "witness," though of course with a Hasidic message. But the Conventions were much more than this. They signified a high point in the yearly cycle of events for Neshei Ubnos Chabad members.

At the Annual Convention in Crown Heights, Neshei Chabad members celebrated their status as an organizational body and relaxed in a four-day holiday atmosphere. For a nominal registration fee, Lubavitcher women enjoyed catered buffets and luncheons, brunch sessions, films and entertainment, speakers, field trips to local sites of Hasidic significance, and the chance to mingle with women of similar interests.[1] Out-of-town guests received free housing accommodations in local homes. The structure of the four-day weekend resembled a female Lubavitcher vacation package, complete with souvenirs. Residents of Crown Heights offered tours of the neighborhood between sessions, pointing out religious institutions, the women's *mikveh*, schools, kosher food markets, and other sources of community pride. During this one week each spring, the women of Lubavitch were honored and toasted, with awards of recognition given to a few stellar figureheads in their ranks. To free the women of the community for Convention events, adolescent girls willingly pitched in as round-the-clock babysitters, messengers, and registration workers. The Conventions became the only non-divinely ordained events to be celebrated annually by women who lived according to a strict religious calendar.

Despite these attractions of ingathering and respite, the primary reason women attended the Annual Convention in Crown Heights was to have *yechidus* (audience) with the Rebbe. The Sunday afternoon address by the Rebbe to the entire assembled Convention was the climax of the weekend activities. It was also one of three times in the yearly cycle when adult women were permitted to sit downstairs in the main synagogue at 770 Eastern Parkway; men who wished to hear the Rebbe's address to Neshei Chabad either crowded outside, sat in an upstairs annex, or used headset transmitters.[2] The privilege of hearing the Rebbe speak directly to his female constituents was the central attraction for foreign and regional visitors, many of whom had no other opportunities to see the Rebbe.[3] For women who were residents of Crown Heights, normally confined to the tiny upstairs women's gallery during other synagogue services and speeches, proximity to the Rebbe in the expanse of the men's section was a great honor.[4] The absence of a physical barrier between women and Rebbe symbolized mutual trust and tenderness on this occasion.

The Rebbe's *sicha* (speech), which was simultaneously translated in several languages on small headsets for those unfamiliar with Yiddish, ended with his personal distribution of hundreds of dollars to the spellbound crowd. These *tzedaka* (charity) dollars were intended for the various causes supported in the Lubavitcher community; most women marked the Rebbe's dollar with the date and saved it as a blessing, and gave one dollar from their own wallets to the charity collectors lined up on Eastern Parkway.[5]

Emotional behavior was not a rarity at such events. When I stood in line to receive my own dollar from the Rebbe, the woman just ahead of me dropped to the Rebbe's feet and laid her bouquet of flowers there, to the embarrassed consternation of the Rebbe and his bodyguards.

As the Conventions grew in size, each year attracting more participants, the highlight of meeting with the Rebbe became a complicated ordeal of fitting several thousand women, many of them pregnant or aged, into a space safely designed for one-fourth their number. Eager visitors vied with local dignitaries for the prized seats adjacent to the Rebbe's dais. Attending one such event, I found my chair literally torn from beneath me by an elderly woman and my subsequent standing position dislodged by two Israeli girls. The awe of the Rebbe's presence put an end to bickering and shoving, and a hushed, rapt audience listened reverently to his statements on the potential within each Jewish woman.

Alone with the Rebbe, Lubavitcher women from the Annual Convention finally had one hour in which to experience their male counterparts' centuries of proximity to Hasidic leadership. Even so, these women would never dance with their own Rebbe, never glean the essence of male disciples' communal bonding and emotion. These women could not enjoy the most intimate of Hasidic actions, singing, with their Rebbe, for like all Hasidic males he was prohibited from hearing women's voices raised in song.

Most scholars acknowledge this poignant distinction between Hasidism's male and female followers. In her critical analysis of S. A. Horodetzky's discussions on women in Hasidism, Ada Rapoport-Albert debates whether devotion to the *tzaddik* granted Hasidic women any sectarian equality with men. Rapoport-Albert instead suggests that as long as there was no equivalent to the all-male *farbrengens* celebrated between a Rebbe and his followers, Hasidic women enjoyed far less communal religious activity with their Rebbe—and on top of that lost desired family time with husbands because of the frequent male *farbrengens* with included meals.[6] In view of the function of the male *farbrengen* as a uniquely spiritual occasion, and the lack of an equivalent religious festivity regularly held between the Rebbe and female followers, it is significant to note that Lubavitcher women *invented* a female occasion on their annual calendars at which the Rebbe might prevail.

But there is no point in pretending that the Rebbe's *sicha* to the gathered Convention audience rivaled a *farbrengen* feast in traditional Hasidic style. And despite the naturally religious content of the Rebbe's remarks at each Convention, the ingathering of female activists each year marked a businesslike organizational function, not a religious holiday. Thus a secular event prompted the rare closeness between Menachem Mendel Schneerson and the women of his community. These facts serve to illustrate the relentless segregation of Hasidic women into communal functions outside of their menfolk's ritual framework. And, of course, while women are never present at a male *farbrengen*, Lubavitcher men eagerly listened in on the Rebbe's annual *sichos* to the assembled women. Armed with headset transmitters, they filled the garden outside 770 Eastern Parkway and enjoyed the benefit of the Rebbe's words.

Although the address by the Rebbe was of central importance to the Convention in Crown Heights, rarely was it made available in printed form afterward, for those guests who wished to study the message further. Instead, the Rebbe did issue a formal letter of

blessing and greeting for each Annual and Mid-Winter Convention. These letters ran from one to three pages long and were printed in both Yiddish and English in the *Souvenir Journals* handed out to all Convention participants. *Di Yiddishe Heim* also published the Rebbe's letter, so that out-of-town Lubavitchers who had not been able to attend the Annual Convention in Brooklyn had access to the Rebbe's blessings via their magazine (a not insignificant sales incentive). As with all Lubavitcher events, the Rebbe's leadership was a constant, ubiquitous theme at the Conventions, and honor to his person was paid throughout each workshop session and panel presentation.[7]

A Look at the Convention Journals

Each Convention represented the work and planning of dozens of women. While the keynote speaker was often a male—perhaps a rabbi from a successful Chabad house, or an aide to the Rebbe—the other organizational details were handled by women, from catering and flower arrangements on brunch tables to program layout and fees collection. And women writers of all backgrounds provided stirring essays along the lines of the Convention theme for the *Souvenir Journals* distributed at each Convention.

Typical Convention journals contained both the program for the weekend's activities and sermon-style articles for readers to reflect on between sessions. Each journal followed the same format from 1956 onwards: a title page, a schedule of Convention events, the reprint of the Rebbe's letter, a list acknowledging the women who had planned the Convention, and then several essays. The journals also included an enormous section of advertisements from area merchants, who had obviously helped to defray the cost of printing. Convention resolutions were occasionally included in the journals, but in most cases they were not drawn up until the final session of the weekend. In some years, the *Souvenir Journals* themselves were not available until after the Convention had ended, in order to include both resolutions and photo highlights from important sessions.

Convention journals often included photographs of the Rebbe, his family, and other prominent leaders from the Lubavitcher dynasty, with brief histories accompanying the pictures. These features were directed at individuals new to Lubavitch, who lacked perspective on the larger context of the sect's history. As a gentle

"nudge," most Convention journals included subscription forms for *Di Yiddishe Heim*. All Neshei Chabad members were urged to read this magazine and to introduce it to other Jewish women; this was such a strong point that resolutions on the importance of *Di Yiddishe Heim* to Lubavitcher women appeared at every Convention.

During the first ten years of Conventions (1956–1965), the *Souvenir Journals* were modest in appearance, and similar in design to very early issues of *Di Yiddishe Heim*. Programs indicated who poured the tea at each session, what foods were served, names of hostesses—elements that illustrated the unwitting influence of the 1950s American club-woman genre on Hasidic women. Reports by guests, too, combined Hasidic values with secular etiquette form, as seen in this brief "Convention Report" from 1959:

> Who could help feeling proud to be part of such a dynamic revolution on the part of Jewish women! Delegate after delegate—from Boston, from Chicago, from St. Louis, from Montreal—rose to tell of classes in Bible, in Jewish laws, in history; of youth work, of charity work.
>
> Mrs. Kenny Deren of Pittsburgh acted as chairlady. It was quite marvelous, the way this attractive, soft-voiced young mother handled the chair and the hall filled with chattering women so smoothly.[8]

The Resolutions from the 1959 gathering cited above were practical: to initiate public speaking courses for women, to prepare materials for study, and to develop regular meetings for Jewish women with little religious background.[9] These resolutions conformed to the Rebbe's goal of *uforatzto* by proposing improvements in outreach style, content, and forum. In 1960, however, Neshei Chabad quickly turned toward issues in the larger American community, lamenting "the sorry state of modesty in our present society, and particularly the immodest dress that is so common, with its consequent demoralizing effect on our youth."[10] Not surprisingly, resolutions centered on the religious education necessary to correct such problems, and called for an extensive campaign to improve educational facilities for high school–aged Jewish girls in communities without the Beth Rivkah Schools of the Lubavitcher system.

By 1963, guests were reading program essays that attacked feminism, defined the Lubavitcher outreach mission as a war

against secular forces, and called for the immediate formation of a national women's league to promote *taharas hamishpocha* (the laws of family purity, which include guidelines on when sexual intercourse is permissable and the necessity of abstinence during menstruation). The formula for Lubavitcher success was couched in terms of battle against the outside society and its corruptions: these sentiments paved the way for a multitude of Lubavitcher campaigns for Judaism expressed in paramilitary terms by the Rebbe and his aides.[11] Over 1,000 women attended the Eighth Annual Convention of 1963; they represented Lubavitcher interests in twenty-five American cities and six foreign countries: Australia, England, France, Israel, Morocco, and South Africa. And although the 1963 Convention featured an art exhibit, a play, and a formal dinner, most important of all were the speeches that addressed the new feminist movement in America.

"A mountain of literature is growing with articles and books discussing the role of the woman," declared Mrs. Risa Posner in the opening remarks of the 1963 Convention. "This mad search to find themselves leads to one conclusion—they are lost! But they have diagnosed their thirst wrongly. It is not for achievement, nor even for recognition nor honor, but a deep spiritual and emotional thirst. Their special gifts of the heart and soul have dried up and atrophied from lack of use."[12] Guest speaker Mrs. Tema Gurary, one of the two editors at *Di Yiddishe Heim*, added her criticisms to the debate on women's role. "The recent emancipation of women, their 'modern equality,' has not as yet brought them the recognition that the Jewish woman received thousands of years ago at Mattan Torah."[13] In other words, no secular opportunities could compete with the mantle of spiritual obligations distinguishing Lubavitcher women.

Why the sudden counterfeminist focus? Betty Friedan's *The Feminine Mystique* was published in 1963, and this text was responsible for much of the debate on woman's role that spilled over into the American Lubavitcher community. That Friedan was, herself, a nonobservant Jew only compounded Lubavitcher hostility to the idea that Jewish women required emancipation. The position of Neshei Chabad was that, having never been enslaved by men, Jewish women needed no liberation, and indeed received more recognition in Jewish law than they did in the secular legal system of Western civilization.[14] However, this privileged status was contingent on living up to the *aishes chayil* title, with responsibilities to God, husband, and family.[15] The efforts of Neshei Chabad to educate Jewish women on the laws of Family Purity

were one part of an instruction process that emphasized the holiness in relationships. And, while Lubavitcher women were disdainful of feminism, they undertook the task of becoming conversant in feminist arguments, the better to persuade Jewish women in secular society that Hasidism was a superior alternative.

The fight to reclaim Jewish women from potential involvement in the American feminist movement was but one facet of the fight against encroaching secularism. Rabbi M. Feller, a keynote speaker at the 1963 Annual Convention, urged all Lubavitcher women to make every home

> a center for Torah dissemination. In times of war, G-d forbid, homes are converted into hospitals and into fortresses . . . for it is WAR . . . We are living in a time when we are fighting the battle for Yiddishkeit against overwhelming odds. Firstly, there are the secularists and atheists who mock religion. Secondly, there are those who mock Torah-true Judaism and put all their efforts into watering down and perverting authentic Judaism.[16]

Rabbi Feller went on to demand that every Jewish woman "must become a soldier for Yiddishkeit. . . . It is acknowledged that Neshei Chabad is at the vanguard of the women's army for Torah."[17] In the first decade of Conventions, then, Neshei Chabad formed an identity: its members were simultaneously warriors and privileged daughters, whose work merited them high rank in both capacities. Sanctification and discipline became goals reflected in the myriad Convention resolutions of the late 1950s and early 1960s: resolutions demanded the instruction of all Jewish women in the laws of purity and modesty, the distribution of *Di Yiddishe Heim* to new readers, and other means of woman-to-woman Jewish education.

In the next decade of the Conventions, 1966–1976, spiritual and political changes in American Jewish society shaped Neshei Chabad concerns. During this period, the full emergence of the feminist movement in the United States and abroad included substantial feminist critiques of religion, family structure, and patriarchy in church and state. Public awareness and discussion of these critiques led many liberal Jewish women to further reject the Orthodox traditions promoted by Neshei Chabad. At the same time, the Six-Day War in Israel, resulting in the Israeli occupation of Jerusalem and the return of the Western Wall to Jewish control,

had a profound affect on worldwide Jewry. Many American Jews, painfully recalling the helplessness of Jewish communities destroyed by the Nazi Holocaust only twenty-two years before, rejoiced in the Israeli Army's strength and its symbolic recapture of a holy site. Pride in ethnic Judaism was restored in a way the Lubavitcher movement had never anticipated; the new identification with Israel became a route back to Judaism for both young and old American Jews. Additionally, the youth rebellions of the late 1960s and the appeal of spiritual alternatives through the early 1970s sent a fresh supply of young seekers to Chabad. This period thus corresponded to growing awareness in secular society that Jewishness was an active and positive, rather than negative, identity.

These changes in American society and in Jewish identification provided new angles for Neshei Chabad interaction with non-Lubavitcher youth. Convention programs, as well as *Di Yiddishe Heim*, basked in Israel's symbolism of Jewish solidarity and possibility, while recoiling from the significance of the hippie movement and women's liberation. Neshei Chabad's concern for Jewish youth resulted in much civic acclaim: when the Fifth Mid-Winter Convention was held in Worcester, Massachusetts, the Mayor proclaimed February 12, 1967, to be "Neshei Ubnos Chabad Day." A special *Souvenir Journal* commemorated this event with photographs of Mayor Joseph Casdin presenting the key to the city to a Mrs. Samuel Popack. The key was intended for the Rebbe, and Mayor Casdin declared, "Tell the Rebbe I am one of his."[18]

The 1967 Mid-Winter Conference exemplified the convergence of Jewish and civic concerns among Neshei Chabad members, who used the Worcester meeting to address national issues within a Jewish context. In her opening address, Mrs. Burton Chandler made it clear that Lubavitcher women were neither unaware of nor immune to those changes occurring in American society: "Our newspapers are filled with daily headlines about draft card burners, civil rights marches, the LSD kick, the pill, and the startling increases in Jewish intermarriage statistics. . . . We often underestimate the full intensity with which the winds of change swirl about the woman who maintains a home and rears a family."[19]

But in a notable departure from Lubavitcher tradition at previous conventions, Mrs. Chandler elected to prove her point by quoting not from Torah, but from statistics on women's history in the United States. Focusing on the longevity enjoyed by most American women in the present era, Mrs. Chandler suggested that

the contemporary woman's prolonged and healthy middle age could result in either the "empty nest syndrome" or increased productivity in home and workplace. Chandler added that the average woman could expect "almost thirty years of life after her last child has turned twenty-one, as compared to her counterpart in the 1890's who could expect only fourteen."[20] These figures helped sustain Chandler's argument that while raising a family was a woman's central responsibility, the post-child-rearing years constituted a substantial portion of a woman's life. Why not prepare for those years by cultivating an active, informed involvement in community concerns? Productivity, not passivity, was always the hallmark of the Lubavitcher woman, and during the late 1960s Neshei Ubnos Chabad was particularly adamant about Jewish women's potential to intervene with delinquent or apathetic youth. Yet Chandler chose to place Lubavitcher women back on the continuum of American womanhood in order to emphasize female productivity—a not insignificant variation from the usual argument that American women and Lubavitcher women were separate categories.

Despite Neshei Chabad's interest in strengthening the fabric of American Judaism through religious activism, the Conventions differed widely in their approach to female involvement outside the home. There certainly was no chronologically progressive trend throughout the history of the Conventions; the more liberal view of women's work and volunteer abilities at that 1967 Mid-Winter Convention soon vanished into a stricter outlook at the Conventions of the early 1970s—largely in reaction to the developing feminist movement in American society.

At the Sixteenth Annual Convention of Neshei Ubnos Chabad in 1971, Rachel Altein, the other editor of *Di Yiddishe Heim*, criticized both careers for women and any egalitarian departure from "the time-honored division of family responsibilities—father the provider, mother the homemaker and rearer of children."[21] Altein lamented the development of women's preoccupation with personal growth and potential, since such attitudes often led to the pursuit of careers outside the home or even a woman's decision not to bear children. Altein also attacked the idea of Jewish women turning to abortion as a means of family planning. Drawing on her own experiences as a marriage counselor to observant young couples, Altein added, "I have had religious young brides ask me if it is right to add to the population explosion—to earth pollution—if humanity's good did not mean less children. What a tragedy! It is the very opposite of

our Torah beliefs in the good of more Jewish souls observing more mitzvos."[22]

Because her speech predated the Supreme Court's historic *Roe vs. Wade* ruling of 1973 by two years, Altein gave away more information than she perhaps intended. Her deliberate reference to abortion in 1971, however acrimonious, clearly suggests that some Jewish women who considered themselves Orthodox or even Hasidic sought and obtained abortions within the legal parameters of New York state. The *Souvenir Journals* often provided such an unexpected subtext, indicative of the reluctant interaction between Lubavitcher women and American politics.

In confronting the issues of the 1970s—feminism, abortion, birth control, the world population explosion—Rachel Altein was clearly aware that gender issues were at the core of current events in American society, both morally and politically. Rather than avoiding these controversial topics, the Neshei Chabad Conventions of the early 1970s maintained a rhetorical dialogue with feminism, and keynote addresses both recognized and responded to contemporary topics in American news. The Convention journals were optimistic in scope, and included many essays by youth who had chosen to become traditionally religious Jews after experimenting with alternative political outlooks.

In other political areas, the Convention speakers and writers condemned and forgave at the same time. Reactions to events in Israel were an example of this tactic. In 1970, the Rebbe issued an angry letter, attacking the Israeli government's tolerance of non-Jewish immigrants; his letter was specially reprinted for the *Souvenir Journal* of the Sixteenth Convention. Neshei Chabad members followed up on the Rebbe's concern by issuing their own telegram to Israeli Prime Minister Golda Meir. The telegram expressed regret for the recent massacre of Israeli schoolchildren at Maalot, but suggested that the tragedy had actually been caused by God's wrath over the relaxation of Orthodox standards for Israel's Law of Return![23] While Neshei Chabad quickly complied with the Rebbe's chastisement of the Israeli government, its members also appealed to Golda Meir "as Jewish mothers to Jewish mother."[24] Convention journals continued to devote space to sympathetic stories on the widows and orphans of Israeli military campaign officers, and Lubavitcher women continued to do charity work in Israel.[25]

In the mid-1970s, the Neshei Chabad Conventions shifted their focus to specific outreach projects and yearly reports from

organizers. The year 1975 was pivotal, for the Twentieth Annual Convention coincided with the introduction of the Rebbe's most beloved women's campaign, the *neshek* project. *Neshek* was an acronym for *neiros Shabbos kodesh*, the holy Sabbath candles lit by Jewish women on Friday nights to illuminate the home and signal the start of the day of rest; significantly, *neshek* is also a Hebrew word for weapon. The *neshek* campaign to educate all Jewish women about their obligation to light candles involved thousands of Lubavitchers, who took to the streets with sample candle-lighting packages. Lubavitcher women distributed countless such kits to Jewish women and girls at schools, fairs, colleges, shopping centers, and on public transportation.

Lubavitcher women felt a strong attachment to the *neshek* campaign from its inception. Lighting Sabbath candles is one of three specific *mitzvot* (commandments) that Jewish women are called on to obey; the others are separation of a portion of *challah* (bread) as a symbolic offering, and ritual purification at the *mikveh* bath after menstruation. Jewish women and girls over the age of three usher in the Sabbath with a ritual blessing, and are thus responsible for the specific act that distinguishes the Sabbath from the ordinary work-week. In Lubavitcher society, where men and boys perform the greater share of public prayers and accrue almost all the religious honors, the importance of Sabbath candle-lighting for women cannot be overestimated. Throughout the 1970s and beyond, Neshei Ubnos Chabad pursued the *neshek* campaign with genuine pleasure, and entire Convention sessions and journals were devoted to the campaign.

Thus the Twentieth Annual Convention of 1975 chose as its theme a reminder of the *neshek* project: "Bringing Light Into the World—The Obligation and Privilege of Every Jewish Daughter." The *Souvenir Journal* featured photographs of young girls learning to light their own Sabbath candlesticks. One journal essay announced, "We have distributed 135,000 candlesticks in metropolitan New York City alone! Our visits to schools all over N.Y.C. met with overwhelming enthusiasm. We have gone to over 350 schools, and are still getting invitations. Many principals or teachers called up or wrote letters to report the heartwarming results of the girls' personal experience in lighting the Shabbos candles."[26]

The Convention sessions reflected great pride over the positive responses of Jewish women and girls to *neshek*. Workshops called for both offensive and defensive strategies in candle-lighting education. Shyness was a problem for many Lubavitcher women,

who, reared in a climate of female modesty and inconspicuous behavior, shrank from approaching complete strangers who "looked Jewish" in order to discuss *neshek*. The Convention journal of 1975 addressed this problem in Nechama Greisman's essay "Victory on the IRT." The author recounted her own reluctance to approach an unfamiliar woman on the subway, the warm reception she met in the stranger, and the happy ending: the stranger accepted the candles, became religious, and eventually enrolled her daughter in a Lubavitcher school.[27] Another essay in the souvenir journal of the Twentieth Annual Convention discussed the power and significance of candlelighting in the Soviet Union, where display of Jewish Sabbath candles was (at that time) a legal and political risk.[28] This theme was extremely influential. If Soviet Jews risked punishment and imprisonment for the sake of Jewish law, it was all the more incumbent on their Western counterparts to keep the faith.

By 1976, the *neshek* campaign had gained momentum, and reports on campaign milestones dominated the Twenty-First Annual Convention. The *Souvenir Journal* presented a most impressive summary of *neshek* outreach actvities:

> Under the leadership, inspiration, and guidance of the Lubavitcher Rebbe Shlita, and the supervision and direction of Esther Sternberg who heads this entire Neshek Campaign, we have to date:
>
> 1. Distributed over 550,000 leichter
> 2. Distributed 1,600,000 brochures
> 3. Visited every school in N.Y.C. (over 450)
> 4. Contracted through the mail over 5,000 Jewish organizations over the entire U.S.A. to avail them of these leichter and brochures (to which we have had wonderful responses from every state—including Hawaii!!!)
> 5. Visited numerous P.T.A. sisterhoods, Hadassah, Mizrachi, and the like groups to speak to women and distribute leichter to them.[29]

The same report added that advertisements for the campaign ranged from radio and television spots to billboards in Madison Square Garden, and that a hired plane carried a banner announcing candle-lighting time "over the entire countryside."[30]

Not to be outdone by the campaigns that radiated from central Crown Heights headquarters, women in other Lubavitcher com-

munities were eager to demonstrate their loyalty to the Rebbe. The Fifteenth Mid-Winter Regional Convention held in Montreal in 1977 featured a program by the Neshei Ubnos Chabad detachment of Quebec. The *Souvenir Journal* on this occasion began with letters of welcome not only from the Rebbe, but from Canadian Prime Minister Pierre Trudeau and Montreal Mayor Jean Drapeau as well. The journal contained glowing reports on outreach campaigns: *neshek* accomplishments on a par with those of Crown Heights; a *kashrus* campaign that influenced local supermarket chains to expand kosher food stock; a Jewish Institute for Brides and Grooms, which provided marriage counseling; a *mezuzah* campaign to canvass Jewish homes in Montreal; and a Neshei Chabad Drama Group. Advertisements in the *Souvenir Journal* included additional testimonials from the Widows and Orphans Fund of the Fallen Heroes of Israel, the Non-Profit Loan Organization of Congregation Lubavitch, the Rabbinical College of Canada, Beth Rivkah Academy for Girls, and various Hebrew summer camps.

Evidence of municipal influence, recognition from political and corporate authorities, and positive feedback from the non-Hasidic Jewish public gave Neshei Chabad new confidence. After twenty years of Conventions, campaigns, and Jewish education, the membership of Neshei Chabad had transformed into an effective group of veteran activists, enthusiastic newcomers, and accomplished public speakers. Against the background of active Christian fundamentalist movements in the late 1970s, proponents of Lubavitcher Hasidism were eager to demonstrate their own religious revival. A new crop of young women were willing to speak out for traditional Jewish values. Accommodating these newcomers in Neshei Chabad, and utilizing their stories to promote increased outreach work, became the hallmarks of the third decade of Conventions between 1977 and 1987.

At the Twenty-Third Annual Convention in 1978, the *Souvenir Journal* devoted exclusive coverage to essays and contributions by or about *baalot teshuvah*. One woman wrote of the enrichment her family enjoyed through frequent visits of *baalot teshuvah* to their home: visits that allowed her children to act as junior outreach workers, guiding the inexperienced guests toward proper observance at the Shabbos table.[31] Another author, chuckling over her own awkward process of becoming *frum* (observant), nevertheless had sufficiently advanced in Lubavitcher scholarship to write about the laws of *tznius* (modesty). Still another young woman wrote painfully of her search for a spiritual identity in the turbulent

early 1970s, noting that she had arrived at the Hasidic alternative only after experimenting with "dope, sex, nature, organic food . . . other religions, Siddhartha, Kurt Vonnegut, Hesse, predestination . . ."[32]

In 1980, the Twenty-Fifth Annual Convention met in Crown Heights. A proud Neshei Chabad reflected back on a quarter-century's worth of meetings and activities. The *Souvenir Journal* featured photographs of previous Conventions, a brief history of Neshei Chabad, and essays calling for recommitment to core concerns: *tznius, kashrus, taharas hamishpocha,* and *neshek.* Not surprisingly, all of these concerns reflected women's particular obligations in Jewish law. A speech at the Twenty-Fifth Annual Convention, printed in the *Souvenir Journal,* gave voice to the impetus for presenting Neshei role models to outside society.

> The women set a living example of how a Jewish woman should live, dress, think, speak, and act in today's world. They openly displayed, in a world pretentiously chattering about the "changing role of women" that a woman who is true to herself is not limited by her position, but finds plenty of room for expressing herself. It came as a surprise to many when they realized that this "poor downtrodden victim of a patriarchal society" was indeed a wife and mother—but also a teacher, building administrator, public speaker . . .[33]

What the Twenty-Fifth Convention celebrated went beyond the specific accomplishments of committees and campaigns. The American Jewish community's trend toward assimilation in the post-Holocaust era had made Orthodox revival difficult in the 1950s, but Neshei Chabad had induced many Jewish women to affirm their ethnicity during the 1960s' decade of diversity and introspection. With the 1970s came the symbolism of "Roots" and intergenerational family history, symbolism that Neshei activists had used successfully in the *neshek* campaign. Pointing to twenty-five years' worth of activism, Lubavitcher women asserted that one could indeed be a practicing Hasid, a wife and mother, and skilled in an administrative or professional capacity as well. And the lavish Conventions, designed to honor the women and their accomplishments, provided proof that Neshei Chabad members were not "downtrodden."

Despite Neshei Chabad's claims of self-motivation, freedom of expression, and lack of limitations, the Conventions remained

inextricably bound to the voice of the Rebbe. The Rebbe's advice governed the actions of any Lubavitcher function, as the results of the Twenty-Fifth Convention made clear.

LETTERS FROM THE REBBE TO THE CONVENTIONS

The Twenty-Fifth Conventions, both Annual (1980) and Mid-Winter (1987), culminated with the publication of books. With characteristic deference and modesty, Neshei Ubnos Chabad determined that these publications would not be retrospective of their own Convention highlights. Instead, they arranged to print the collected letters from the Rebbe to each Convention in special volumes. The resultant paperbacks were *Letters by the Lubavitcher Rebbe to N'Shei Ubnos Chabad, 1956-1980*, and *Letters by the Lubavitcher Rebbe—Neshei Ubnos Chabad Mid-Winter Conventions 1963-1987*. The Kehot Publication Society, the self-proclaimed largest publisher and distributor of Hasidic books, produced both commemorative volumes and made them available to Lubavitcher women at a low cost through the bookshops of Crown Heights.

These collections demonstrate the Rebbe's style and role as guardian of Lubavitcher Hasidism. He discusses little of the "secular" Convention events in his letters, instead concentrating on the Jewish calendar and Jewish history; but the commemorative volumes allow one to refer easily to a quarter-century's discussions by the Rebbe. For the women of Crown Heights, the volumes were tremendously important and flattering. For the reader specifically interested in the Rebbe's comments on the role of women, the books yield some splendid insights.

What emerges foremost in a comparative reading of the two volumes is that little change occurred in the Rebbe's views between 1956 and 1987. And age did not diminish his brisk tone or intellectual acuity. In his Convention letters there are few specific references to passing political phenomena in the United States. The Rebbe does not mention modern Israel or the Soviet Union, although references to the latter abound in the Rebbe's usual *sichos*. Instead, the Convention letters dwell on the immediate and long-term obligations for Jewish women: their responsibilities in the forthcoming Jewish holiday, and their potential for religious influence on others. There is more distinction between the letters addressed to the Crown Heights Conventions and those addressed

to the Mid-Winter Regional Conventions than there is between letters decades apart in each respective volume. The Rebbe is more severe with his home team, and includes an extra note of affection in his letters to the guests of the Mid-Winter Conventions—the latter being an audience of largely isolated Lubavitchers, residing far from their Rebbe, in many cases sent by him on *shlichus* (mission) to lonely towns. Neshei Chabad's small but valiant Conventions in places such as Missouri or Wisconsin exacted special praise from the Rebbe. Because the letters to the Mid-Winter Conventions are addressed to women the Rebbe saw infrequently, the letters to Crown Heights Conventions are more direct and more demanding; they constitute the definitive volume.

In the Introduction to *Letters to N'Shei Ubnos Chabad 1956–1980*, an anonymous author briefly familiarizes the reader with the relevant themes of woman's role in Chabad Hasidism. The power of the Jewish woman to influence both men and other women is attributed to natural character traits, to woman's extra measure of understanding; qualities that make Lubavitcher women particularly well-equipped candidates for outreach work: "Women possess certain qualities in greater measure than men—gentleness, kindness, and sympathy; giving her an advantage over men in her efforts to spread Yiddishkeit and in raising children."[34]

The emphasis on women's effectiveness as educators and outreach activists is an interesting departure from attention to their domestic talents alone. In light of the Rebbe's mission to prepare world Jewry for Moshiach, the power of women to spread faith received new scrutiny and acclaim. The praise expressed in the Rebbe's letters to Neshei Ubnos Chabad is both blessing and exhortation, reflecting the Rebbe's confidence in the ability of his women followers to perpetuate Hasidic ideals in both private and public domains.

The first letter from the Rebbe to the first Neshei Ubnos Chabad Convention in 1956 addressed the role Jewish women played at Mount Sinai and calls for an expansion of Neshei activities. Henceforth the Rebbe's letters followed an almost identical pattern: greeting and blessing, comments on the weekly Torah portion or the symbolism of the Jewish calendar date, and confidence in the women's abilities to "bring about a radical change . . . through the dissemination of Yiddishkeit."[35] The similarity of the Rebbe's letters is partly attributable to their recurring emphasis on the festival of Shavuos. The Annual Convention is always held after this holiday, which commemorates the giving of the Torah, in

order to remind the community of Jewish women's faith and integrity on that occasion.

For the first ten years of Conventions (1956–1966), the Rebbe's letters read as though from a benevolent coach to a winning team of players. The 1959 letter urged Neshei Ubnos Chabad to "devise and organize a program of action" with "renewed vigor and energy."[36] Occasionally, as in his 1963 letter, the Rebbe retold a popular story of Hasidic courage, in which riches and blessings accrue to the husband whose devoted wife commits a daring, unselfish act in times of poverty and oppression. During the early and mid-1960s the Rebbe stressed the preservation of home harmony and the education of children. By 1968, however, writing in a year of global and national political upheaval, the Rebbe made his first references to the role of Lubavitcher women as citizens in the larger world, expressing concern that Jewish unity was threatened by pluralistic school systems and the opportunities presented in "free" society. Numerous Jewish writers have analyzed the function of anti-Semitism and circumscribed political rights in fostering Jewish community unity. In an absence of politically enforced restrictions or distinctions, does Jewish culture flourish? Or is rampant assimilation the natural result? The Rebbe's challenge—and the challenge he presented to his followers—was to overcome Jewish resistance to ultra-Orthodoxy. "Freedom," for the Rebbe, was a two-sided coin: in Western society the Lubavitchers were free to proselytize and to practice their particular brand of Judaism. Yet they encountered a much stronger resistance to Jewish fundamentalism from Jews. (In response to these concerns, the 1968 Annual Convention of Neshei Ubnos Chabad selected as its theme "Freedom—Its Challenges and Opportunities.")

The introduction of politics and the discussion of freedom in the Rebbe's letters reflected several beliefs in the Crown Heights community—loathing of Communism and the suppression of Judaism in the East European regions from whence most Hasidim emigrated, and the equation of freedom with submission to Hasidic principles. True freedom demanded obedience to a higher set of goals and purposes. During the late 1960s, Lubavitcher rhetoric focused on these issues—that throughout history many Jews had been forbidden to study and practice their own laws and culture, so that the contemporary observant Jew savored a freedom still denied his or her Soviet counterpart.

The Rebbe's Convention letter of 1970 also addressed events in the secular world. Concerned with the fluctuating hemlines and

fashions of women's dress in U.S. society, the Rebbe suggested that *tznius* (modesty) should be the theme of the 1970 Annual Convention of Neshei Ubnos Chabad. His letter to the adult women attending the Convention stresses the sancity of the Jewish home and the impurity of symbolic and literal forms of nakedness.[37] This continued his concerns from earlier that winter, when the Rebbe had issued an unusually strict letter to young Bnos Chabad girls for Chanukah:

> The message of Chanuka, for Jewish girls and women, is that they should not allow themselves to be influenced by the environment. . . . Surely it is unnecessary to elaborate to you at length as to the cult of the ancient Greeks, which was to worship physical strength and beauty, discarding all modesty, etc. So shameless they became in their conduct, that they ascribed the same obscenities and vulgarities to their pagan gods, as is well known from their mythology. . . . In light of the above, the issue, in so far as Jewish girls are concerned, is not merely the length of a dress, whether it be longer or shorter, but the fact that following the trend of the non-Jewish cult means subservience to it all along the line.[38]

The Rebbe was particularly concerned about the impact of the women's movement on regional Neshei members. In 1971, he wrote an unusually stern letter on "liberation" to the Mid-Winter Convention:

> The Torah concept of freedom is the very opposite of what nowadays passes for "liberation," which really is nothing but a clamor for freedom to do as one pleases, in order to gratify the natural appetite without restrictions and inhibitions. This kind of liberation is nothing but an attempt to legalize the lowest animal passions, and there is surely no greater slavery than being a slave to one's own passion. True liberation from enslavement . . . can be achieved only by submission to the Will of G-d and the acceptance of the "yoke" of the Torah and Mitzvos.[39]

His message hinted at the controversy over changing sexual mores in the early 1970s. The juxtaposition of Torah restraints with liberation hedonism remained the Rebbe's favorite tactic throughout the "Me Decade" of the American 1970s. Some women did,

indeed, turn to Hasidism for the stability a regimented lifestyle could provide, after disappointing (or violent) experiences of sexual exploitation.

The most revealing letter to the the Mid-Winter Conventions appeared in 1975, near the *yahrtzeit* (anniversary of a death) of the Rebbe's predecessor and father-in-law, the Rebbe Joseph Yitzchok Schneerson. In this letter, the reigning Rebbe told Neshei Ubnos Chabad:

> It is timely to recall once again his profound concern to involve Jewish mothers and daughters in activities to spread Yiddishkeit with Chassidic light and warmth. Thus, immediately after his liberation from behind the Iron Curtain, when he began to publish his discourses and teachings, he saw to it that some of them were translated into Yiddish, to make them accessible also to the women. In this way he underscored the vital role of the Jewish mother and daughter, which has aptly been expressed in the Convention's slogan: "To illuminate the home, the community, and the world."[40]

What did this passage unintentionally reveal? If the previous Rebbe promoted women's access to his works by translating them into the vernacular, Yiddish, it means those pious Lubavitcher women of the earlier generation could not read Hebrew. Their standards of education so contrasted with those of their menfolk that they were not expected to read in Hebrew, their community's language of religious literacy. In view of these hints from the past, the rise in learning and the multilingual publications by Neshei Ubnos Chabad in the United States represents a remarkable change.

It is clear from the Rebbe's letters that the women of Neshei Ubnos Chabad had one outstanding task: he expected them to influence the outside environment, while actively resisting that environment's influence over them. As model Hasidot, women played a major role in transmitting the Rebbe's messages to less observant Jews, and the Conventions helped whip up the necessary enthusiasm for another successful year of campaigns in the spirit of the Rebbe's expectations.

In the years since the Twenty-Fifth Annual Convention of 1980, Convention programs have continued to gain in sophistication and breadth.[41] Emphasis on *chinuch* (education of the child)

and the fight against birth control became predominant themes for Neshei Ubnos Chabad in the 1980s. The 1981 Convention praised large families, discussed the problem of individual attention to each child in large families, and examined the role of the child whose parents were out-of-town *shluchim* (missionaries for Lubavitch). Attacks on feminism and the zero-population-growth movement accompanied the essays and presentations on the dignity of motherhood and religious childhood. While all of these positive and negative themes were used throughout the *Souvenir Journals* of the 1980s, a trend toward female learning emerged as well. By the later 1980s, more Convention essays were well-written articles on the history of woman's role in Judaism. These articles were frequently accompanied by photographs and other graphics that literally illustrated the new advantages of modern Lubavitcher living within traditional boundaries: the contemporary *mikveh*, learning Torah on computer, mail-order *kashrus*, and similar innovations.

Certainly the Conventions produced confidence, improved visibility of Neshei Chabad members, and gave voice to a generation of *baalot teshuvah*. But while the creative and inventive elements of the Conventions cannot be denied, it is important to remember that most topics, themes, and campaigns were suggested by the Rebbe. Therefore, although Jewish womanhood was the language of the Convention, a male superstructure prevailed. Because the Rebbe only made one appearance, keynote speakers were often male Torah scholars, men who worked closely with the Rebbe and were qualified to represent his words in Convention addresses.

Women never appeared to resent male intervention in their gatherings. On the contrary, they were honored by the profuse attention from important administrators in the Lubavitcher hierarchy. Although male and female were assigned different roles in the Rebbe's community, both looked to their leader for inspiration and guidance, and the Rebbe's male proxies were an essential part of Convention proceedings.

The history of the Conventions demonstrates the rapid ascent of many Lubavitcher women from interested discussion guests to committed, astute spokeswomen at the forefront of extensive campaigns. Each year, Lubavitcher women presented statements on the responsibilities of Jewish womanhood and then received fresh instruction on those responsibilities from the Rebbe himself. Every woman attending the Annual Convention thus obtained both an active and passive role in the process of fostering Lubavitcher womanhood. The essays and resolutions that ensued from each Con-

vention served to enlighten other women about the Rebbe's ideals, and to establish those ideals as sacred in the hearts and minds of Jewish women everywhere.

One more aspect of Convention life must be mentioned. I brought my own preconceived notions to a workshop on "food carving" at the 1987 Annual Convention, disappointed that this (rather than more scholarly workshops) attracted the women attending from so many regions. As we saw demonstrations of apple birds, tomato roses, and other garnishing, I realized that a workshop on effective food presentation was hardly irrelevant when so many Lubavitcher women worked out of their homes as caterers in a community with round-the-year banquet celebrations (weddings, *bar mitzvot*, circumcisions . . .). Catering is a powerful economic role in the Hasidic community, yet also comfortably within gender boundaries, employing many women. Watching guests take notes on apple birds, I understood I was not watching the trivia of domestic femininity, but a skills workshop for female livelihood. The Conventions unwittingly offered guests like me the chance to glean new feminist perspectives.

FOUR

"Hakol Min Ha Isha"
Everything Emanates from the Woman
Di Yiddishe Heim

As modern heiresses to the lineage of Hasidic belief and practice, Lubavitcher women themselves are living, walking texts of tradition. But because ultra-Orthodox Judaism never welcomed women into religious debate and interpretation, women's words lack the might and significance of male *yeshiva* talk. As discussed in Chapter 2, East European Hasidic girls who learned Yiddish but not Hebrew could hardly hope to compete with their brothers' Talmudic discussions. However, Jewish folksinger Alix Dobkin reminds us that Yiddish, as a "women's" language, is chock full of derisive terms for annoying and unreliable menfolk. Clearly, Jewish women have always forged oral traditions of their own.

In the not-so-recent past, there was no incentive for Lubavitcher women's thoughts to be preserved as text. But in the United States, their impassioned testimony from the front lines of traditional family life became crucial to the Lubavitcher mission of resisting assimilation and winning new adherents. This chapter examines the first one hundred issues of the magazine so often mentioned thus far in this study: *Di Yiddishe Heim*.

Beginning in the mid-1950s, in keeping with the philosophy of *uforatzto* (spreading the ideals of Chabad), the women of Lubavitch began organizing other small chapters of Neshei Chabad throughout New York.[1] The Crown Heights Executive Committee quickly appointed presidents to eight borough chapters of Neshei

Chabad, but with an agenda of distributing religious publications to Jewish women and groups outside of Crown Heights, and developing membership in out-of-town Neshei Chabad groups, the ladies desperately needed a medium for linking their small member chapters.

With the approval of the Rebbe, the Council decided that the publication of a quarterly magazine for women would best suit the Lubavitcher outreach agenda. The first issue of *Di Yiddishe Heim* appeared in the fall of 1958, bringing information and news to Lubavitcher women around the country and around the globe. The magazine, published by the Council Neshei Ubnos Chabad, was available to the public for fifty cents: a modest price that would not increase for another fifteen years, and then only by a quarter.[2]

The first issue was a curious mix of outreach philosophy, birth and marriage gossip from the neighborhood, Jewish women's history, and homemaking tips for young mothers of young children. The groundbreaking editorial announced:

> The basic role of the Jewish woman, "bat melech" in her devotion to her household, and her creativity in this inner sanctuary, has been to nurture with care the flower of Jewish Youth. But, at moments of dire need and stress, the "aishes chayil" has gone out of her four walls, to give of herself, for the strengthening of the structure of the Jewish community. Now at this moment, we have need for both qualities simultaneously. The ways of strangers have insinuated themselves into the Jewish stronghold.[3]

Di Yiddishe Heim thus proposed to uphold the traditional qualities and responsibilities of the Jewish wife, while acknowledging her role in strengthening Jewish observance and identity outside the home. The justification for going outside of the domestic sphere lay in those forces of assimilation that Lubavitcher women believed threatened their authority on the home front and in child rearing.

From its inception, the magazine placed Jewish women completely within the context of family. The words "woman" and "wife" were used interchangeably in the first issue, just as they are often conflated in the Yiddish language; the duties of both revolve around dedication to others. The magazine proposed to meet the threat of assimilation by bringing women's values out of the domestic sphere and into the public sphere, using the pages of *Di*

Yiddishe Heim for comments and suggestions. At the same time, the magazine also provided the space for an ongoing gallery of Lubavitcher women's poetry, prose, and learning.

FORMAT

Di Yiddishe Heim followed the same basic format from 1958 onward. Each issue was approximately forty pages long and included articles in English and in Yiddish, submitted by members of the Lubavitcher community. Although features and contributors varied from issue to issue, two women served as a permanent editorial board. Rachel Altein, as English editor, and Tema Gurary, as supervisor of Yiddish content, wielded tremendous influence over the magazine in their choices of material—and in their judicious editorial comments, which they occasionally inserted directly into a contributor's article.

Yet these two women, who were highly regarded as individuals of stature in the community, rarely contributed full-length articles or essays themselves. The Lubavitcher premium on modesty demanded that no one woman emerge as a glamorous star in the new publication, and Mrs. Altein herself deflected praise for her years of editorial service with "I am not a trained writer or editor, nor is there one person who writes for the magazine who is a writer by profession."[4] (This phenomenon of self-deprecation among high-status Hasidic women who are locally empowered to instruct or guide women is hardly limited to the Lubavitcher sphere in America; Tamar El-Or noted the same behaviors in her research among the Gur Hasidim of Israel.)

Each volume of *Di Yiddishe Heim* consisted of four issues that appeared in fall, winter, spring, and summer, corresponding to the appropriate season of Jewish holidays.[5] An issue contained anywhere from ten to sixteen articles in both English and Yiddish, usually without footnotes. Despite the orientation toward womanhood and the solicitation of materials from Lubavitcher women, no issue was written exclusively by women, and only the first two issues in 1958 were solely directed toward "female" concerns.

Although over 150 women contributed articles to *Di Yiddishe Heim* between 1958 and 1987, many wrote only on a one-time basis and did not subsequently reappear in the magazine. In contrast, male contributors numbered far fewer, approximately 95 rabbis; but their articles more frequently appeared in serial form, continuing

from one issue to the next in installments on a particular religious theme. Most men who contributed once did so again.

In short, a smaller group of male authorities significantly outweighed the large pool of female authors with respect both to repeat contribution and length and learnedness of article. Although certain women did contribute work to the magazine in serial form, male scholars and male-authored series dominated many issues. Yet there is still another important distinction to be made between male and female writing. In many instances, the male scholar wrote interpretations or translations of works by previous Hasidic Rebbes, providing explanations of complex texts for readers. Because women had less opportunity for higher religious learning, they seldom ventured into the realm of text commentary or translation, instead contributing original essays on their daily experiences as Hasidim. Therefore the female-authored works in *Di Yiddishe Heim* were far more creative and varied than those by men, for while all contributors addressed Lubavitcher philosophy, men did so through text reconstruction, and women did so by describing the practical application of that philosophy to their own lives in America.

Still, the scholarly works by men eventually outweighed women's writing in terms of quantity. The percentage of female-authored content peaked at 80 percent in the first year of publication, with a rapid decline in subsequent years. A mere three years after *Di Yiddishe Heim* began publication, articles by women comprised only 40 percent of the magazine; a 50 percent reduction from the first year's format. By 1967, the ninth year of publication, *Di Yiddishe Heim*'s female-authored content dwindled to a mere 20 percent. During the years 1966–1973, while the rest of American society grappled with the emerging women's movement and the general activism of young people, entire issues of *Di Yiddishe Heim* were written by men—rabbis, secretaries to the Lubavitcher Rebbe, young Chabad organizers, *yeshiva* educators. Although content by women rose again to a high of 60 percent per issue during 1975, it plummeted back to 20 percent in 1986. An average issue of *Di Yiddishe Heim*, selected randomly from the first 100 issues printed between 1958 and 1987, featured perhaps two to five articles by women, as compared with anywhere from four to eight articles written by rabbis.

What accounts for such overwhelming evidence of growing male dominance in the presentation of women's issues in a women's magazine? What happened to the focus on, or by, the Jewish wife?

There was no intentional or patronizing takeover of *Di Yiddishe Heim* by community rabbis. Men typically supervised all levels of female religious activity in Lubavitch, so that the less erudite female might consult them on points of Jewish law and practice. Few women in Crown Heights had the time or the community support to become avid students of those legal texts that addressed their own religious obligations. In fact, women generally had less time to write, period; the high birth rate of the Lubavitcher community meant that most women were continually absorbed with childbearing and child care. Those who did write for *Di Yiddishe Heim* were often mothers of grown children or women who had not yet had children. Men, on the other hand, were trained and indeed urged to interpret and write about Jewish law, and given constant opportunities to do so. This rapid profusion of English-speaking and -writing rabbis in the postwar era provided the perfect ready-made staff for the magazine.

The role of the Lubavitcher male as a contributor to *Di Yiddishe Heim* was to lend the magazine a more learned status from writers with *halachic* (Jewish legal) authority. Men who wrote for *Di Yiddishe Heim* provided busy homemakers with patient and accessible versions of legal commentaries, translations of the Rebbe's most recent speeches, and up-to-the-minute resolutions of disputes on women's issues in Jewish law. Since countless Lubavitcher rabbinical scholars were, at any given time, already engaged in writing commentaries on Jewish womanhood for forthcoming texts and conferences, they had no lack of such material for *Di Yiddishe Heim*, and the magazine relied heavily on such translations or reprints. Most Lubavitcher women felt that male essays fulfilled the purpose of *Di Yiddishe Heim* splendidly: after all, the magazine was created to promote the Hasidic ideals of womanhood, and who could explain the rationale for such sacred responsibilities better than a rabbi, or, best of all, the Rebbe? This reliance on male contributors, however, altered the tone of the magazine: women not only created a dialogue on Jewish womanhood, but also received that dialogue ready-made from influential male authorities.[6]

The average article by a male author did not directly discuss women or women's issues per se. For example, the longest-running series articles in *Di Yiddishe Heim* were biographies of previous Chabad rabbis written by current Chabad rabbis. These series—"A Bit of Sound Advice" by Rabbi Solomon Z. Hecht, "The Golden Chain" by Rabbi Alter ben Zion Metzger, "From My Flesh I Behold G-d" by Rabbi J. Immanuel Schochet, and the Chabad-Lubavitch

emigration story as related by Rabbi Israel Jacobson—continued on and off for years in *Di Yiddishe Heim*, and focused entirely on the history of men or male duty in Hasidism. In contrast, a very early attempt at a series on "Great Women in Jewish History," also male-authored, lasted for a mere eight issues. (The seven women featured were Sarah, Esther, Hannah, Miriam, Donna Gracia Nasi, Dvorah Leah, and Pearl; volume 2, number 2 did not focus on a specific woman but explored instead the general concept of self-sacrifice in Jewish women's history.)

Male articles usually focused on religious exegesis, the father-to-son lineage of Hasidic study, the exile of previous Rebbes in Tsarist or Soviet Russia, and other male experiences. Female readers were always proud of and interested in such history, even if woman's role in it was only peripherally apparent. As daughters of rabbis and mothers of sons—with these relationships serving as the source of their status—Lubavitcher women accepted the presence of male-oriented literature in their magazine, welcoming assistance from men in clarifying family issues relevant to traditions for male children.

A typical issue of *Di Yiddishe Heim* included a letter from the Rebbe or an essay based on one of his recent *sichos*; an article or two on Hasidic history and the development of the Lubavitcher movement in Europe or America; a philosophical interpretation of daily prayer or the observance of an upcoming holiday; an essay exhorting women to become more involved in promoting Lubavitcher values; a "humor" piece on housewife stress; and an article on the education of children. While this format remained fairly reliable throughout one hundred issues, the tone of the respective articles certainly fluctuated with the political and social phenomena occurring in secular American society.

Di Yiddishe Heim avoided direct political commentary. Rare references to the U.S. government, for instance, stayed safely within two contexts: gratitude for religious freedom, compared with the Soviet oppression of Jewry, and the delicious possibility of state aid to parochial schools. Beyond this, *Di Yiddishe Heim* never mentioned U.S. presidents, promoted no candidates, discussed no secular laws, and certainly never mentioned such current events as the draft or the U.S. involvement in Vietnam. The magazine's sole intention was to spread Chassidus. Therefore, an issue written in 1962 is more or less indistinguishable from an issue written in 1980, since Jewish law and Hasidic observance of that law underwent no changes, in contrast to the mercurial nature of secular

society and politics. Lubavitcher women's writing showed more of an influence of secular idioms and events, but also stuck to "timeless" themes, such as the origin of Chanukah or the scholarship of the Alter Rebbe. When and if references to secular themes occurred, authors used the Hebrew word *l'havdil*, literally, "to separate," between their own Torah-informed language and the language of non-Jewish phenomena.

CONTENT

Articles in *Di Yiddishe Heim* could be provocative, smug, mystical, gentle, or lachrymose, depending on the issue. The magazine asked two questions: How might the Lubavitcher community carry out its spiritual and ethical obligations in this time and place? And why did female followers choose such work? The answers provided were: God and the Rebbe will show us how; we do not choose, but rather, we have been chosen. Virtually every piece of writing, long or short, echoed these crucial themes. Faith and action were influenced by the outside world, but only to the extent that Lubavitcher women felt compelled to respond to secular trends challenging an ultra-Orthodox status quo.

Yet the development of American social movements in the 1960s forced *Di Yiddishe Heim* to address the changing role of women in U.S. society. Both the feminist movement and the so-called sexual revolution challenged the sex role definitions and sexual morality upheld by Lubavitcher Hasidim. Concerned that young Jews were also attracted to these radical social movements, writers for *Di Yiddishe Heim* attacked the changing morality of American society and blamed it on the decline of religious education for young people. Because of its completely religious perspective, *Di Yiddishe Heim* never presented any political analysis for reasons behind American social upheaval. This lack of references to the assasinations of Kennedy and King, the civil rights movement, the antiwar movement, public distrust of the Nixon administration, or any other motivation for discontent and activism encouraged readers of *Di Yiddishe Heim* to believe that only a lack of religious education had enticed young people away from an Orthodox Jewish lifestyle and into protest movements.[7] Although Hasidism itself had been a revolutionary movement within Judaism in the eighteenth century, leading to the arrest and excommunication of adherents, and although the Lubavitcher sect had experienced

social oppression by both Tsarist and Soviet governments, the causes for dissent or activism among the non-Jewish population in contemporary America did not interest or concern *Di Yiddishe Heim*.

In its first decade, 1958–1967, *Di Yiddishe Heim* slowly changed from an entirely female-focused magazine to a general forum for Lubavitcher writing, often dominated, as noted, by male scholars, and thus read by men as well. The Homemakers' Page, self-consciously female marriage and birth announcements, and the series "Great Women in Jewish History" all disappeared by 1961 and never returned.

Instead, during the early 1960s, essays by women focused on vanity and materialism and urged other Lubavitcher women to resist this two-headed demon of the consumer age. Modesty was an ever-popular subject. Editor Rachel Altein, contributing her first full-length article in 1960, reminded mothers of daughters that "An absolute minimum of social contact between the sexes is considered essential to the maintenance of our high moral standards."[8] While Altein admitted that American culture was "attractive," she also severely criticized any Jewish mother who allowed her daughters to date, referring to such behavior as "mindless aping of our spiritual inferiors."[9]

Many other articles in *Di Yiddishe Heim* were similarly antimainstream (and anti-Gentile), acknowledging the allure of assimilation into non-Jewish culture and thus defending the separation of women from men and Jews from non-Jews. The presence of such articles on dating and interaction is highly significant, suggesting that there was indeed a streak of discontent or rebellion among the well-chaperoned Lubavitcher teenagers at this time.[10] By asserting that Lubavitcher values were spiritually superior to those of Gentile culture, Lubavitcher women revealed their awareness of and preoccupation with cultural difference.

Di Yiddishe Heim celebrated its fifth anniversary in winter 1965, which was actually its seventh year of production. But 1965 was an auspicious date in Lubavitcher history: twenty-five years since the previous Rebbe's arrival in America, and fifteen years since the reigning Rebbe Menachem M. Schneerson had assumed leadership from his father-in-law. A feeble effort was made to connect *Di Yiddishe Heim*'s forgotten fifth anniversary with the other commemorative dates, but the resultant editorial, by Rabbi Zalman

Posner, all but ignored women's contributions to the "reshaping of a Jewish continent."[11] Posner's editorial discussed the history of Chabad in the United States, the rise in *yeshiva* education opportunities for Lubavitcher men and boys, and the work of the Rebbe, but did not dwell on female achievement. Only at the close of his article did he briefly mention women's contributions.

> Everyone knows the instruction to Moshe to speak to the daughters of Israel first, and then tell the men about the Torah, for only thus will Yiddishkeit be assured. The establishment of Beis Rivkah schools, providing Torah education in a Chassidishe atmosphere, then the institution of Neshei Ubnos Chabad, providing opportunity for learning and good works for the women of Chabad, brings that truism to fruitful life.[12]

Posner did not address the resistance Lubavitcher women encountered during their postwar struggle to gain recognition and education resources from the American Hasidic community. No one had spoken to the daughters of Israel first in America. The peripheral status of female achievement was evident even in the very essay lauding *Di Yiddishe Heim*.[13]

I would argue that the seeming belittlement of female achievement, however, stemmed from Hasidic belief in modesty as the essence of Lubavitcher womanhood. It was fitting that the efforts of women to publish and popularize their own magazine be seen in the context of a larger, genderless goal: the general development of Chabad in America and the Rebbe's outreach platform in particular. While it was left to a rabbi to appraise *Di Yiddishe Heim*'s real worth, the fifth anniversary issue contained many pages of congratulatory ads from both male and female well-wishers, testifying to the magazine's importance among community women and even Lubavitcher women abroad.

From 1966 to 1972, the majority of *Di Yiddishe Heim*'s writers were men. As though to stem the tides of change in American society, rabbi after rabbi contributed stern articles on the role of Torah values as a solution to nationwide confusion. Most rabbinical articles from this period have blustering, self-explanatory titles: "The Changing Morality," "Speak English but Think Jewish," "Torah Atmosphere: The Depollutant," "Divergent Approaches to Freedom," "Divine Responsibility in Motherhood." This is the period when we also see a brief break from apolitical dialogue in the form of several articles on state aid to parochial schools.[14]

For the most part, the essays by male scholars discussed Hasidic values in highly esoteric, rather than practical, terms. "Outside" society existed only for purposes of scorn in such writings. No rabbi writing for the magazine mentioned Christianity by name until 1970. But Lubavitcher mothers wrote frankly about the non-Jewish influences they felt jeopardized their teenagers. In keeping with Lubavitcher sex role distinctions, which allocated scholarly concerns to men and practical, domestic concerns to women, the woman writer addressed specific social problems, while her male counterpart wrote within the context of philosophy and prayer.[15] Lubavitcher women did not shy away from introducing controversial references in their few articles throughout the late 1960s. Miniskirts, cults, drugs—Lubavitcher women were well aware of these trends from their daily experiences on Brooklyn's streets and subways, and spoke out as concerned mothers, denouncing American popular culture and expressing pride in "living in the past."[16] Female authors declared proudly that their teenage children did not "take pot" or "paint butterflies around their eyes."[17] One woman responded to burgeoning campus radicalism by asserting that "College is no place for a Jewish boy or girl."[18] Crown Heights residents were happy to demonstrate their high standards of morality and filial respect (*kibud av*) while other parents worried about losing children to campus revolutions or drug experimentation.

Rachel Altein, in one of her rare but eloquent editorials, pointed out that 1960s liberalism had not affected the image of the Lubavitcher community. Her 1967 article "My Heroines" suggested that while secular Americans had begun to respect nonconformists and social and ethnic diversity, Hasidic women were often ridiculed for their "different" way of life, and would doubtless continue to be criticized by the very liberals who applauded diversity and tolerance. Altein began her essay by stating her identification with the average, overlooked Lubavitcher housewife. She praised those women who upheld Jewish motherhood to the point of dismissing modern options such as birth control, abortion, career opportunities, and so forth. She suggested that choosing traditional motherhood required far more integrity and dedication than the pursuit of a nontraditional career. With mingled good humor and defensiveness, Altein wrote:

> All right, the reader is thinking at this point, so she admires brainless cows who enjoy diaper-changing and bottle-washing;

it's a free country. . . . My heroines are capable, intelligent women, who would have been successful in any career they chose. But they have freely and deliberately chosen to expend their considerable intellect and talents on motherhood . . . considering it as challenging and honorable an occupation as, say, being a secretary or a nurse, a teacher or a physicist. Maybe my heroine would enjoy such a position, and be successful at it too. But she rejects the idea of denying Jewish souls the right to be born, she knows she can't manage a career on top of the responsibilities of a large family, so she chooses what, by any measure of Torah standards, is right.[19]

Altein granted her heroines recognition for their actions, not their passivity. While Altein's candid style conceded a note of sympathy for those readers who were beginning to identify with feminism, the main message of her essay was that Lubavitcher women, too, were choosing a different path and deserved support from other women. Altein ridiculed those women in the Orthodox Jewish community who wore short skirts in the fashion of the day, and praised the real grit of those women who chose to dress conservatively. By suggesting that Hasidic women were also "nonconformists" who experienced oppression due to their choices, Altein attempted to grant a measure of countercultural status to the housewives in her own community. And by juxtaposing Hasidism with other alternative movements in a bid for tolerance, Altein also placed Hasidic women in a larger, non-Jewish context.

Appropriately for readers with limited Talmudic learning, the bulk of material written by women for women in *Di Yiddishe Heim* dealt with the practical side of Jewish observance and identity. Mothers candidly addressed the reality of child care and schooling issues, not hesitating to point out where Lubavitcher schools failed their children.[20] Every mother considered herself to be an educator, whether from her experience as a teacher or volunteer in the Lubavitcher schools, or simply because she was the parent most responsible for instilling Hasidic values and behavior at home.

Aside from the overwhelming number of articles on Hasidic parenting, women also contributed learned articles to *Di Yiddishe Heim*, based on their own studies. Most Lubavitcher families summered at bungalow colonies in the Catskills, where guests had the opportunity to study with rabbis in special lecture series or tutorials. Often men remained in the city to work in the summer, joining their families only for weekends. This summer experience in

communities where women outnumbered men permitted some women to engage in personal tutorials with rabbis over several weeks.[21] From these vacation courses, women gleaned additional understanding of Hasidic history and theology and contributed a variety of essays to *Di Yiddishe Heim* on religious topics. These essays most frequently dealt with the laws of marriage, prayer, and household, responsibilities Lubavitcher women took very seriously and were eager to impart to peers or to the newly observant.

During the early 1970s, *Di Yiddishe Heim* began to publish both religious and satirical essays on the issue of feminism. Both men and women wrote along these lines, but the most appealing new voice came from the *baalot teshuvah*—women who had embraced Hasidism as adults, women with secular college educations. This new group of writers created a fresh perspective for *Di Yiddishe Heim* by providing articles on their own adjustment process in the Crown Heights community. Such women presented an enthusiastic point of view, as all of Lubavitch was new to them. As relative outsiders, they were also able to offer criticisms of the Crown Heights social structure while simultaneously comparing it favorably to the secular world they had recently abandoned.

Drawing new strength from its *baalot teshuvah* population, *Di Yiddishe Heim* featured original material by a variety of articulate women who had traded secularism for Hasidism. Such articles followed two patterns: confessional, describing the *baalat teshuvah*'s unhappy past and controversial experiences in various secular contexts; or inspirational, lauding the Rebbe and the Crown Heights community as models of true Jewish committment in an era of rampant atheism. *Di Yiddishe Heim*'s format allowed readers to chart the progress of some newcomers to Lubavitch; in a few cases, the appearance of several articles by the same author over time demonstrated her gradual socialization into and acceptance of Lubavitcher norms, including acceptance of Jewish separatism from non-Jews. Those *baalot teshuvah* who brought progressive politics with them at the onset of their religious transformation soon adopted the one-party platform of allegiance to the Rebbe. *Di Yiddishe Heim* is a most useful document for studying this phenomenon of conversion to group values.

The work of Esther Stern is a perfect example of one *baalat teshuvah*'s conversion to a Jewish separatist viewpoint, as seen through the pages of *Di Yiddishe Heim*. Stern first visited Crown Heights as a college student in 1967, and was both fascinated with and repelled by Lubavitch worship. After a period of resistance to

Orthodoxy, Stern moved to Crown Heights, became a *baalat teshuvah*, and married a young man from a similar background. Between 1972 and 1981 Stern contributed no less than thirteen articles to *Di Yiddishe Heim*, beginning with anecdotes on her own experiences as a newcomer, and eventually writing sophisticated commentaries on the nature of prayer. Stern wrote honestly and touchingly about having to dismiss non-Lubavitcher activities from her life, her mixed feelings about her parents and upbringing, and her efforts to raise her own children according to the strictest of Lubavitch standards. The Esther Stern series provides rare insight into the self-image of a modern *baalat teshuvah*, and is but one example of the ways in which *Di Yiddishe Heim* acted as a barometer for psychological and social trends in the women's community.

In her first article, "A Rock of Strength," which appeared in the Spring 1972 isssue of *Di Yiddishe Heim*, Stern wrote about her very first encounter with Lubavitch. At the time of this writing she had been a Lubavitcher for nearly five years, and felt sufficiently secure in her chosen community to speak about her initial trepidation.

> As a liberal, American-Jewish college student, a member of NAACP and CORE, how did I find myself at a Chassidic table on this Friday evening, listening to my hostess go on about her plans for me to become totally religious! . . . This is a farce . . . Quit college to learn Torah? . . . Could never marry one of these fellows, much too serious . . .[22]

Stern felt the greatest unhappiness at the prospect of abandoning her secular education.

> I was churning inside, angry at her blithe dismissal of my richly enjoyed college studies, and upset . . . I would seemingly have to make an abrupt and clean break with my past.[23]

But, moved by the close-knit community, and by the timeless pageantry of synagogue worship and celebration at 770, Stern became convinced that sacrificing her past would be possible—with the Rebbe's guidance. Her first essay ended with complete acceptance of the Rebbe's role in her spiritual transformation: "I would have the Rebbe's help all the way."[24]

Like many newcomers, Stern appeared to elect commitment to Jewish observance not so much through a matured faith in God,

but because of the charisma of the Rebbe and the warmth of family-oriented Crown Heights. Her attraction to Lubavitch was primarily social. These social motives are a constant theme in the research on *baalot teshuvah* conducted by Debra Kaufman and Lynn Davidman. Kaufman interviewed *baalot teshuvah* whose comments on why they became religious included "The people had such faith in me, even though I was so ambivalent," and "I liked being with the Orthodox people . . . and the rebbetzin, she was incredible . . . spiritual, learned, capable. I wanted to be like her . . . to be so sure of myself."[25]

Certainly women are socialized, both in Hasidic and Gentile cultures, to respond primarily to others' needs rather than to comprehend religious mysticism. One must not overestimate the role of religious comprehension in Hasidic faith. Rabbinic doctrine dictates that it is appropriate to observe the Jewish commandments even if one does not yet believe or comprehend, for in acting, one may come to acquire faith.[26] The Rebbe's standard approach to anguished young Jews, who felt they should not become observant until they understood and believed in each ritual, was to offer a scientific analogy: one does not indefinitely postpone eating until one studies and understands higher nutrition principles, for one would starve. Hasidism teaches that the soul, too, needs immediate and continuous nourishment.[27]

By 1974, Esther Stern had given birth to two sons and moved into a house in the Rebbe's neighborhood. Proud to be a full member of the community, she daringly wrote her second article in *Di Yiddishe Heim* on the increasing problem of white flight, which had induced numerous Jewish families to abandon Crown Heights. Stern upheld the need to coexist with black residents in order to retain the Hasidic toehold in the area; she called those Jews who had relocated to white suburbs "cowards." Her 1974 article praised the attributes of Jewish life in Crown Heights, pointing to the neighborhood's rich Jewish immigrant history and unique Hasidic environment (*shtiblach* on every corner). Rather than capitulating to exaggerated fears of crime and antagonism, Stern suggested, Jewish residents should involve themselves in the voluntary municipal committees and renovation campaigns organized by Lubavitchers. She also hinted that interracial cooperation could only enhance Crown Heights' image in the press.[28] Written in 1974, these words revealed the brewing racial conflict that would explode fifteen years later. In some ways, Stern's approach could be interpreted as a plea for coalition work.

However, Stern herself had undergone many changes in perspective. Her 1974 article demonstrated the subtle transformation of the former CORE activist into Hasidic-identified writer. While she criticized the departure of Orthodox families from Crown Heights, Stern rationalized:

> If we know that we are in *golus* and our numbers seem few compared to the people around us, what difference does it make if these neighbors are Italian, Irish, Spanish, or black? We have to live in *golus* no matter where we are.[29]

The tone of such words represented a dramatic departure from the ideals Stern had brought to Crown Heights in 1967. By 1974 she had adopted the full Lubavitcher outlook on *golus*, or Jewish exile, believing that tolerating a non-Jewish majority in the surrounding society must suffice until the inevitable coming of the Messiah. With this belief guiding her pen, Stern portrayed the non-Jewish residents of Crown Heights as part of the burden of exile, and justified her prescription for urban cooperation with a reminder that anywhere outside of Israel Jews must endure the non-Jewish majority. This leap of faith marked the transition from liberal to religious isolationist: Stern had assumed the "we" and "they" outlook employed by many Hasidim.

Soon afterward, in the summer of 1974, Stern wrote "What Might Have Been" for *Di Yiddishe Heim*, and in this extraordinary article completely denounced her college experience. Now an enthusiastic outreach activist for Lubavitch herself, Stern wondered what had become of the other radical Jewish students she had associated with as an undergraduate. She mourned their probable apathy toward Judaism and regretted her own college career as "a total freak." That she and her peers had "gone astray on a college campus" she attributed to ". . . the all-pervasive hedonism of the college campus today," the ". . . two-fisted assault on Torah values one faces in the college classrooms," the ". . . lack of modesty, the almost Dionysian revel of all your classmates," the ". . . secular hedonistic values."[30] Unconsciously, Stern employed a contradictory writing style found in many *baalot teshuvah* confessions. She used language learned from secular higher education, such as the phrase "Dionysian," to illustrate her contempt for secular higher education.

The break with her past was complete. She regretted that she herself had not been a Chabad representative in the late 1960s,

capable of directing her wayward peers out of the university and into Crown Heights.

A new *baalat teshuvah* was always in search of ways to demonstrate her Orthodoxy, and proselytizing was one of two acceptable routes. The other was childbearing. In her most revealing article for *Di Yiddishe Heim*, "Yossie Goes to Yeshiva," which was published in 1975, Stern described the process of selecting a school for her sons—a school that reflected not her own personal standards, but those of the community. Stern and her husband, who was also a *baal teshuvah*, enrolled their children in a *yeshiva* where no secular subjects were taught.

> It is the unique Yeshiva my son attends, where Torah is studied all day long with dedication and zest, which is turning this child, born of American, Baalei Teshuveh parents, into a Chassidishe, G-d-fearing Jew. . . . But when the time came to enroll Yossie, it began to shock me that my own son would not be taught any English subjects at all.[31]

Stern confessed that she still did not feel assimilated into the Hasidic community and was well aware of her deep-down, pleasurable memories of English education. But these conflicts had, in fact, prompted her selection of Yossie's strictly Lubavitcher school. Her sense of being an outsider only fueled her determination to ensure that her children would be full-fledged Hasidim; she regretted her own inability to provide this religious tutoring. "As a Baal-Teshuvah . . . I am unsure of myself in many areas of halacha, unable to give the answers to many of the boys' questions, and somehow tainted to a certain extent by a secularist, material view."[32] Stern expressed her fears that this well-intended schooling would actually alienate her sons from their parents: "After all, who wants a mother who studied Rousseau instead of the Rambam, l'havdil?"[33]

Stern's compromise in enrolling her son in a non-English-speaking *yeshiva* was that she reserved for herself the role of English tutor. Thus, she transformed her otherwise questionable background in secular education into an acceptable skill for furthering family needs. She proudly noted that her efforts were probably superfluous, as her son was already teaching himself English by reading food packages aloud at the table. She concluded frankly, "I want him to bridge the gap into a world I have just broken into."[34]

This phenomenon of a five-year-old boy outranking his college-educated mother in community status is part of the *baalat*

teshuvah's lot. Stern acknowledged her son's superiority with gratitude as well as fear, knowing that his performance in a demanding *yeshiva* would affirm her own Lubavitcher motherhood credentials. The stricter the *yeshiva*, the fewer secular subjects taught, the more sincere the *baalat teshuvah* parent appeared in the eyes of the community—and in the eyes of the Rebbe. Eight years after joining the world of Crown Heights, Stern had narrowed the range of topics and issues in her home to exclude almost all of the racial-integration ideals she had explored pre-Lubavitch.

Perhaps fired by the idea of keeping pace with her sons' religious studies, Stern began to contribute more learned articles to *Di Yiddishe Heim* in 1977 and wrote interpretations of morning prayers, faith, and modesty through 1980. She advised new *baalot teshuvah* to form discussion groups to assure the correct resolution of religious and marital questions. She warned women to be "scrupulous about what we read and what we see, about weeding out the immoral teachings of today's society from our lives."[35] Stern also outlined possible outreach projects for other activists, mocking her own misdirection as a college student.

Esther Stern was but one writer whose contributions to *Di Yiddishe Heim* demonstrated the gradual commitment to group ideals in a newcomer to Lubavitch Hasidism. The *baalat teshuvah*'s eagerness to make up for lost time by negating non-Hasidic influences in her life differed from the zeal of the lifelong Lubavitcher, but both types of adherents readily affirmed what they perceived as the superiority of Lubavitcher culture.[36]

Satire

Although its format was serious, *Di Yiddishe Heim* regularly included humorous pieces, almost all of which were contributed by an author named Felice Lieberman Blau. Blau wrote thirteen satires in prose and poetry form for *Di Yiddishe Heim* between 1960 and 1975. The titles of these works reflect her role as resident humorist: "Trials of a Teacher," "Keeping Up with the Schwartzes," "Shenanigans of a Shadchunte," "A Teacher on a Pro-Teen Diet," "The Pharoah of Fashion," "Of Yiddishe Mommas," "Summer CAMPaigns," "Baby Talk 'n' Kid Stuff," and a long antifeminist poem, "Women's Lib. Oration." Because of the lighthearted treatment Blau gave to otherwise crucial women's issues in Jewish law, her essays were almost always reserved for the last pages of the

issue she appeared in. *Di Yiddishe Heim*'s editors expected readers first to study the serious rabbinical lessons presented in the main portion of the magazine, but as "dessert," Blau's satires elicited a knowing chuckle and left readers well-satisfied.

Editor Rachel Altein praised Blau as "an extremely gifted teacher, who taught in girls' *yeshivos*."[37] And, indeed, much of Blau's writing reflected her amused exasperation with the unruly conduct of students and teenagers in general. Blau's obvious affection for mischievous Lubavitcher children lent important and relaxing realism to the pages of a magazine where impeccable motherhood was a constant theme. By observing the quizzical or wry moments in the lives of adolescents around her, Blau provided one of the few glimpses into the intersection of strictly religious and normative American teen behavior. With her clever wordplay technique, Blau also blended English, Yiddish, Hebrew, and American slang references into painful puns, much amusing her peers whose literary skills were not as glib, and allowing other readers to identify with the multilingual humor of Jewish culture.

Despite her preference for satirizing recreational or juvenile scenes in Lubavitch life, Blau was also ardently opposed to feminism and on occasion turned her very sharp pen toward this issue. As early as 1966, she was satirizing the American women's movement, then in its beginning stages of political development. In one of her only serious essays for *Di Yiddishe Heim*, Blau asked "Is the Aishes Chayil Disappearing?" She explored the sense of inferiority many Jewish women felt and traced it to the exclusion of women from central Jewish rituals. Blau did not deny the difficulty of the Orthodox woman's lot, and stated outright that many peerless Lubavitcher women nonetheless had concerns about their role in religious observance.

> How come a man blesses daily "shelo asani isha," "Who did not make me a woman"? Doesn't this indicate that his counterpart is a mere nothing in the universal scheme of things? Does not the blessing a woman makes: "Who made me according to His will," seem to express a spirit of resignation and submission? Is this not proof of the inferiority of woman? . . . And so the lesson is hammered home to the woman, on many days and in countless ways.[38]

Having constructed a deliberately provocative outlook, Blau then dismantled feminist interpretations of woman's inferior status

in Judaism. Her article went on to praise the modesty of Jewish women, the extra portion of understanding with which women might face their role responsibilities, the "greatness" of a woman's exemption from study so that she might better run her household. And Blau ruthlessly criticized those women who had sought success in the business and professional worlds, ascribing their ambitions to "unwarranted complexes of inferiority. It was this dangerous state of mind that drove her out of the house and home in the first place, to compete with man and 'prove' her value."[39] Blau blamed equal rights movements for transforming the once-distinctive Jewish woman into an unrecognizable imitation of man. Unlike Rachel Altein, who had emphasized Jewish women's ability to succeed in any career, but stressed the correctness of choosing motherhood, Blau intimated that a Jewish woman's professional success was a mere sham, a "temporary trick." Her underlying message was that women preferred the rewards of motherhood, which were eternal, to the rewards of commercial success, which were temporary.[40]

After this brief turn at straightforward writing, Blau returned to satire, but continued to snipe at the women's movement. By 1971, the rhetoric of feminism was familiar to most *Di Yiddishe Heim* authors, who denounced the movement as the antithesis of Hasidic, divinely ordained sex roles. Blau's love of wordplay and contempt for feminists made her the perfect featured contributor in the early 1970s, and her most exhaustive antifeminist piece appeared in 1970 as a two-page poem. This satire revealed the level of personal hostility many Lubavitcher women felt for the growing feminist movement. Blau's "Women's Lib. Oration" was the longest poem ever to appear in *Di Yiddishe Heim*. One stanza asserted:

> . . . It is not for the legislature
> To redesign the laws of nature
> For doing diapers and fixing barrettes
> Is better than being suffragettes
> The women have unleashed a nest like Pandora
> Generations to come will surely deplore her
> Deep down she wants the movement to fail
> To be once again subdued, to be fragile and frail.[41]

Blau tackled the full spectrum of popular feminist issues in her satire: suffrage, petitions, and statistics on discrimination, non-

traditional occupations for women, equal pay. But her emphasis was on the negative tone of feminism: what she perceived to be antimarriage or antimale crusades and trivial demands for symbolic change.

The disparity between the perspectives of Altein, Stern, and Blau demonstrates that there was no uniform style of rhetoric on feminism in Lubavitch, and no uniform approach to such issues in *Di Yiddishe Heim*. Each author in the magazine selected her own means of justifying the role assigned to women in Judaism. Stern gave her readers a glimpse into a confusing secular world with too many options; Altein acknowledged that the women of Lubavitch were capable of any role but rightfully settled on the one Judaism required; Blau ridiculed everything in her path, and was therefore all the more merciless toward the women's movement.

These three women in no way complete the vast repertoire of female (and male) personalities in Lubavitch writing. They do, however, represent a typical cross-section of those women moved to write for *Di Yiddishe Heim* in the first thirty years of the magazine's history. As *baalat teshuvah*, influential Rebetzin, and young teacher, respectively, Stern, Altein, and Blau used their literary talents to defend the righteousness of Hasidism and the supremacy of the Rebbe. Their differing styles and backgrounds did not detract from their uniform goal of upholding Lubavitcher ethics; indeed, their writings demonstrated the many unique ways there were for Lubavitcher women to express the same ideals. Poetry, satire, editorial, scholarly essay; all literary forms were suitable for conveying the spiritual message to readers. By providing such variety, *Di Yiddishe Heim* appealed to a wide range of tastes, as well as indicating to potential contributors that all voices had a place in the magazine's agenda.

By the 1980s, *Di Yiddishe Heim* had become a glossy, contemporary-looking magazine, thanks to the introduction of computer graphics and other printing innovations. Content, however, remained consistent with old goals. More than ever, articles focused on the coming of the Messiah, the problem of integrating *baalot teshuvah* into the growing Crown Heights community, and the fight against assimilation. Far more articles were written by women who had experienced professional success in a mainstream American career before embracing Hasidism.[42] These women drew heavily on their experiences in the secular world to illustrate their points on Lubavitcher philosophy and meaning. In contrast to this rather sophisticated genre, those articles written by "lifetime"

Lubavitcher women were frequently self-mocking depictions of domestic life, often relegated to the end pages as Felice Blau's pieces had been.

Thus, while male authors continued to contribute interpretive articles on the nature of Lubavitcher customs, ethics, and prayers, women writers split into two categories that were often distinguished by differences of class as well as religious background. On the one hand, the *baalat teshuvah* writer might be a physician, journalist, artist, or performer, who possessed one or more academic degrees, had traveled widely, and enjoyed a moderately high income with no child-care expenses. The "lifer," on the other hand, wrote realistically and wittily of the unglamour in a traditional Lubavitcher woman's home life. Throughout the 1980s, this ironic disparity was evident both in women's writing and in general outreach policy to adult women. Glamorous women, such as successful *baalot teshuvah*, were used to promote the value of an unglamorous lifestyle, and were frequently more visible than women from the oldest Lubavitch families.

Di Yiddishe Heim, for all its quirks and shortcomings, offered something for everyone, at every stage of religious consciousness. For the Crown Heights woman, it provided an opportunity to write, to commit her particular experiences as a Lubavitcher woman to print. For Lubavitcher women on *shlichus* (missions) in distant outposts, the magazine provided warm glimpses of normal Lubavitcher life back home in Brooklyn—and as a vehicle for carrying the messages of the Rebbe to women across the country, *Di Yiddishe Heim* kept Lubavitchers in distant communities apprised of the priorities at 770 Eastern Parkway. For women new to Lubavitch, stories by other *baalot teshuvah* provided encouraging insights and advice, and the magazine's essays on the history and philosophy of Chabad were reliable sources of remedial Lubavitch education. For young mothers struggling with child-rearing responsibilities, both the humorous housewife pieces in *Di Yiddishe Heim* and the more serious articles on the female role in Judaism were uplifting messages, easily read in five-minute snatches of time between domestic demands.

Finally, the high-quality articles and reprints from scholarly rabbis circulated a broad range of translations from the Rebbe's talks to male and female readers, making *Di Yiddishe Heim* more of a family magazine than one entirely restricted to women. The title, "The Jewish Home," reflected such a goal. In Lubavitch, women were universally portrayed within the context of family

life. To discuss womanhood or women's issues without the framework of husband, children, and home would be pointless. It was therefore inevitable that the magazine intended as a forum for women gradually incorporated the voices of men: husbands, fathers, teachers, also with an investment in the home and family. The presence of articles by men also familiarized women readers with the male world of scholarly discourse and the historical continuum of male leadership in Lubavitch Hasidism. Statistically, it would appear that in *Di Yiddishe Heim*, as in every other area of female life in Lubavitcher culture, the presence of that male voice ultimately altered and defined the nature of what was female. Yet the broader goals of the magazine entailed an inevitable cooperation and symbiosis between male legal interpretation and female practical application of Lubavitcher principles.

FIVE

"Azoy Vi Es Goyet Zich Azoy Yiddelt Zich" Whatever Is Happening in the Gentile World Is Reflected in the Jewish World: Reactions to Feminism

> *It is almost an insult to our beautiful way of life to assume that we are threatened by anything and everything said by the so-called Women's Liberationists. There is no question that this is a viciously destructive movement to all family structure.*[1]
>
> *One might think that the increased Jewish feminist awareness of the past decade, corresponding to the general "women's movement," would be met with opposition in Torah circles. However, the recognition of the importance of the woman . . . has been welcomed, for actually, the Torah gives the Jewish woman a lofty status. The times are ripe for a deeper look into the essence of Jewish womanhood.*[2]

Has feminism liberalized or marginalized the Lubavitcher community? The passages cited above illustrate a deep degree of conflict within Lubavitcher and Orthodox circles on how best to confront American feminist thought.

On the one hand, the American feminist movement's support of nontraditional sex roles and nontraditional family structures threatened the very core of Jewish law and custom. Rigidly defined sex roles are an intrinsic part of Hasidic belief and practice, and feminism, in suggesting that such roles were outmoded and oppressive, met with particularly vehement opposition from the Lubavitchers. On the other hand, the fresh interest in women's studies

and women's history generated by the American feminist movement inspired countless Jewish women to reclaim the cultural identity of their foremothers. Feminism, curiously, led some women back to Orthodoxy.

Exploration of race, class, and ethnic identity politics within feminist activism of the 1970s and 1980s resulted in Jewish feminist groups on both the West and East coasts. These feminist *chavurot* attracted spiritually motivated individuals who met for study, celebration, and socializing. Whether they were rediscovering or critiquing the tenets of Judaism, Jewish feminists were engaged in ongoing dialogue on the nature of the Jewish experience and woman's role therein. This development naturally delighted Lubavitcher outreach activists, whose goal was to break through American Jewish apathy. For Lubavitcher women, the feminist movement, though initially distasteful and intimidating, provided new proselytizing opportunities. Speaking to women who were already interested in Jewish women's history and heritage, Lubavitcher activists found it easier to raise issues of faith, or to introduce Hasidic views on woman's role in Judaism.

What were Lubavitcher women's personal reactions to the American feminist movement between 1959 and 1990? I have identified three stages of response:

1. Initial derision and mockery of "women's libbers" as strident outsiders irrelevant to Jewish life.
2. Growing conflict among Lubavitcher women about voicing their own needs for greater male support and assistance in the domestic sphere.
3. Belief that Jewish women were attracted to feminism only because of their ignorance and stereotypes about traditional sex roles in Judaism. And this conclusion resulted in a massive educational drive by Lubavitcher women, and numerous publications directly refuting feminist theory.

Throughout each stage of response, one may see the gradual influence of feminist thought on the Lubavitcher women's community, as the very women who criticized feminism struggled with their own resentment at being tied to the home. As the economic opportunities for women broadened in U.S. society, due in large part to lobbying campaigns by feminists, Lubavitcher activists found more and more professionally powerful women among the population they wished to educate. Where Lubavitcher women suc-

ceeded in convincing these professionals to embrace Hasidism, we find career women who became prolific anticareerist writers. This irony will be explored later in the chapter.

The feminist movement's initial attack on established religious structures and patriarchal religious institutions appeared to the Hasidic community as just one more vehicle for anti-Semitism. Indeed, Jew-baiting within progressive feminist and leftist movements, not to mention the radical Black Muslim and Nation of Islam movements, remains a significant problem. But it is important to distinguish between overtly malicious anti-Semitism and that which stems from ignorance, or from more serious critique. This distinction was complicated by the emergence of critical feminist scholarship on women and religion, scholarship that frankly addressed sex-role limitations in Jewish law as well as in Christianity and Islam.

Anti-Judaism in the feminist movement, both calculated and unintentional, certainly informed Hasidic response, especially because of the Hasid's sensitivity to religious criticism. In the Lubavitcher community, only one or two generations removed from religious suppression and exile under Soviet rule, the association of feminism with socialist causes also created anxiety and reaction. Hence, it is important to understand that Lubavitcher responses to feminism and feminists were based only partly on what feminist theory had to say about women.

LIBERATION WITHIN MARRIAGE: THE COMMUNITY DIALOGUE

The economic roles for men and women in Judaism differ from those in other sex-role-defined cultures. For centuries, the Jewish woman worked to support her family, thereby permitting her husband to reserve a portion of his time for the study of Torah. The Lubavitcher Rebbe himself noted the important function of working women in Hasidic culture:

> What is false is to replace women's sacred mission with the ideal that having a business or professional career is a goal for itself. But as a means of furthering Torah study, for example, there is a long Jewish tradition of women working to allow their husbands to devote themselves totally to studying Torah.[3]

Under appropriate circumstances, therefore, the working woman in Lubavitch won approval instead of rebuke. But the male Hasid, too, traditionally viewed his vocational role as secondary to his religious studies, which continued throughout his adult life.[4] Earning a living, for men, became a mere means to economic survival, and quite separate from their spiritual schedule of responsibilities. Any discussion of equal career rights for women must be seen in relation to Lubavitcher men's lack of emphasis on career identities for themselves.

Regardless of their mutual disparagement of professional aspirations, and mutual acceptance of economic obligation, Lubavitcher men and women assumed divergent roles within the home. The greater obligation of study borne by the male precluded his involvement in the trivial repetitions of housework. For the male to use his spare time assisting in the female domain of domestic work and child care would be *bittul Torah*, a waste of the time better spent in study. The woman who freed her husband for such extra study time accrued honor for her passive contribution to the process of Torah learning. Her role in enabling male piety was respected by the community, which profited from her husband's erudition and reputation.

During the late 1950s and early 1960s, Lubavitcher women nonetheless began to discuss the conflict they felt between their need for more assistance with housework and child care and their desire not to burden a scholarly husband with chores unbefitting his stature. While women throughout disparate sectors of U.S. society were raising the same questions, in Crown Heights the new outlet for female opinion was *Di Yiddishe Heim*. Its quarterly publication broke down the isolation between women in Lubavitcher households and permitted them to speak out on a number of issues and to draw support from one another. I have suggested that the design of *Di Yiddishe Heim*, like that of other women's magazines, provided a variety of short features that the busy homemaker might read in installments between chores and errands. Yet the omnipresent male perspective in the pages of *Di Yiddishe Heim* ensured that women's essays on the burdens of housework were frequently answered with rabbinical reprimands by male authors.

As early as the third issue of *Di Yiddishe Heim*, which appeared in the summer of 1959, an article by a Rabbi Hodacov belittled Jewish men who assisted with housework.

> Women boast of how good their husbands are, how much they help with the housework. . . . But when the emergency help

becomes a permanent thing, it is easy to forget the price that is paid for it. He may have washed the dishes, but he has not refined his qualities . . . by his study of the Torah; the loss is far greater than the gain.[5]

Women with real grievances of poverty and overwork at home were naturally reluctant to complain about dishwashing when the response from community leaders was that the Messiah would come through study, not through domestic cooperation. One recalls the cry of the desperate mother in Anzia Yezierska's *The Bread Givers*, who tells her scholarly husband, "You're so busy working for Heaven that I have to suffer here such bitter hell."[6] And rabbinical rhetoric about the sanctity of the household sphere proved fickle. Women's work lost its supposed religious importance when men participated in it.

Despite the possibility of reproval, Lubavitcher women wrote to *Di Yiddishe Heim* throughout the 1960s and 1970s, timidly expressing their need to get out of the house on occasion, as well as their intellectual frustration. The possibility of anonymity in submitting such letters permitted individuals to speak out where they had hitherto been reluctant to raise issues. One woman wrote:

My mind wanders back to the goals and thoughts of my "idealistic" youth, although I am still considered young. I guess many "girls" my age face this "age of confusion," a sort of settling down to reality—a plunge into physical activities—a systemizing of diaper pails, hem fixing, tights darning, listening to endless stories of schooltime incidents—Enough is enough— my brain is rotting— a meeting—a simchah, anything! I must get out of the house or I'll bust![7]

The author of this letter went on to say that she had discussed "the problem" with her husband, a self-described old-fashioned Russian Hasid, who apparently blamed American society for the "materialism" that prevented young Hasidic mothers from focusing on the purely spiritual aspects of motherhood.[8] When her letter appeared in *Di Yiddishe Heim*, it was paired with a response from a Lubavitcher rabbi in Pittsburgh, who advised that the young mother should devote more time to helping others. The rabbi declared:

Your embittered feeling may actually be a blessing in disguise that can give you the strong drive necessary to go out and do

something for others. . . . When was the last time *you* invited a girl to your home to bring her closer to Yiddishkeit? When did you offer to take care of your friend's children so that *she* shouldn't burst?[9]

This response was typical of the advice that male community authorities offered to exhausted young mothers. These authorities either superficially acknowledged or tactfully glossed over the housewife's frustration, but the final response remained the same: become more involved, more committed, as a Lubavitch representative or religious outreach worker. Add more plates to the Shabbos table, house more guests, cook more, bring the world *in*. The idea of creating more free time for women was simply never discussed. Rather, changing the nature of woman's work to incorporate more responsibilities became the rallying cry of the Chabad movement in the 1960s and 1970s.

Certainly, outreach work did bring women out of the home and into the public sphere. Yet the accompanying problems of arranging child care, pacifying a husband who wanted his dinner, and the guilt over neglecting family for community work remained unresolved. The development of the secular feminist movement actually impeded the Lubavitcher woman's pursuit of dialogue on domestic issues, for the inevitable comparison with "women's libbers" made many religious women reluctant to voice protest of any sort. Some female writers, such as Felice Blau, wrote humorously of domestic exhaustion, exposing the Lubavitcher woman's lot through satire and sarcasm. Yet we recall that Blau also produced antifeminist articles such as "Is the Aishes Chayil Disappearing?," in which she scoffed at women's career aspirations.[10] The need to address the homemaker's dilemma without necessarily advocating feminist solutions continued to simmer in the women's community. By 1973, Crown Heights women reached a compromise that permitted the discussion of feminist issues within a traditional and religious context.

In the summer of 1973, a group of Hasidic and Orthodox Jewish women staged their own "consciousness-raising" session at the Camp Emunah facility of Greenfield Park, New York. The twelve participants were of varying ages and backgrounds, and met for two forums on the nature of domestic and marital responsibility versus personal development. These sessions were moderated by a Rebbitzen, and *Di Yiddishe Heim* published summaries of the resulting discussions, with an invitation for readers to submit comments and opinions.[11] The questions under discussion included the following:

- What can be done to improve the husband-wife relationship?
- To what extent can a woman help her husband develop to his greatest potential?
- How can a married woman keep the tempo of self-development from slowing down in married life?
- To what extent is it helpful, harmful, or both for a woman to get involved in outside activities when children are young?
- How can a woman with several babies and a household to clean and manage in general, run everything so she can have some time to call her own?[12]

In her two-part report from the Camp Emunah discussions, Lubavitcher writer Rivka Shusterman began by announcing that the participants were not interested in being identified as feminists.[13] With this disclaimer well-displayed, Shusterman proceeded to summarize the contrasting opinions of the twelve women who had participated in the forum on domestic issues. All agreed that "a wife should try to help her husband develop his potential," but one woman felt that this was permissable at the expense of the woman's own development, while another dismissed the idea of protecting a husband's ego.[14] Older and younger women differed on the housework question as well, with the former regarding housework as inappropriate for their prominent scholarly husbands, whereas newlyweds welcomed the contributions and assistance offered by husbands at home. Too much role reversal, however, disturbed all the participants:

> Someone had read about a woman professor whose husband stayed home to care for the house and children. It was felt that this was an example of the reversal of the sex role which seemed to be a prime factor in the breakdown of the modern family.[15]

Despite their contempt for the concept of house-husband, the women in the discussion group readily acknowledged the need for some women to go out to work. Again, the group was divided, with some participants defending the right of talented women to seek fulfilling work, while others limited the working wife's choices: "She shouldn't indulge in professional shop-talk that excludes her husband. Some of the discussants felt that a wife should not earn more money than her husband under any circumstances."[16]

The concern over a husband's exclusion from shop talk demonstrated an interesting double standard. On the one hand, most women were permanently excluded from their husbands' Talmud discussions because of their own lack of religious learning. Yet this was never considered a slight to women, as the general topics of *mitzvos* and Jewish heritage included and interested them. The non-Hasidic business and professional spheres in American society, on the other hand, often excluded Hasidic men, many of whom devoted their adult lives to study. Thus, a woman who knew more about the Gentile business world than her husband did might subsidize his Torah learning with her income, but she could not insult his importance by discussing her own work identity in the "outside" world.

At this point in Shusterman's article on the summer forum, *Di Yiddishe Heim*'s editor Rachel Altein inserted a lengthy "Editor's Note" in parentheses. Altein steadfastly refuted the notion of going out to work as a solution to feeling bored and isolated at home. She expressed her impatience with prevalent feminist ideals in the following terms:

> The vast majority of the women I know, of all ages, educational background and talents, have been brainwashed into feeling wasted and unhappy about staying home, into believing that keeping house and bringing up children as their sole occupation is a shameful fate worse than death.[17]

Despite Altein's careful monitoring of the article at such theologically sensitive spots, Rivka Shusterman's report on the Camp Emunah sessions revealed some surprising and candid opinions. Shusterman casually reported that "In general, there was agreement that the wife should try to build up her husband's ego because if not, she herself will come to grief."[18] Certainly this reference to domestic grievance and female self-abnegation hints at abusive situations existing within households. Lubavitcher literature stressed the high regard for women in Judaism and in the Jewish home, yet the notion of catering to a husband in order to prevent "grief" points to the possibility of emotionally or even physically hurtful marriages. While there are few sources on domestic abuse in the Lubavitcher community, the sentiments expressed within the "Forum" article raise disturbing questions. In fact, one reader was deeply affected by Shusterman's report, and subsequently wrote an angry letter to *Di Yiddishe Heim*:

> Why must we counter the stridency of Women's Lib with 1950ish advice on nurturing the male ego and pampering the tired hubby as he walks in the door after "putting in a full day's work," and never mind how *you* feel after a whole day in the house with three kids home from school and four unexpected guests in for Yom Tov! Is it really necessary to insist that these are "frum" (religious) attitudes? Can't Yiddishkeit mean mutual respect and interdependence? . . . Let us drop the European modernity of "male chauvinism," the feeling of shame and secrecy implicit in the remarks quoted in your article[19]

The above letter expressed an exasperation felt by many religious women, who saw the Lubavitcher community responding to the threat of encroaching feminism with unnecessarily conservative propaganda. Women who had always worked outside the home, and who had seldom voiced any discontent over their role in Hasidism, felt insulted by the lengths to which the Lubavitcher press went to disassociate itself from anything promoting female equality or independence.

The anonymous writer of the aforementioned letter to *Di Yiddishe Heim* demonstrated that times had changed, even for observant Hasidim, since she criticized 1950s attitudes and male chauvinism. Yet she, too, took care to disassociate herself from the "stridency of Women's Lib." Knowing about women's gains in the Gentile world was one thing; using that knowledge to critique Hasidism was another. Once again, Lubavitcher women, struggling to raise important questions about domestic conditions and marriage roles, felt impeded by the existence of a nonreligious feminist movement to which they were inevitably compared.

Despite the fact that women all over the United States were asking the same questions, Lubavitcher women, reared in a culture of separatism, resisted identifying with non-Jewish housewives, working women, or both. Lubavitcher women—and men—believed that their roles were divinely ordained, and that the only solution to domestic discontent was to look for compromises within a strictly Hasidic format. The proposals by non-Jewish feminists to improve women's lives and marriages by altering or even reversing sex roles seemed blasphemous.

As a result of these theological differences, the distance between Hasidic and non-Hasidic women increased rather than decreased. Non-Hasidic feminists, including many liberal Jewish

women, pointed to Hasidic housewives as examples of victims trapped by hopelessly patriarchal religious institutions, and Lubavitcher women, while cautiously continuing a dialogue on domestic boredom/stress within the pages of *Di Yiddishe Heim*, made sure to disassociate themselves from feminism.

OUTREACH TO JEWISH WOMEN:
THE LUBAVITCHER WOMEN'S PRESS

Both men and women in the Lubavitcher community felt obligated to denounce feminism during the 1960s and 1970s. Most Hasidim believed that the feminist movement was but one more unattractive and amoral facet of the secular culture trying to insinuate itself into the Hasidic community. Yet the feminist movement could not be merely ignored, for more and more American Jewish women were listening to its messages and taking issue with some of the deepest beliefs in Judaism: separate roles for male and female.

How to portray Jewish women's roles as grandly fulfilling? In *Di Yiddishe Heim*'s earliest issues, a short-lived series entitled "Great Women in Jewish History" focused exclusively on the biblical matriarchs and pre-Hasidic heroines. The series did little to transfer traditional images of Jewish women's agency into modern contexts. Aware of such criticism, the author even issued a statement in his own defense, beginning the dialogue of different-but-equal that would characterize Lubavitcher responses to feminism for the next twenty-five years:

> Contrary to the misconception prevailing in many quarters, womanhood and leadership of the people are *not* contradictions in Torah Judaism. Jewish women can be and have been leaders of our people, but in the manner and within the roles assigned to them by the law of the Torah, given by the Creator who created man and women.[20]

Leadership by women, above all, had to be strictly within the limits of *tznius*, or modesty, which circumscribed excessive public appearances or acclaim. The modest and acceptable leadership roles for women included the written word and the example set in one's home. Thus, throughout the 1960s and 1970s, Lubavitcher women were encouraged to demonstrate leadership roles either as writers for *Di Yiddishe Heim* or as hostesses and role models for

visitors interested in becoming observant. Since these paths of activism only led to encounters with persons already attracted to the Lubavitcher way of life, the problem of reaching out to nonobservant women remained. How might other American Jewish women be educated to overcome their misconceptions and stereotypes about ultra-Orthodox customs? How might the Lubavitcher community mobilize to demonstrate the rewards of female status in Judaism?

By the mid-1970s, Lubavitcher women realized that the only way to confront feminist stereotypes about Hasidism was to publicize and explain the innermost details about female religious culture, in a medium capable of reaching and interesting an extended Jewish audience. Betweeen 1976 and 1984, drawing on the talents of many former writers for *Di Yiddishe Heim*, the Lubavitcher Women's Organization published five full-length texts celebrating the role of the Hasidic woman.

The book series began in 1976 with a mild, entertaining, home-style collection of recipes and *kashruth* regulations, entitled *The Spice and Spirit of Kosher Jewish Cooking*. The cookbook represented the collective efforts of dozens of Lubavitcher women, who assembled a concise legal guide to kosher food preparation, a cross-sampling of ethnic variations on similar recipes, and tips on Americanizing kosher products to appeal to children growing up in fast-food culture. The cookbook deliberately introduced Lubavitcher women in a very traditional context: the kitchen sphere.

The cookbook encouraged Jewish women to forge a link between themselves and their grandmothers. But the next book published by the Lubavitcher Women's Organization encouraged women to forge a link between themselves and their daughters. *A Candle of My Own*, a collection of Jewish schoolgirls' essays on the meaning of Shabbos candlelighting, appeared in 1979. It was an extraordinary effort, meant to capitalize on the Rebbe's well-publicized *neshek* campaign by turning candle-lighting stories into a sourcebook on female pride. Rather than discussing the limitations or restrictions inherent in the female role in Judaism, Lubavitcher women seized on the primary weekly ritual reserved for women, and solicited letters from very young girls on the pleasure of being chosen for the divine privilege of candlelighting. *A Candle of My Own* also included instructions on the proper prayers and procedures of Sabbath candlelighting, thus continuing the Rebbe's outreach project of *neshek*. The book contained stories, poems, and photographs from over 100 girls, testifying to the high esteem each

felt on lighting her own candle. Text by Neshei Chabad writers between sections of letters from children dwelt on the ancient tradition that was passed between women, the sense of importance given to each little girl as she welcomed the Sabbath to the family's home, and the power of women's prayer in uniting and sustaining the Jewish family throughout history.

While the majority of the children's contributions came from girls in the Hasidic or Orthodox day schools of greater New York, the book included letters from girls in South America, Canada, and the western United States. The editors also took care to highlight contributions from newly arrived Soviet and Iranian Jewish emigres.[21] Although photographs of the Rebbe appeared discreetly toward the end of the book, the final product was diverse in its images of Jewish community, celebrating the participation of Jewish girls from all ages and denominational backgrounds. One editorial passage by the Lubavitcher Women's Organization declared:

> The little girl who begins lighting Shabbos candles suddenly feels a new sense of importance. *She* has been chosen by the Great Ruler to brighten up *His* world. . . . It is a fact that she is the very first in the family to greet the Shabbos Queen, before her father and brothers, even before her mother (for Mommy must watch her little daughter light her candle, and make sure all goes well, before lighting her own).[22]

The emphasis on satisfaction, status, and women's important role in household religious ritual was one way Neshei Chabad confronted feminist barbs about the lack of significant religious roles for Hasidic women. At the same time, however, Lubavitcher women were at work on another book, *Return to Roots*, which was a straightforward account of the growth of Neshei Chabad in Europe. This text was also published in 1979, and contained photographs, documents, and reprints of the Rebbe's speeches from British Neshei Chabad conventions and other outreach programs throughout Western Europe. For the first time, a major publication based entirely on the organizational and outreach capacities of Lubavitcher women was available, to demonstrate the breadth of the female community role and success in proselytizing. *Return to Roots* was much more of a display case for the Rebbe's specific platforms than the preceding books had been. While impressive in its documentation of Neshei Chabad accompolishments abroad, *Return to Roots* served as a community organizational scrapbook,

rather than a text directed at unifying Jewish women outside of Lubavitcher culture.

It was not until 1981 that the Lubavitcher Women's Organization took on the American feminist movement in a frank, footnoted, comprehensive anthology entitled *The Modern Jewish Woman: A Unique Perspective*. This book contained thirty essays on the nature of the female role in traditional Judaism—marriage, the husband-wife relationship, sex and the laws of *niddah*, career versus motherhood, birth control, modesty, women's spirituality, and other issues about which non-Hasidic Jews often had questions. Only four of the thirty essays were by rabbis, including a statement by the Rebbe; a surprising ratio, considering the trend toward male dominance in *Di Yiddishe Heim*. Even the book's introduction made it clear that "This book has been written primarily by women for women."[23] The editors emphatically insisted that the book be used to provide an accurate portrait of intimate issues in the lives of Hasidic women, in order to disprove prevalent stereotypes about their lives.

> Ignorance is the greatest enemy of the Jewish people; misconceptions and outright myths about the Jewish woman have prevailed until very recently, turning many women away from an appreciation of Torah and from accepting a Jewish lifestyle. It is of crucial importance that valid, thorough information be available on this subject.[24]

The structure of the book deliberately led readers through a Jewish order of life-stage topics and units, proceeding from articles on the woman as individual to articles on couples, childbearing, child rearing, and reflections on the Jewish woman in history. Throughout the book, authors confronted the secular concept of modernity and liberation with the parallel of Jewish culture and its history. One woman stressed that Judaism had no need for the sexual revolution of the 1960s and 1970s, because such a social development was really a reaction to the old morality of Church and Christian doctrine that declared women corrupt and sexuality shameful.[25] Other authors similarly rejected the idea of a "Judeo-Christian" morality in U.S. society, since Judaism and Christianity contained differing perspectives on both the physical and the spiritual realms.[26] One woman suggested that feminist criticism dealt largely with Western sex roles: the male as independent aggressor, the female as passive, dependent victim of machismo—yet these

roles were not consistent with Judaism, which offered different standards of masculinity.[27] Finally, the Rebbe himself scorned feminist criticism of old-fashioned Hasidic women and declared:

> No wife and mother needs to feel chagrined at being dubbed "old-fashioned," or at odds with modern times and modern culture. What "modern culture"? That which produced the Holocaust? The Holocaust of a million Jewish children? . . . It is a sacred duty and eternal merit of every Jewish mother to help replenish this horrible void.[28]

Elsewhere in *The Modern Jewish Woman*, authors made similar points: that Jewish progressivism must be viewed through a separate lens, and judged by a different set of criteria. In view of the genocide of the Holocaust, population control or contraception were doubly inappropriate for the world Jewish community. God would provide; the true believer never permitted financial worries to dictate family size. And within the marriage relationship, the laws prohibiting sex during menstruation were not to be regarded as punitive measures for women, but rather as safeguards for sexual excitement and respect. On this latter point, one woman defined the laws of *niddah* as a built-in guarantor of her privacy and her control over sex.

> While at first I dreaded being *niddah* for fear I'd fall apart for lack of physical contact, I found that I almost didn't want it to end! I experienced a sense of inner strength; of self-respect and autonomy in the relationship which I had never felt before. . . . The laws of Family Purity inevitably force the man to see her not as a sexual object, as someone who is there to satisfy him and his needs, but as a person in her own right.[29]

The Modern Jewish Woman offered articulate arguments to persuade suspicious feminists that Judaism already contained liberated views of women, such as their right to sexual respect and satisfaction. Judaism, the authors maintained, encompassed a religious history that revered women as strong models of faith and integrity, rather than condemning them as temptresses in need of supervision or admonition. Of course, the central purpose of *tzniusdik* (modest) dress and behavior and strictly enforced sex segregation was to prevent any image of female sexuality outside of marriage, and thus it could be argued that modest dress, like the laws

of *niddah*, actually liberated women from sex objectification by any man but her spouse. Significantly, this same rationale is offered by many observant Muslim women in defending hair-covering and veiling.

Although the book was relatively successful in demonstrating the pro-woman elements within traditional Jewish roles, there was no discussion that such roles might be optional. Marriage and childbearing were mandatory stages in the Jewish woman's self-determination.

Then, three years after the publication of *The Modern Jewish Woman*, the Lubavitcher Women's Organization produced its fifth book: the 1984 collection *AURA: A Reader on Jewish Womanhood*. *AURA* contained twenty-one separate essays; but this time, only *five* were actually written by women. Male rabbis contributed over 75 percent of the book's contents, making *AURA* much more in keeping with the format seen in *Di Yiddishe Heim*, as opposed to the by-women-for-women format of *The Modern Jewish Woman*.

AURA had no specific organization. A long section at the end of the book was reserved for a brief history of the Lubavitcher Women's Organization, rules for Sabbath candle lighting, and a spectacularly thorough candle-lighting time schedule for the entire remainder of the twentieth century. Many of the articles by male authors dealt only peripherally with womanhood, focusing instead on issues of concern to all Lubavitcher believers: the coming of Moshiach, the goals of the Lubavitcher Rebbe, the concept of faith, contributions of past Hasidic rabbis, and the meaning of the Jewish holidays. Some rabbis discussed the role of women superficially by concentrating on the special qualities of the three *mitzvot* entrusted to women, or by addressing women's separate legal obligations in light of the divine creation of male and female.

In contrast, the five female authors in *AURA* spoke personally and practically about the meaning of Jewish observance in their daily adult lives. All five were successful professionals: two physicians, two university professors, and a computer analyst. Their perspectives hardly reflected the education backgrounds of average Lubavitcher women reared in Crown Heights; indeed, most of the women authors were not even Crown Heights residents.

As their academic training lent both credence and sophistication to their writings, one may surmise that the five women were chosen to create a female counterpoint to the scholarship of the rabbis. Once again, the Lubavitcher movement used its pool of *baalot teshuvah* professional women to issue an appeal to non-

observant readers. Although secular academic status did not always command respect in Crown Heights, the non-Hasidic readers for whom *AURA* was intended would be impressed by authors' academic bylines. The religious knowledge of the university professors demonstrated that Jewish women might indeed attain a high level of proficiency in Torah. And the women physicians used their status and training to write scathing rebuttals of contraception and population control, claiming that such measures were both anti-Semitic and economically unnecessary.[30] And *AURA* differed from *The Modern Jewish Woman* by refraining from lengthy analysis of secular society. Though authors might indeed live in that outside world, or hold titles or honors bestowed by secular institutions, the *AURA* articles focused inwardly on Hasidic belief and interpretation.

REFUTING FEMINIST THEORY: SHAINA SARA HANDELMAN

One author in particular distinguished herself as a prolific and scholarly writer during Neshei Chabad's campaigns against feminist criticism. Between 1976 and 1984, Shaina Sara Handelman contributed over ten articles to Lubavitcher women's publications, including *Di Yiddishe Heim*, *The Modern Jewish Woman* and *AURA*. Handelman was in many ways typical of the *baalat teshuvah* who turned her literary talents to essays on the righteousness of the Chabad movement, the nature of Jewish womanhood, and glorification of the Lubavitcher Rebbe. Despite her articles for the Lubavitcher press on the emptiness of secular education, Handelman completed her own academic training, and eventually left Crown Heights for a successful career as a university professor.

Handelman's first article for *Di Yiddishe Heim* appeared in 1977. Entitled "The Jewish Woman . . . Three Steps Behind? Judaism and Feminism," it was adapted from a speech she delivered at the Chabad House of Buffalo, New York, in 1976. In this extraordinary essay, Handelman acknowledged the parallel between Jewish and feminist identity: that both Jews and women in Western society live outside of the dominant culture of Christian men and therefore question "the very validity of the culture into which they desire to assimilate."[31] Handelman went on to compare feminist and Jewish separatism, suggesting that both groups maintain a source of power through their apartness from the dominant society

and its misguided standards. For the Jew, this apartness had a long-term spiritual significance: "that of elevating and transforming the world."[32]

In Handelman's argument, the problem of negative identity began when the outsider found herself constantly defined by society's oppressive stereotypes. Jews and women in Western society were forced to reconstruct their identities defensively against the dominant stereotypes, and this merely confirmed the power of Christian and male society to set up negative constructs. Handelman acknowledged the political "passion which comes from a sense of historical injustice done to Jews or women."[33] Yet she asserted that it was not anti-Semitism which defined the Jew, but Torah and faith; whereas feminism had no divine tradition itself and was merely an argument against prevailing ideas about women. Handelman added that feminism had "become a kind of psuedo-religion for many, but has been unable to articulate a larger vision of the world and the person."[34]

Handelman's first article suggested that while mainstream American feminists were still trying to establish a bold new identity, the Jewish woman had no such dilemma, particularly as, historically, "the Jewish woman didn't suffer at the hands of the Jewish man, and the home was never a place of emptiness and repression."[35] This viewpoint fails to acknowledge the many Jewish woman whose marital or domestic experiences did not live up to such rosy generalizations. However, Handelman was hardly alone in defending Jewish sex roles in this manner. Sociologist Lynn Davidman found identical comments among the *baalot teshuvah* students at Bais Chana in Minneapolis.[36]

Echoing themes from other Lubavitcher women's writings on feminism, Handelman conceded that whereas the non-Jewish woman may have needed a feminist antidote to historical oppression, Jewish women were never limited by the dichotomy between goddess and seductress that marked the female image in Christianity. She concluded that most other religious movements emphasized brotherhoods, asceticism, and the separation of spiritual fulfillment from marital relations and female physicality—unlike Judaism, with its emphasis on procreation and the duality of male and female.[37]

In summary, Handelman accepted feminism as an inevitable development for women in Western society, but she denied the need for any such development in Judaism, and lauded traditional Jewish culture as a stronghold of female status. Such an approach

signified a break from other Lubavitcher women's writings, for Handelman both acknowledged and legitimized aspects of non-Jewish Western culture. But Handelman's Jewish bias limited her critique by ignoring ways in which Jewish males did have, and abuse, power over women. Reverent female imagery in Judaism did not preclude, for instance, corrupt divorce proceedings that victimized women, or other events in which Jewish women depended upon male compliance in religious jurisprudence.

In 1977, Handelman contributed a second, far more personal essay to *Di Yiddishe Heim*, describing "Finding Home in Brooklyn"—her own journey back to Orthodoxy and her pleasure in discovering the timeless religious community of Crown Heights. Handelman subtitled this essay "An Encounter with Chabad," dovetailing her own experience with the Lubavitcher outreach movement's "Encounter" programs.[38] It was the only nonscholarly article she contributed to the Lubavitcher women's publications. In the next two years Handelman wrote six articles, most of which dealt with concepts of purity in Hasidism, as explained by the Rebbe or exemplified by women's adherence to religious laws. In two articles, Handelman returned to secular issues. "The Search for Truth," which appeared in *Di Yiddishe Heim* in 1978, discussed the unfulfilling nature of the university and the bleak, disillusioning content of modern science and literature—as compared with the truth contained in Torah study. Here Handelman assumed the standard Hasidic perspective that higher education led to cults, experimentation with missionary Christianity or Eastern mysticism, and the ultimate defection of students from Judaism.

> Secular knowledge very often leads to arrogance. The opposite is the case with the study of Torah, which is absolutely true, and contains all wisdom.[39]

The above passage is typical of a *baalat teshuvah*'s journey through the various stages of accepting Lubavitch Hasidism. Almost all *baalot teshuvah* who wrote for the Lubavitcher women's press at some point issued a denunciation of their secular pasts and secular educations, not unlike political converts in the process of reeducation. Handelman's dichotomy of university as meaningless and Torah as absolute truth occurred midway through her involvement with Lubavitch.

In 1978, in another article entitled "Judaism and Feminism," Handelman also examined what she called "distorted ideas about

Jewish women" in the secular academy.[40] She lamented that Judaism was falsely promoted as an excessively patriarchal religion by secular sociologists and literary critics who wrote from a non-Jewish perspective, or who had limited access to Talmud. Certainly this revealed that Handelman herself had read a variety of works by male and female scholars on the limitations of the female role in Judaism. She urged those women who were "in search of a true religious and feminine identity" to study both written and oral Torah, as well as Hasidic philosophy.[41]

The 1978 article was a difficult and well-done synthesis of Hasidic scholarship and commentary on writings by the Lubavitcher Rebbe. Handelman followed her own advice, and went directly to the sources to satisfy her interest in Lubavitcher definitions of womanhood. Her article proved that there was indeed opportunity for study and expression by observant women. Most important, Handelman demonstrated that she had familiarized herself with both worlds—secular and religious—before choosing to write her own analyses. Her expectation that critics do the same revealed a sense of fair play, rather than any fear of conflicting dialogue.

Handelman's style of writing represented a refreshing break from the male antifeminist voice in Lubavitch, which had dominated *Di Yiddishe Heim* for years. Rather than warning traditional women to stay away from un-Torah-like ideas, she invited feminists to study the very sources they regarded as oppressive, thus extending the presumably patriarchal sphere of scholarship not only to other Jewish women but to non-Jewish feminists as well. For contrast, we see that during the same period *Di Yiddishe Heim* published a viciously antifeminist article by a male author, who, far from depicting Lubavitcher women as potential scholars or as well-informed individuals without need of superfluous liberation, portrayed them as weak and impressionable victims of feminist propaganda.

> The agitation and propaganda from the outside (and the women writers of the movement as well as their many strong adherents know how to speak to the hearts of their feminine comrades extremely well, not unlike the serpent of old) are much too strong and too enticing for the average woman to resist outright.[42]

The author, A. Yerushalmi, lamented the lapse of obedience by women to the will of their husbands, and declared that the com-

munity activity or other public involvement by women inevitably led to the victimization of the husband (lost study time, home a shambles) and the mental collapse of the wife. The author upheld the Hasidic distinction between women as "heart" and men as "head," explaining that this distinction formed the basis for the exclusion of Jewish women from testimony, as "they cannot be fully objective and give a fully objective judgment in court, except in certain rare cases, for in these areas a cool and dispassionate view is needed. Men are more suited for these areas and qualified for them."[43] Yerushalmi charged Jewish community leaders with laxity, reminding them of their responsibility to confront women over the proper limitations of their activities outside the family sphere. While this style of rhetoric was common in *Di Yiddishe Heim*, the popularity and frequent reprinting of Shaina Sara Handelman's works revealed Neshei Chabad's preference for pro-female voices.

Handelman continued to produce woman-identified articles that countered the deprecating style of male Lubavitch writers. By 1981, however, she had also accepted a faculty position at a non-Jewish university, a seemingly abrupt about-face from her earlier belief in the untrustworthiness of secular academia. She continued writing for the Lubavitcher Women's Organization until 1984, contributing several in-depth articles to *The Modern Jewish Woman* and to *AURA: A Reader on Jewish Womanhood*. In each article, Handelman carefully explained the Hasidic rationale for customs and laws affecting women. While Handelman recognized that feminists were unhappy with Hasidism's emphasis on female modesty and the relegation of women to the private sphere, she suggested that a public identity was unnecessary for those who were already deeply committed to a spiritual role. In her discussion of modesty, Handelman explained that a woman's body was not covered through shame, as in Victorian or Puritan traditions, but because

> in the value system of Torah, that which is most precious, most sensitive, most potentially holy is that which is most private—in the spiritual as well as the physical realms. The holiest objects, such as the scrolls of the Torah, are kept covered.[44]

It is flattering to compare woman to Torah, although one cannot miss the connotation that the female body is a holy "object."

Yet the Torah is infinitely more than a physical scroll, too. In many ways, Handelman's writings offer glimpses of the fine line between physicality and spirituality that is the essence of Hasidism.

Shaina Handelman created a new style in Lubavitcher women's rhetoric: a confrontational approach to feminist argument that anticipated women's questions and explained the spiritual basis for Hasidic custom, defining Hasidic culture against the background of Western society's development. Handelman was one of the most effective writers in the Lubavitcher dialogue with modern feminism, for she wrote not as a wife and mother, as did most female authors in *Di Yiddishe Heim*. And she did not write as a cringing *baalat teshuvah*. She wrote as a scholar, and never as an apologist. Significantly, she wrote as an expert in two worlds. This extraordinary combination made her essays valuable resources in the proselytizing literature distributed by Neshei Chabad, despite Handelman's defection later on.

<center>⋐◈⋑</center>

Throughout the 1980s, Lubavitcher activists continued to urge women to explore their Jewish identity: through study groups or classes at *baalot teshuvah* schools, through acceptance of *mikveh* and motherhood responsibilities, through providing a Jewish education for their children. Lubavitcher women's literature remained divided between essays that merely ridiculed feminism in the non-Jewish population, and essays hoping to entice Jewish women away from feminism and into Orthodoxy.

This contrast can be seen clearly in one particular issue of *Di Yiddishe Heim* from the spring of 1982. Two articles printed side by side illustrated contrasting Lubavitcher approaches to American feminism. In "The Jew in Suburban Long Island," author Beatrice Siegal Commack discussed her former career as Vice-President for a chapter of the National Organization for Women, her awareness of the second-class status of women in the business world, and her role in consciousness-raising groups. Commack had spent many years fighting the oppression of women and had dedicated herself to the struggle for women's rights. Then she became involved in the Lubavitcher movement and pronounced it far more personally and spiritually fulfilling than "the folkways and mores of rootless suburbia."[45] She concluded that her pursuit of female equality within the American dream was inappropriate because, as a Jew, her place was in an entirely different culture with its own built-in controls for female status.

In contrast, Bas Chana's article "Beating the Blahs," which began on the very next page, attacked anyone and anything associated with feminism:

> Now I don't want anyone to think that I am a Women's Liberationist. Chas v'shalom, that I be categorized with the strident advance guard of the "Me decade." I certainly want it to be clearly understood that I hold no brief for marches, speeches, and demonstrations devoted to the overthrow of family life. Not me. No, I am definitely not one of them. In over ten years I have not gone out of the house without a stroller. . . . I think that my credentials are impeccable as a family-oriented, traditional woman.[46]

Bas Chana's essay went on to air her feelings of being emotionally drained and intellectually stifled at home—complaints that had led Lubavitcher women to take pen in hand for nearly thirty years. Yet Bas Chana felt the need to preface her dissatisfaction with a disclaimer, not unlike the women who had gathered for the "Forum" at Camp Emunah in 1973. Aware of feminist approaches to and explanations of domestic boredom, Lubavitcher women rushed to ward off possible inferences that they too had joined the "strident advance guard." In this way they defended themselves against both feminists and eagle-eyed community rabbis. In terms of the Lubavitcher outreach movement, however, it is clear that the hostile tone of Bas Chana's article might very well have repelled someone like Beatrice Commack, if, for instance, Commack's first exposure to Neshei Chabad was through the pages of *Di Yiddishe Heim*. It took a rare author such as Shaina Handelman to bridge the gap between Jewish feminists and Lubavitcher Hasidim.

Despite Lubavitcher rejection of everything feminism represented, a more conciliatory tone on feminism prevailed in Lubavitcher women's literature in the 1980s, as outreach activists recognized that the Jewish feminists of today were the *baalot teshuvah* of tomorrow. Finally, the appearance of professional women in Crown Heights—*baalot teshuvah* who owed their professional success and educational opportunities to those advances feminists had helped secure for American women—meant that Lubavitcher publications took on a slick, modern look. Professional women who wrote for the Neshei Chabad texts made a religious message more palatable for wary readers. By using women who had profited from

feminism, but had chosen Torah, to *counter* feminist argument, the Lubavitcher women's community hoped to demonstrate to nonobservant women that true fulfillment and true female status lay in the separate culture of Jewish tradition, which contained its own history of struggle for justice and liberation.

SIX

"M'DARF LEBEN MIT DER ZEIT"
WE MUST LIVE WITH THE TIMES

On August 19, 1991, the golden era of Lubavitcher public relations in America literally crashed to a halt when a car in the Rebbe's motorcade ran a red light and killed a black child in Crown Heights. The ensuing race riots, which included the "revenge" murder of a young Lubavitcher scholar by black youths calling out "Kill the Jew!," introduced a shocked American public to the faces of black-Jewish conflict in urban America. In this struggle for turf, for police protection, for clashing definitions of minority rights and cultural autonomy, the Lubavitchers experienced an unplanned media soundbyte. Their religious apartheid no longer appeared as the behavior of the righteous, but as an unusual extension of white privilege. In short, the Rebbe and his community were accused of racism, late-twentieth-century America's metacrime.

Throughout the early 1990s, powerful critiques of inner-city Hasidic separatism appeared continually in the *New York Times*, and the Crown Heights race riots received a full chapter in Jerome Mintz's 1992 book *Hasidic People*. Critics and sympathizers debated whether the Lubavitchers, an isolated minority group once threatened with extinction, had nonetheless attained sufficient political power to assume preferential treatment by authorities. The painful standoff of 1991 forced Lubavitcher women to vocalize (or deny) their own racism (and their power, as a historically oppressed group, to oppress others).

Extensive interviews with Crown Heights Lubavitchers and their black neighbors eventually found artistic expression in the work of one "outsider," African-American actress Anna Deavere Smith. Her extraordinary one-woman play *Fires in the Mirror*, a series of monolgues representing more than two dozen black and Hasidic men and women, re-created the events of August 1991 as narrative texts. Since 1992 audiences across the United States have marveled at Smith's embodiments of Crown Heights personae. In his own Foreword to Smith's published play, scholar Cornel West pointed out a basic problem in black-Jewish dialogue: "We usually conduct the conversation as if the tensions between Black and Jewish *men* are exactly the same as those between Black and Jewish *women*."[1]

Both men and women of the Crown Heights Lubavitcher community were grappling with hard questions of identity politics, and still fending off investigative reporters, when the Rebbe died in June of 1994. And the unexpected death of the Rebbe, at such a turbulent moment, left all of his followers without a sense of closure.

It is for this reason that I have chosen to address the Lubavitcher community as it existed prior to 1991. In these final pages, I will draw several interlocking circles of postwar Lubavitch history, and examine their discrete meanings. For it was during the golden era of the seventh Rebbe that the women of Crown Heights contributed to new definitions of Lubavitch history, American women's history, and the contested turf stretching from ultra-Orthodoxy to feminism.

An Era of Bringing Moshiach

The Rebbe left behind no designated heir. The personal guidance he dispersed to his global community of followers, for over forty years of postwar change and expansion, remains unmatched by any Hasidic leader. His achievements throughout four decades of leadership were phenomenal: so much so that toward the end, many Lubavitchers saw their Rebbe as the potential Messiah.[2] Certainly, no clear preparations for his successor were made in the Lubavitcher organization. The Rebbe's aide, Rabbi Yehuda Krinsky, denied that the Lubavitchers believed their Rebbe to be the Messiah; yet Rabbi Krinsky himself told the *New York Times*: "Our

sages tell us that the Messiah is a man of flesh and blood who lives among us. In every generation there is a potential Moshiach. If I were asked in this generation who was the most suitable, beyond any question in my mind, it would be the Rebbe."[3]

To comprehend this debate over the Rebbe as Moshiach, we must remember that the years of his counsel were notable for their emphasis on the Messiah, and the slogan "We Want Moshiach Now" appeared in any number of programs, products, and publications. This aggressive preparation for redemption and redeemer shifted the focus away from the Lubavitchers' past and onto a world Jewish future—thus providing an active role for every member of the Lubavitcher community (including women), an approach that could attract other Jews. Although the traditional study of Jewish law and the literature of previous rabbinical sages continued to dominate Lubavitcher education after World War II, the Rebbe's expansion of Lubavitcher goals signified a change from the purely historical emphasis of Judaism to its revival as a means of directly engaging with the present and future. This philosophy of an immediate, living Judaism, relevant to all aspects of personal and political choice, governed the Rebbe's outreach policies, and can be recognized in the following statement from Rachel Altein, editor of *Di Yiddishe Heim*.

> Jewish history has to be different from general history—unless it informs our daily lives, unless it helps us live as better-informed, practicing and believing religious Jews, it is worse than useless. I am so afraid of today's generation relegating our glorious past into just that—interesting *past*—with no relation to the present and future.[4]

At the beginning of the Rebbe's leadership in the 1950s, however, women outreach activists operated with a limited agenda. Initially, there was no point in encouraging young women to leave the college campus for a Lubavitcher *yeshiva*. No *yeshivos* for women existed, and until 1974, there were no comprehensive facilities for adult *baalot teshuvah* education. And, of course, the role of study was always secondary to that of motherhood in a Jewish woman's life. Thus, the female activist's job was to promote the survival of the observant Jewish family in contemporary Western society. Whatever individualism or interest in social change a young woman brought to the Chabad movement was quickly deferred to her higher goal as a family oriented *akeres habayis*.[5]

This inability of Lubavitcher activists to conceptualize a woman's life outside the context of family was the main contrast to the rhetoric of the new American feminist movement. In order to combat that feminist rhetoric more effectively, Lubavitcher women went out into secular society, and used feminists' own tactics against them. It was this appropriation of feminist tools and strategies for the advancement of a counterfeminist cause, without any resultant modernization of the Lubavitcher worldview, that characterized the development of Lubavitcher women's activism in the second half of the twentieth century. The ongoing response to the women's movement by the Rebbe, and his followers, was simply to refute the need for any liberation of Jewish women.[6]

By the late 1960s, population issues framed the debate over women's liberation in Lubavitcher publications, in response to feminist discussion of birth control, reproductive rights, and optional motherhood. The traditional matrilineality of Jewish status meant that Lubavitcher women felt particularly adamant in disparaging intermarriage, birth control, abortion, premarital sex, and non-Orthodox conversion—all of which were seen as barriers to Jewish motherhood and as detractors from the dwindling Jewish population or gene pool. Perpetuating world Jewry through childbearing and child rearing was a Jewish woman's foremost priority. These concerns cemented the two parts of the Rebbe's platform: on the one hand, a call for Judaism; on the other, a call for Jews.

The Lubavitcher Hasidim, like other American Jewish organizations, chose to address both spiritual assimilation and its accompanying demographic trends. But Lubavitcher approaches aggressively linked the survival of an ethnic Jewish population and the survival of traditional Jewish practices. More often than not, the Messianic element in Lubavitcher proselytizing determined policy. The least educated, most stubbornly secular Jew was welcomed as a potential Hasid, since the Rebbe declared that each Jew, no matter how assimilated, carried a *pintele Yid*, or Jewish spark. These sparks had to be redeemed for the sake of the individual's soul—but, more important, to advance the coming of Moshiach. Similarly, giving birth, bringing more Jewish souls into the world, allowed women to fulfill pre-Messianic requirements by adding to the "quota of souls."[7] While the secular American public discussed the benefits of zero population growth and family planning, the Lubavitcher community rushed to counteract such propaganda with its own formula for salvation. And that Jewish population campaign enhanced the Lubavitcher movement's tran-

sition from a sect mourning the losses of the Holocaust to a contemporary movement eagerly replacing those losses in the hope of bringing Moshiach.

COUNTERFEMINISM

As more and more American women left the home sphere to demand participation and equality in the economic and political strata, Lubavitcher women too became more visible. Despite deeply ingrained ideals of modesty and minimal public participation, Lubavitcher outreach workers realized they had to be a visible movement in order to combat prevalent notions about the anachronism of ultra-Orthodoxy. Therefore, while feminists organized conferences and distributed posters on college campuses, Lubavitcher women on *shlichus* (mission) for the Rebbe used the same energetic methods to advance their own cause. Neshei Chabad handed out posters and pamphlets, staffed booths in student unions and fairgrounds, approached women in malls and in subways, led workshops, gave speeches, and sent out mass mailings—with the message of motherhood, *mikveh*, and Torah values.

Was female activism, as encouraged by the Rebbe, a carefully timed counterfeminist tactic? In their own writings, Lubavitcher women denied that they were puppets of the Rebbe's (male) public relations authorities. They confronted, head-on, extremely intimate queries about female stature and spirituality. And they were not reluctant to express, within limits, criticism of their Hasidic menfolk. We have seen that the pages of *Di Yiddishe Heim* often resounded with demands for greater male support. To the extent that the American feminist movement incited all women to discuss isolation in the domestic sphere and the lesser funding allocated to female education, Lubavitcher women certainly joined in asking for assistance and respect. But this never became the equivalent of demanding fundamental *change* in the structure of Hasidic sex roles. Ironically, in preparing for Lubavitcher marriage and motherhood, many *baalot teshuvah* came full circle: they left unfulfilling marriages or college careers in order to "find themselves," and this included returning to (Lubavitcher) school. At Machon Chana, Jewish women were invited to find themselves in a challenging but supportive study program that virtually guaranteed a fulfilling marriage after graduation.

Throughout the 1970s, feminists continued to criticize orga-

nized religion and Lubavitchers continued to criticize feminism. This pitched battle included converts on both sides: formerly Orthodox women denounced Judaism as part of the patriarchal oppression of women, while observant Jewish women who had sampled the feminist movement denounced the lack of family stability/morality presumably caused by changing gender roles. By the 1980s, the continuing presence of *baalot teshuvah* whose own former careers had benefited from hard-won feminist legislation guaranteed a flow of information from the feminist movement to Crown Heights. Those *baalot teshuvah* who remained in touch with non-Orthodox, progressive feminist friends contributed much of the vocabulary of feminism to articles in the Neshei Chabad press. In this manner, an article that was written as an assault on feminism actually familiarized more isolated Lubavitcher readers with the dialogue of feminist campaigns in the outside world— although not always accurately!

But Neshei Chabad was unprepared for Jewish women who embraced *feminist* spirituality and religious ritual in the 1970s and 1980s. Rather than disparaging Jewish traditions, many Jewish feminists formed woman-only prayer groups, woman-identified *havurot*, progressive synagogues. The affirmation of spirituality and ethnicity in cross-cultural women's studies, plus strident Christian fundamentalist political campaigns in the 1980s, led many feminists to examine their Jewish identities and to confront the existence of anti-Semitism in American society.[8] This move toward ethnic and religious Jewish identification was precisely what Lubavitcher women had hoped to engineer among feminists, but the new trend lay in the "wrong" direction, according to Lubavitcher standards: women were electing to reconstruct rituals in accordance with nonsexist, woman-centered frameworks. This represented not only a break with Orthodox tradition, but denial of male authority and interpretation as the core of Judaism.

Lubavitcher women were baffled by Jewish feminists who scorned the finer points of Orthodox practice and philosophy but demanded the right to become ordained rabbis. Jewish feminist demands for full equality of participation in services led other Orthodox leaders to ponder, worriedly, the possible effects of the feminization of the synagogue. With lapsing male membership in congregations across the United States, rabbinical authorities feared that any increase in female control of liturgy would further reduce synagogue attendance by men.[9] Panic in the Orthodox community led to the misapplication of the label "feminist" to any

innovation that seemed to challenge the status quo, and Lubavitcher women too felt the effects of the ongoing debate about deviation from male leadership. That religious and *sheitlach*-wearing women ended up defiled as "feminists" demonstrated the growing conservatism of American Orthodoxy, brought about in part by the revival of an active, vocal Hasidic lobby in the United States and in Israel.

THE IMPOSSIBILITY OF CHANGE: ORTHODOX FEMINISTS

Lubavitcher women have a proud legacy in postwar America. But their expanded activities have been, without exception, guided and sanctioned by the Rebbe and other male authorities. Intolerance toward autonomous women in Orthodox and ultra-Orthodox circles may be seen in the ongoing outrage toward religious Jewish women who seek to form prayer groups at Jerusalem's Western Wall.[10] In Brooklyn, the equivalence of female religious autonomy with "deviant" political feminism came to a head in 1982, when a group of Orthodox women from Brooklyn formed a women-only prayer group called The Flatbush Women's Davening Group. This case tells us much about the limitations on Orthodox Judaism's female sphere. Rather than any attempt to incite reform, the purpose of the Davening Group was simply to allow prayer in a female atmosphere without the traditional barrier of a *mechitzah* between the women and the main service.[11] Although the women never called themselves a *minyan* (the quorum of ten men traditionally required for Jewish services), nor recited the portions of the service customarily led by men, the group was almost instantly attacked. *The Jewish Press*, a right-wing Orthodox newspaper based in Brooklyn, printed a ban on women-only prayer groups, ushering in a long period of derogatory writings aimed at the prayer group's founders. According to one account of the case in *New Directions for Women*, the prayer group members "were decried as divorcees, man haters, idolators; one author played on the Hebrew words kadusha, which means holy, and kadaisha, which means prostitute."[12] Rivka Haut, the founding member of the Flatbush Women's Davening Group, declared "We were not violating the laws. We have no argument with the Torah. We took away from the synagogue as a male-dominated arena. It really was a political, not a religious, issue."[13]

The women under attack pointed out that they had never

referred to themselves as a *minyan,* nor did they in any way violate Orthodox restrictions on prayers that are to be recited by a *minyan.* Despite this evidence of compliance with *halacha,* five rabbis at Yeshiva University, acting as representatives of the Rabbinical Council of America—the governing branch of U.S. Orthodox Judaism—denounced the group and referred to it as the "women's minyan." Haut protested, "They did not cite sources for their decision against us. They said our motives were 'impure'; we were not doing this for religious reasons, but out of rebellion and for our own glorification. They asked, why can't we be normal women?"[14]

New Directions for Women explored the possibility that the attack's ferocity was motivated by the Orthodox status of the women in question. That women who "covered their hair," a standard Jewish euphemism for modesty and religious zealousness, might defy convention struck at the Orthodox community's deepest fears. Rivka Haut's statement to the press confirmed the source of that fear: "In the group, women are approaching the primary source of information themselves; they're dealing with halacha themselves."[15] And Fran Snyder, who interviewed Haut for *New Directions,* suggested that "They (the women) were motivated by discomfort in their synagogues, where women are physically separated from the area central to the service, and by the actual and spiritual distance between them and sacred texts."[16]

The Crown Heights community reeled at the implications of woman-led prayer. Although Lubavitcher women taught sacred texts at Beth Rivkah and Machon Chana schools, interpretation and worship were governed by the male authorities from whom women received the meaning of liturgy. *The Jewish Women's Outlook,* a magazine popular with both Lubavitcher and Orthodox women, finally addressed the controversy in 1986. In an article entitled "Prayer Meetings and Midnight Feedings," Rabbi Avi Shafran, a high school Rebbe at the New England Academy of Torah, pointed out that the legitimacy of women's prayer groups had already been addressed by leading rabbinical authorities and was a moot issue.

> The advisability of such endeavors was put to a group of respected scholars of Halachah at a leading Yeshiva. A preliminary ruling was issued by that group in which the entire concept of a woman's prayer group was frowned upon; it was described as not only an empty gesture but an insincere one at that. The ruling noted that the prayer groups were no doubt

inspired by the women's liberation movement and, as such, were motivated more by concern for social status than by yearning for spiritual growth.[17]

This analysis suggested that the women were not only aping men, but, worse, aping secular role models such as feminist agitators. There was no consideration that the women had acted on their own initiative. Rabbi Shafran duly noted that the women, who were never asked why they desired their own prayer group or even contacted by the aforementioned authorities, were angry at the preliminary ruling and objected to it. These defiant reactions further inflamed Shafran's critique.

> The women spoken of in the article are supposedly Orthodox. . . . The prayer-group women could not, of course, have been genuinely motivated by a desire to experience their Judaism more intensely. Had they been, they would have accepted the Halachic guidance given them. . . . Their frumkeit had, however, been selective, and few evils are as invidious as selective frumkeit. Their motivation needed no interviews to be ascertained; it was obvious. They did not like being women, at least not with all that Jewish womanhood entails.[18]

"All that Jewish womanhood entails," according to Shafran, included *halachic* guidelines on modesty and visibility, the idea being that women are discouraged from positions of public visibility or leadership in order to protect their *tznius* in the community's eyes.[19] Presumably, an innovative women-only prayer group would draw excessive attention, violating the prerogative of female modesty—a point introduced rather late in the debate. By insinuating that none of the women in the prayer group were genuinely motivated, when his only contact with them was hearsay, Shafran did a great disservice to his own ideal of objective *halachic* guidance; yet he agreed with the Yeshiva University rabbis that "their motivation needed no interviews to be ascertained." It should be noted that Orthodox law deems women to be unreliable witnesses, and thus a panel of rabbis served its decree without any consultation of the accused. Shafran extended the male judgmental privilege to himself—and, indeed, any Jewish male is considered more fit to rule on *halacha* than any woman.[20]

Shafran's final remark, "They did not like being women," pro-

vides some insight into the issues simmering below the surface of the prayer group controversy. Jewish dissent is nothing new. Throughout history, observant Jews have disagreed with their own rabbis, and Yiddish folklore overflows with anecdotes based on standoffs between learned scholars and their constituents. The entire Hasidic movement itself came about as a result of dissent between Orthodox factions, and to this day different Hasidic sects malign each other's Rebbes, defy each other's rulings, and distrust each other's *kashruth* certificates. When such conflicts arise, occasionally resulting in *cherem*, or banning of the disfavored, a typical accusation is that the opponent is not a "true Jew." Yet, in the discussion of dissent between the Flatbush Davening group and the rabbis of Yeshiva University, writers such as Shafran emphasized that the accused were not true *women*. This focus on gender, rather than pure theological deviance, reveals that women occupy a very separate category in Judaism.

Without their own legacy of scholarship, Jewish women must passively accept the legal interpretations handed down to them by male authorities. Renouncing passivity and daring to question a *halachic* decree does, indeed, signify a break from prescribed female behavior in Judaism.

The Flatbush Women's Davening Group case reopened long-suppressed discussion of the implications of separate spheres for men and women in Orthodox and Hasidic Judaism. Without question, the interpretation of *halacha* is the essence of Jewish learning and status. It is also the definition of masculinity in a culture where such higher study is required of men and all but forbidden to women.[21] While the exemption of women from the male occupation of scholarship pushed many women into the role of family breadwinner, thus expanding female economic importance, Jewish women throughout history had no opportunity to attain the training in religious law that was available to the least intelligent male. The result of this centuries-old system was that Jewish women had no role in the legal debates that determined their own religious obligations.

The controversy generated by the 1982 prayer group case indicated growing disagreement among Jewish women over the necessity of depending on a male intermediary to dictate the meaning of Torah in their daily lives. Traditionally, women with no direct access to Torah required that intermediary to prevent any error in the understanding and practice of *mitzvot*. A woman-only prayer group virtually blasphemed by suggesting that untrained women

were competent to pray without male supervision; the risk of error during worship haunted the Orthodox community. And for women to perform, even separately and modestly, those prayers that would otherwise be led by men embarrassed the community: it suggested there were no properly erudite males available to fulfill those leadership duties. In summary, despite the emphasis on segregation by sex in the Orthodox and Hasidic traditions, there is no precedent for an autonomous women's group. There are male-only groups, and there are women's groups led by men.

These points are crucial to understanding the modern Lubavitcher woman's experience. Whereas Lubavitcher males answer to the Rebbe, who answers only to the Almighty, Lubavitcher women operate in an entirely different hierarchy. They must first obey their husbands, then the local Rav (any *halachic* authority), then the Rebbe's aides who dictate women's obligations in the community, then the dicta of the Rebbe himself. The chain of deference places a spectrum of male authorities between woman and God. This deference to male authorities exists for non-Hasidic Orthodox women, too—hence, the impetus by some, such as the Flatbush group, to eliminate one or two levels of intermediaries and enjoy pure worship alone with God.

In the Lubavitcher community, reverence for the Rebbe personalized the religious women's obedience to a God-like male authority. All Lubavitchers served as representatives of the Rebbe wherever they where sent—with men too accepting a measure of childlike status under the Rebbe's fatherly benevolence and instruction. Any discussion of "women's history" in Lubavitch must be seen in this context. Without any female representation in the Jewish legal system, Lubavitcher women are subject to male guidance from cradle to grave. The one authoritative role available to them—motherhood—also changes to deference as young sons grow up to be halachic experts themselves: one thinks of Esther Stern. In his writings, the Rebbe even dictated appropriate childbirth labor etiquette for the women in his community.[22]

It is fair to state that nearly all of the programs "for women" developed in the years of Rebbe Menachem M. Schneerson's leadership were dominated by men. The keynote speaker at the Neshei Chabad conventions was usually a Chabad rabbi representing the Rebbe, and, of course, the convention highlight was the address by the Rebbe himself at 770. In both the Beth Rivkah and *baalot teshuvah* school systems, rabbis instructed the most advanced and challenging classes, frequently perpetuating a double standard

whereby those classes taught by women appeared less important or interesting (and subsequently suffered from discipline problems).[23] Most important, *Di Yiddishe Heim* demonstrated a rapid transition from a magazine written by and about Lubavitcher women to a forum for memoirs and scholarly treatises by and about men. Even in the one corner of Lubavitcher literature reserved for the female perspective, whole issues of *Di Yiddishe Heim* were devoted to essays by well-known rabbis about other well-known rabbis.

How, then, does one approach or construct the idea of a woman's sphere in Lubavitch? Male-only strata are evident in Lubavitch. But is there a truly female-only sphere, any area in which women operate independently of male instruction or supervision?

According to Lubavitcher women themselves, this is the wrong question. Rachel Altein finds it inappropriate to separate what is female in Lubavitch from the higher purpose of Judaism as a way of life. In her view, there is no women's literature in Lubavitch—there is only Lubavitch literature.

> *Di Yiddishe Heim* is just one aspect of what Lubavitch is all about—spreading the teachings of Torah and mitzvos in every way we can find. It is not published in the name of literature— Jewish or otherwise, general culture, or women's culture per se.[24]

Lubavitch history, too, must be seen as separate from other forms of Jewish history and culture, for the role of the Rebbe fomented a cult of personality inseparable from other factors in a Lubavitcher's experience. In many ways, the Rebbe *was* Lubavitch Hasidism. A Lubavitcher woman would not be a Lubavitcher Hasid without the Rebbe, and there is no part of her life, and no women's sphere, where his influence and authority have not informed actions and values. This reverent devotion to a man who is, strictly speaking, not a blood relative (in most cases) adds a unique dimension to the lives of women in Hasidic society. Women serve both visible male superiors (husband, the Rebbe) and nonvisible but clearly male-symbolized deities (God, Messiah). And so the appropriate historical question, the one I sought to answer, would be best expressed as: How did the Rebbe expand opportunities for his women followers?

Although Lubavitcher women carried out different domestic and religious obligations than their male counterparts, the Rebbe

saw women as equal to men in the campaign to spread Lubavitcher teachings among assimilated Jews. Thus it became permissable for women to leave the domestic sphere of Crown Heights and to venture unchaperoned into Gentile society, since the purpose of such contact was the advancement of Lubavitcher goals. Interestingly, despite their dependence on male religious interpretation, Lubavitcher women are considered less liable to temptation than men. Chabad philosophy dictates that women are more spiritual and possess an extra measure of understanding, uniquely suiting them to missionary work.[25] There is absolute trust in the piety of a Lubavitcher woman outside her home. Under the Rebbe's campaigns, women were urged to extend the traditional sphere of the home into mainstream American society—in the name of uplifting other Jewish women.

Lubavitcher women, neither impressed by the secular world nor attracted to it, did not find the hierarchy of male authorities surrounding them to infantilize them in any way. On the contrary, the Rebbe's confidence in their piety, as he invited women to take an active missionary role, signified their maturity and readiness for additional obligation. What the Rebbe requested, he received. And in his role as leader of the postwar Lubavitcher generation, he wanted visible, educated, committed women, who could compete with the visible and educated women of secular society, in order to attract *baalot teshuvah* to Lubavitch.

Locating Lubavitch History in Women's Studies

The highly flexible nature of the female sphere, as it is continually redefined to suit the expedience of male authorities, is a hallmark of American women's history. The Lubavitcher woman's experience is unique within the framework of religious and ethnic subcultures, yet it can be recognized as part of the history of female moral activism in the United States. Christian women in nineteenth-century America, bound to the prevalent cult of domesticity, also broadened their educational and vocational opportunities by bringing the ideals of domestic morality into public reform movements. For these women, too, legal rights and roles were circumscribed and left to male interpretation and jurisdiction.[26] Lubavitcher women are hardly the only women in American history who were expected to honor the traditions of their mothers while transforming the world through the merits of their sons.

During the nineteenth-century cult of domesticity, American women were expected to diffuse moral influence within the home while preparing male children to assume active roles in the larger, public polity. Vicarious citizenship through the guidance of sons substituted for women's own enfranchisement—just as we see the Lubavitcher mother rearing Torah-obedient sons who will gradually become guardians of those laws governing their mothers. In strictly defined domestic spheres across time and culture, we find that "traditional" wives and mothers are expected to nurture the political or religious identities of their menfolk, but to refrain, themselves, from actively participating in the public rites of those affiliations.

In the cultures of both Christian and Hasidic domesticity in America, what brought women into the public sphere was the growing secularization of the surrounding society. By the end of the nineteenth century in the United States, the inevitable transition of community and domestic responsibilities (education, utilities, health) to bureaucratic institutions both reduced the traditional female burden and further isolated women from public policy-making. Suffragists, for example, argued effectively that as mothers they had a responsibility to protect their children by understanding and participating in the law-making process that affected families.[27] Likewise, the post–World War II Lubavitcher community, confronting the growing secularization and assimilation of American Jewry in the mid-twentieth century, accepted the need for female participation in the fight against non-Jewish values. Women were permitted to become *shluchot* (missionaries), to leave Crown Heights for distant posts with few observant Jews, all in order to bring their religious domestic morality to those areas with endangered Jewish populations.

In summary, we can see that the Lubavitcher model of separate spheres for male and female is flexible in that both sexes have equal opportunity to serve the Rebbe, although their other functions might be unequal in terms of scholarly or leadership opportunity. The Lubavitcher woman contributed vicariously to the realm of scholars and leaders by rearing sons who perpetuated the acting male hegemony, from which she herself was excluded. The woman who desired to uphold Jewish law through higher study of its application was, instead, directed to demonstrate her faith through example, not scholarship; practice, not understanding.

Throughout Lubavitcher history, social and domestic values and activities were preserved through the policy of separate spheres

for men and women. In the twentieth century, the destruction of all Eastern European Hasidic communities and the transplantation of the Lubavitcher empire to a secular, Western nation challenged the old structure of separate spheres, for in the United States both male and female Lubavitchers enjoyed legal rights and opportunities never before permitted. With this assurance of religious protection, however, came secular responsibilities, such as the mandatory instruction of English and other non-Jewish subjects for boys and girls in the Lubavitcher schools. As post-World War II American society made fewer and fewer distinctions between Jew and non-Jew, Lubavitcher authorities hastened to augment the significance of those differences in Crown Heights publications and policies. As outside society liberalized, the rhetoric of religious separatism and gender differences increased in the postwar Lubavitcher community.

While the continuity of separate spheres was assured by the new Rebbe who assumed control of Lubavitch in 1950, his use of articulate and appealing women to promote the staus quo signified a break with earlier Lubavitch (and Hasidic) custom. The Rebbe's faith in the moral integrity of his female followers, and his ten-point *mitzvah* campaign on family observance, alleviated much hesitancy among his male followers about the role of women as Lubavitch representatives. As outreach work was essentially work for the Rebbe, all Lubavitchers accepted that involvement in public activism was normative. Soon missionary work joined the list of activities expected of the ideal *aishes chayil* (woman of valor). The sphere for Lubavitcher women expanded without any change in the values it contained—despite the fact that in the rest of American society, the expansion of roles for women occurred as part of feminist rebellion against the status quo.

Because Lubavitcher women's activism developed without any subsequent liberalization of female rights in the community, we must be careful to distinguish Lubavitcher women's history from other women's history trends per se. The existence of a truly women's culture in Lubavitch is qualified by the hierarchy of male supervision already noted. But that female culture does exist. In the prologue to this study, I provided a description of "women's hours" at the Lubavitcher youth library in Crown Heights. The chaotic intimacy of that environment demonstrated a very real social construct, a time and place for women and children only. This, then, is the essence of woman's sphere in Lubavitch. And, significantly, the young girls crowded around the library tables were engaged, as they

arrogantly informed me, in "work for the Rebbe." No one could convince them that theirs was not an important contribution. This empowerment of schoolgirls represents a remarkable shift from the previous eras of scanty female education and opportunity.

Public activism in the name of the Rebbe was one way women showed their piety in the years from 1950 to the present. Undertaking the job of spreading his word also accorded Lubavitcher women higher status in the Rebbe's community, for such holy work was commendable—and outside of domesticity women had few opportunities to merit any disctinctions or awards (as compared with male competition and scholarship honors). For women entering the Lubavitcher community as adults, besmirched by lengthy pasts in non-Jewish capacities, becoming a speaker for the Rebbe's causes guaranteed acceptance and respect—preconditions for marriage and a household.

If we view the postwar era as a parentheses, with the moral watershed of the Holocaust at one end and the political-personal watershed of the feminist movement at the other, we can better see how an entire generation of Hasidic women were forced to redefine freedom and survival. The Rebbe and his predecesor had declared postwar America to be the new center from which Hasidic thought and work might be dispersed to surviving Jewish communities worldwide. But beyond a basic appreciation of religious freedom, the Rebbe and his followers never intended to assimilate into American society. The ever-present temptation of assimilation certainly affected Lubavitcher women's relationship to mainstream society and to other American women. Ironically, the centuries-old qualities developed by religious Jewish women in order to resist physical and spiritual coercion are qualities seldom seen as "feminine" in the West: verbal self-defense, sarcastic humor, economic power within the family, multilingual academic skills, and access to political information.

Education was the rallying cry of the seventh Lubavitcher Rebbe, Menachem M. Schneerson.[28] That his emphasis on education extended to improving female school systems and the female role in religious proselytizing may be a coincidental part of his larger platform. Yet the resultant visibility of Lubavitcher women through new educational facilities, publications, and conferences not only gave many Lubavitcher women new confidence and opportunity, but attracted sufficient numbers of *baalot teshuvah* to expand the Crown Heights population and to alter its formerly homogenous character.

The Rebbe was not Moshiach. There will be a successor within the next two decades, and the nature of women's activism and opportunity may change again. But the outreach work of a generation of women activists has helped secure an increase in both Jews and traditional Judaism both in the United States and abroad. And, as women continue to give birth to four, five, and six children in each Lubavitcher family, the population growth and continuing visibility of the Lubavitcher sect—including its female advocates, organizers, and writers—appears assured. Thus, according to the goals of Lubavitcher Hasidism and the reigning Rebbe, Lubavitcher women have indeed been women of valor, with all the accompanying respect that title holds in their own world.

Glossary of Yiddish and Hebrew Terms

ahavas Yisroel	love of one's fellow Jew
aishes chayil	woman of valor
akeres habayis	foundation of the household
alef-bais	first two letters of the Hebrew alphabet
avodah	work; worship
baal teshuvah	one who repents and returns to the faith
bar mitzvah	ceremony marking the thirteenth birthday of a Jewish male and his acceptance of adult religious responsibilities
bas melech	princess; lit. "daughter of a king"
bentch	act of praying; to bless
Besht	acronym for Baal Shem Tov, or "Master of the Good Name." Israel ben Eliezer, the founder of eighteenth-century Hasidism.
bittul Torah	waste of time better spent in Torah study
Bnos Chabad	daughters of Chabad; unmarried Lubavitcher girls
Chabad	intellectual approach to the service of God; the outreach program of the Lubavitcher Hasidim. An

	acronym for *Chochmah* (wisdom), *Binah* (understanding), and *Daat* (knowledge)
challah	bread eaten on the Sabbath and most festivals; a portion is removed by women during preparation and burnt as a symbolic offering
Chassidus	Hasidic philosophy
Chassidishe	in a Hasidic manner
chas v'shalom	God forbid!
chavuroth, havurot	Jewish affinity group for adult religious activities and celebrations
cheder	religious elementary school
cherem	excommunication
chinuch	education
chinuch habanos	girls' education
Chumash	the Five Books of Moses; the Pentateuch
daven	pray
derech eretz	respect and good manners
devekus	adhesion to God
Di Yiddishe Heim	"The Jewish Home"; the journal of the Lubavitcher Women's Organization
farbrengen	Hasidic gathering for prayer, discussion, and exhortation at the meal following the conclusion of the Sabbath
frum, frumkeit	religious, religiosity
gemilas chesed	acts of loving-kindness
geniza	depository for worn religious texts
golus	exile; any place outside of Israel
halacha	Jewish law
Hashem	"The Name"; a euphemism for God

Hasid (or *Chasid*)	Literally "pious one"; follower of the eighteenth-century mystical religious movement; normally an individual aligned with a sect, community, or specific Rebbe
hechsher	seal of kosher certification
hislahavus	ecstasy; fervor
hoyf	court of a Hasidic dynasty
illui	genius in religious scholarship
kabbala	esoteric genre of Jewish mysticism
Kaddish	prayer recited for the dead
kahal	self-governed Jewish community
kallah	a new bride
kashruth	laws governing kosher food or the ritual appropriateness of products
kavannah	devotion, intent, or attachment in prayer
khapper	lit. "catcher"; those agents of the Tsar who captured young Jewish males for army service in nineteenth-century Russia
kibud av	the commandment to honor one's parents
klippos	empty husks; shells of evil left by the implosion of God's light during Creation
leichter	Sabbath candles
l'havdil	to separate or signify a distinction
licht	Sabbath candle lighting
Lubavitcher	Follower of the Chabad movement, a sect of Hasidic outreach activists; the seven generations of Lubavitcher Rebbes and followers take their name from the town of Lubavitch ("City of Love") in Russia, where the Chabad dynasty emerged in the nineteenth century.
maamor	Hasidic discourse

Maskilim	"enlightened" Jews; those attracted by the Haskala movement of Westernization and secular culture in nineteenth-century Europe
mechitzah	barrier between men and women in Orthodox synagogues
melave malke	meal and ceremony indicating the end of the Sabbath; lit. "escorting the Queen"
mesiras nefesh	self-sacrifice
mezuzah	religious scroll affixed to doorposts of Jewish homes and buildings
Midrash	exegesis of the Scriptures; rabbinic collections of interpretations
mikveh	ritual bath for purification
minhag	custom
minyan	quorom of ten men over *bar mitzvah* age required for daily and festival prayer
Mishnah	Oral Law, considered by Orthodox Jews to have been handed down to Moses from God at Sinai and thence transmitted from Jew to Jew for generations. The *Mishnah* was compiled and edited by Rabbi Judah the Patriarch in the second and third centuries.
Misnagdim	opponents of Hasidism
Mitzrayim	Egypt
mitzvah, mitzvot	the commandments, negative and positive, of Judaism
Moshe	Moses
Moshiach	the Messiah
na'aseh v'nishmah	unconditional acceptance or belief ("We shall do and we shall obey.")
Neshei Ubnos Chabad	Women and daughters of Chabad; the Lubavitcher Women's Organization

neshek	acronym for *neiros Shabbor kodesh*, or holy Sabbath candles. Also a Hebrew term for weapon.
niddah	period during and after menstruation, when women are prohibited from sexual activity and other displays of affection (physical contact) toward the husband
pintele Yid	Jewish spark; the spark of holy light contained within each Jewish individual
Rebbetzin	wife of a Rebbe or prominent Rabbi
sefirot	the ten divine attributes described in the *Zohar* and in Hasidic mysticism
seforim	books
Shabbat, Shabbos	Sabbath
Shechinah	the Divine Presence of God (feminine) and the tenth Sefirah
sheitel; sheitlach	wigs worn by observant married women
Shlita	"may he live and be well"
shlichus	outreach mission
sholiach, shluchim	emmissary or missionary for Chabad
sholom bayis	harmony in the home
shtetl, shtetlach	small village or town
shtiblach	small room used for prayer
Shulchan Aruch	Code of Jewish Law, compiled by Joseph Caro in the sixteenth century
sicha, sichos	address by a Rebbe
siddur	prayer book
simcha	celebration

smicha	rabbinical ordination
taharas hamishpocha	Laws of Family Purity
tallis	prayer shawl worn by men during morning services and all day on Yom Kippur
tefillin	also called phylacteries; leather boxes containing religious scrolls strapped onto the head and arm; worn by adult men over the age of thirteen during morning worship
tehillim	psalms
tikkun	redemption or repair
tkifus	strong Orthodoxy
tzaddik	a righteous and holy man; usually connotes a Rebbe or leader
tzedaka	righteousness; the act of giving charity
tzimtzum	contraction of the Infinite during Creation, according to Kabbalah.
Tzivos Hashem	"Army of God"; a youth organization
tznius, tzniusdik	modesty; generally refers to women's dress, demeanor, and behavior
uforatzto	"you shall go forth"; outreach
yahrtzeit	anniversary of a death
yechidus	private audience with the Rebbe
yeshiva, yeshivos	academy for higher religious study
yetzer hora	evil inclination
yichus	prestige based on Jewish ancestry
Yiddishkeit	Jewishness, Judaism
yom tov, yontiff	a holy day

NOTES

CHAPTER ONE

1. It is not always accurate to name Hasidism as just another "fundamentalist" movement, particularly in the current era of religious activism in political institutions. For a lively discussion on definitions of Jewish fundamentalism, see Ian Lustick's *For the Land and the Lord* (New York: Council on Foreign Relations, 1980); p. 6.

2. The New York communities are concentrated in Williamsburg, Boro Park, Crown Heights, Bensonhurst, and other Brooklyn neighborhoods, as well as in wholly Hasidic upstate towns such as Kiryas Joel and New Square. In Israel, key Hasidic settlements include B'nei Brak, Kfar Chabad, Tzefat, and the Mea Shearim district of Jerusalem. Other significant Hasidic communities exist today in Los Angeles, Chicago, Pittsburgh, Toronto, Montreal, London, Paris, and several Australian cities.

3. One of the first Hasidic books, *Toledot Ya'akov Yosef*, written by Rabbi Jacob Joseph of Polonnoye in 1780, addressed this rift. The Rabbi denounced the contempt wealthy scholars exhibited toward their unlearned brethren, which he felt caused *perud*, or separation between the elite class and the working class of Jewry.

4. Jerome Mintz points out that whereas sixteenth-century kabbala was restricted to an esoteric few, "The hasidim . . . in an outpouring of religious emotion, sowed kabbalistic mysteries among the population." *Legends of the Hasidim* (Chicago: University of Chicago Press, 1968), p. 27.

5. Aryeh Rubinstein, *Hasidism*. Jerusalem: Keter Publishing House, 1975; pp. 65–70.

6. Mintz, pp. 144–45.

7. There are important scholarly challenges to this interpretation of Hasidism as a movement with social protest tones—as opposed to interpretations of Hasidism as a system of overlapping circles of attachment to specific *tzaddikim*. See articles by Benzion Dinur, Shmuel Ettinger, and Murray Jay Rosman in *Essential Papers on Hasidism* (New York: New York University Press, 1989), ed. Gershon David Hundert.

8. This practice of naming is certainly not limited to sects with Eastern European village origins. Today a group of Hasidim in Boston revere an American-born leader known as the "Bostoner Rebbe."

9. I maintain the use of "Lubavitcher" because of the enormous impact of the sixth and seventh Lubavitcher Rebbes on women's opportunities in their sect. And "Chabad" means an intellectual movement, not a location or a dynastic pedigree, in terms of Hasidic heritage. Furthermore, while Lubavitcher adherents may self-identify as Chabad Hasidim or work through campus Chabad programs, their leader is always the "Lubavitcher Rebbe," and never the "Chabad Rebbe."

10. This pattern is not limited to male scholars. Israeli author Rachel Elior, for example, chose to focus on the relationship of Hasidic worship to mystical elevation in her book *The Paradoxical Ascent to God: The Kabbalistic Theosophy of Habad Hasidism* (Albany: SUNY Press, 1993, trans. Jeffrey Green). And a somewhat sideshow-carnival look at Lubavitch mysticism written, sans footnotes, by Anne Lowenkopf appeared as *The Hasidim: Mystical Adventurers and Ecstatics* in 1973, as part of a Sherbourne Press series that included books on haunted houses, UFOs, witchcraft, werewolves, and ESP.

11. In previous years, however, guidebooks for appropriate female behavior and religious observance had been published, in English, for Hasidic women and girls by the rabbis of their own communities.

12. These works include *The Jewish Woman*, edited by Elizabeth Koltun (New York: Schocken, 1976); *Nice Jewish Girls: A Lesbian Anthology*, edited by Evelyn Torton Beck (Watertown, MA: Persephone Press, 1981); *On Being a Jewish Feminist*, edited by Susannah Heschel (New York: Schocken, 1983); *Jewish and Female*, edited by Susan Schneider (New York: Simon and Schuster, 1984); *The Tribe of Dina*, edited by Melanie Kaye-Kantrowitz and Irena Klepfisz (Montpelier, VT: Sinister Wisdom, 1986); and *Standing Again at Sinai*, by Judith Plaskow (San Francisco: Harper and Row, 1990). Two history texts published in that same period included *The Jewish Woman in America*, by Charlotte Baum, Paula

Hyman and Sonya Michel (New York: New American Library, 1975) and *Written Out of History: Our Jewish Foremothers*, by Sondra Henry and Emily Taitz (Fresh Meadows, NY: Biblio Press, 1983). Two influential texts combining feminist critique of Judaism and Christianity were *Religion and Sexism*, edited by Rosemary Radford Ruether (New York: Simon and Schuster, 1974), and *Womanspirit Rising*, edited by Carol Christ and Judith Plaskow (San Francisco: Harper and Row, 1979).

13. For example, two Orthodox-perspective texts on the role of women in Judaism are *Jewish Woman in Jewish Law* by Moshe Meiselman (New York: Ktav Publishing House, 1978) and *On Woman and Judaism* by Blu Greenberg (Philadelphia: Jewish Publication Society, 1981). These authors offer Orthodox male and female viewpoints on the appropriateness of female participation in formerly male-only Jewish roles and rituals. Yet both discuss feminist goals versus Orthodox tenets without mentioning the Hasidic female reality or historic experience. This is due in part to the distaste many in the modern Orthodox movement feel for American Hasidism—a split dating back to the Lithuanian *misnagdim's* excommunication of Hasidic adherents.

14. This view is not shared by all scholars of Hasidism. In *Hasidism*, edited by Aryeh Rubinstein, an unspecified author attempts to disprove S. A. Horodezky's claim that Hasidism offered women an honored position in community life. This "full" discussion of woman's role in Hasidism covers exactly one page out of the 120 in Rubinstein's book (*Hasidism*, Keter Publishing House, 1975; pp. 96–97). Similarly, Jerome Mintz presents a limited view of Hasidic women's role, with no discussion of the Rebetzin's function, yet concedes that in his research on Hasidic folklore "very few women were interviewed." (Mintz, *Legends of the Hasidim*; p. 19, pp. 82–88.)

15. Rabinowicz, *The World of Hasidism*. London: Vallentine Mitchell; p. 202.

16. Ibid., pp. 203–04.

17. Ibid., p. 205.

18. Rabinowicz, p. 206. See also S.A. Horodezky, *Leaders of Hassidism* (London: Hasefer, 1928). See the more recent interpretation of the Maid of Ludmir, by Adah Rapaport-Albert, in *Jewish History: Essays in Honour of Chimen Abramsky*, edited by Rapaport-Albert and S. Zipperstein (London: Peter Halban, 1988).

19. In *Jewish History: Essays in Honour of Chimen Abramsky*, pp. 495–525.

20. Rapoport-Albert, pp. 503–04.

21. Mintz, *Legends of the Hasidim*, pp. 243–45.

22. These conditions are a very important theme in the literature of the Lubavitcher women's quarterly magazine, *Di Yiddishe Heim*, discussed in chapter 4. The image of the threatened but valiant Lubavitcher woman in Tsarist Russia is employed to trivialize contemporary Lubavitcher women's complaints of domestic boredom or stress in the less overtly anti-Semitic United States.

23. Rapoport-Albert, p. 497.

24. See Kate Loewenthal, "Be Fruitful and Multiply," in *AURA: A Reader in Jewish Womanhood*. Brooklyn: The Lubavitch Women's Organization, 1984.

25. Kiddushin, 33b.

26. See Ellen Koskoff, "The Sound of a Woman's Voice: Gender and Music in a New York Hasidic Community," in Ellen Koskoff, ed., *Women and Music in Cross-Cultural Perspective*. New York: Greenwood Press, 1987.

27. Yaffa Eliach, "Jewish Hasidism, Russian Sectarians: Nonconformists in the Ukraine, 1700–1760." Dissertation, City University of New York, 1973; pp. 2–3.

28. Rabinowicz, p. 236.

Chapter Two

1. Tzipporah Muchnik, "A Treatise on the Meaning of Chicken Soup." *Souvenir Journal*, the 24th Annual Convention of Neshei Ubnos Chabad, May 1979; p. 42.

2. S. Bar Yochai, "The Rebbe and His Dual Standards," in *Di Yiddishe Heim*, v. 3, n. 4, Spring 1962; pp. 14–15.

3. Beila Hayes, "Motivation for Education." *Di Yiddishe Heim*, v. 7, n. 1, Summer 1965; pp. 22–23.

4. An alternative, feminist explanation is that women were exempted from time-bound commandments because they naturally experienced time cycles through menstruation. Men, lacking the built-in cycle of nature, were obligated to participate in regularly timed meetings for ritual and prayer. However, this radical interpretation hardly exhausts the range of feminist analysis concerning "exemption." Fear and even hatred of women certainly figure in the exclusion of women from community activities valued as most precious to observant men. Generations of rabbis

argued that learned women participating in the public (male) sphere of religious activities where an embarrassment. Concern for modesty, always mentioned in the debate over separate spheres, reveals male anxiety toward female sexuality and its accompanying menstrual taboos.

5. While some feminists despair of the larger implications of the Orthodox prayer, Jewish feminist writers such as Alice Bloch claim that the wording "has probably been invoked more times in this decade by Christian women to condemn Judaism than by Jewish men to thank G-d." Alice Bloch, "Scenes from the Life," in *On Being a Jewish Feminist*, ed. Susannah Heschel (New York: Schocken, 1983), p. 174.

6. Mishnah, Sotah 20a, 21b.

7. Arthur M. Silver, "May Women Be Taught Bible, Mishnah and Talmud?" In *Tradition*, v. 12, n. 3, Summer 1978; p. 76.

8. Palestinian Talmud, Sotah 3:4.

9. Talmud Torah 1:13; Babylonian Talmud, Kiddushin 31a.

10. Talmud Torah 1:13; Mishnah, Sotah 3:4.

11. Throughout history, we find cases where education is denied to an entire class of people who are then, ex post facto, deemed to be incapable of learning. All African slaves and many women in eighteenth- and nineteenth-century America struggled to attain literacy in the face of such attitudes.

12. Sefer Abudraham, Part Three: blessing over the commandments. This translation appears in Rachel Biale, *Women and Jewish Law* (New York: Schocken, 1984), p. 13.

13. Silver, p. 79.

14. "The Rebetzin Channah," in *Di Yidishe Heim*, v. 16, n. 3, Winter 1975, p. 1.

15. Deborah Weissman, "Bais Yaakov: A Historical Model For Jewish Feminists," in *The Jewish Woman*, ed. Elizabeth Koltun (New York: Shocken, 1976), p. 141. While Weissman uses the spelling Schenierer, other Hasidic, Orthodox, and secular writers variously spell the name as Schenirer, Schenerer, and so on.

16. Silver, p. 80

17. Naftali Loewenthal, "The Wisdom of Womanhood: Thoughts on Jewish Education for Women Today," in *The Rebbe: Changing the Tide of Education* (Brooklyn: Lubavitch Youth Organization, 1982); p. 176.

18. However, the education of women among the Gur Hasidim in present-day Israel remains contested, as Tamar El-Or demonstrates in *Edu-*

cated and Ignorant. She cites one letter from the head of Israel's Zikhron Meir religious court, a rabbi Shmuel Halevy Vazner, dated 1986, in which limitations on female learning are upheld: "I will nevertheless not abstain from expressing my humble opinion. *It is the nature of women that they cannot attain and understand the true point of the Torah, and as a result they trivialize the Torah's intentions.*" This emphasis, according to El-Or, appeared in the original letter. *Educated and Ignorant*, pp. 75–77.

19. Weissman, pp. 142–43.

20. Ibid., p. 146.

21. Ibid., pp. 146–47.

22. Rabbi Israel Jacobson, "Chassidus Study for Girls," in *Di Yiddishe Heim*, v. 8, n. 3, Winter 1967; p. 11.

23. Ibid., p. 12.

24. Ibid., p. 13.

25. Silver, p. 82.

26. Other Hasidic groups also adopted the Bais Yaakov structure to suit their own sectarian ideologies: hence, the Bais Chana schools of the Klausenberger Hasidim, the Ohel Rachel and Bais Sorah schools of the Satmar Hasidim, and so forth.

27. El-Or, p. 68.

28. Sudy Rosengarten, "The Girls' Yeshiva," in *Di Yiddishe Heim*, v. 14, n. 4, Spring 1973; p.21.

29. Ibid., p. 22.

30. Ibid.

31. Chana Heilbrun, "Can We Improve Our Schools?," in *Di Yiddishe Heim*, v. 5, n. 2, Fall 1963; p. 13.

32. Heilbrun, "Can We Improve Our Schools? Part II," in *Di Yiddishe Heim*, v. 5, n. 3, Winter 1964; p. 17.

33. Brochure distributed by Beth Rivkah Schools, 1986; p. 7.

34. "Neshei News," in *The Neshei Chabad Newsletter*, v. 13, n. 2, December 1986; p. 19.

35. "Bais Rivkah," in *The Neshei Chabad Newsletter*, v. 13, n. 4, April/May 1987; p.3.

36. Rivka Shusterman, "One Small Still Voice," in *Di Yiddishe Heim*, v. 14, n. 1, Summer 1972; p. 11.

37. "A Chance Meeting," in *Di Yiddishe Heim*, v. 15, n. 4, Spring 1974; p. 19.

38. See Daniel Goldberg, "The Lubavitcher Rebbe: Eighty Years," in *The Rebbe: Changing the Tide of Education*.

39. Nechama Greisman, "Machon Chana," in *Souvenir Journal* of the 20th Annual Convention of Neshei Ubnos Chabad, May 1975; p. 25.

40. Ibid., p. 26.

41. Jewish law dictates that the commandment *kibud av*, "Honor thy father and mother," may not be invoked to override a child's desire to be more Torah-observant than her own parents.

42. Machon Chana brochure, "Get in Touch with Over 5,000 Years," 1983.

43. Ibid.

44. Machon Chana brochure, "Where Women Who Are Jewish Learn to Be Jewish Women," 1986.

45. Machon Chana poster, "For Women Only," summer 1985.

46. In her dissertation on *baalot teshuvah*, sociologist Lynn Davidman found the atmosphere of Bais Chana to be cultlike in terms of limits on privacy and free time, ubiquitous photographs of the Rebbe, and overseeing of young students by zealous professional activists. The initial character breakdown process, whereby students' secular pasts were discarded in favor of new Torah-defined standards, resembles both military drill and the Christian ideal of being "born-again." See Davidman, *Tradition in a Rootless World*.

47. Machon Chana brochure, "G-d is Not for Men Only," undated.

48. *Mendy and the Golem* comics, v. 1, n. 4, 1982; p. 8.

CHAPTER THREE

1. The registration fee for the 1987 Convention was less than $50 total for banquet sessions, brunches, and audience with the Rebbe; workshops were free.

2. Lubavitcher women also took over the men's main section to have private audience with the Rebbe just before Rosh Hashonah and on Beth Rivkah's graduation day.

3. The Rebbe never left New York after assuming leadership in 1950—except for one trip to Paris, the purpose of which was to bring his mother to Brooklyn.

4. See Lis Harris's description of the women's gallery at 770 in *Holy Days: The World of a Hasidic Family*, pp. 122–25.

5. Assorted panhandlers, well aware of the Rebbe's schedule for distributing *tzedaka* dollars, crowded the streets on these occasions. The problem of distinguishing between legitimate and fraudulent charities was eventually addressed in *The Neshei Chabad Newsletter*, v. 13, n. 3, February/March 1987, p. 21.

6. Rapoport-Albert, p. 498.

7. At the 1987 Annual convention in Crown Heights, women in the audience saw a film that featured the Rebbe speaking to a group of Jewish schoolchildren. Interestingly, this Lubavitcher home movie replaced a previously scheduled film about Jewish women's history, "In Her Own Time," which Convention organizers ultimately decided overstepped the boundaries of *tznius*. As women caught sight of their beloved leader on the movie screen, many of them rose to their feet.

8. Esther Katzenmellenbogen, "Convention Report," in *Di Yiddishe Heim*, v. 1, n.3, Summer 1959; pp, 21–22.

9. Ibid.

10. "Resolutions of the 1960 Convention of Neshei Ubnos Chabad," in *Di Yiddishe Heim*, v. 2, n. 3, Fall 1960; p. 23.

11. This trend culminated in the development of *Tzivos Hashem*, or "Army of God," a Lubavitch children's movement founded in 1980.

12. Mrs. Risa Posner, "Opening Remarks." *Souvenir Journal* of the Eighth Annual Convention of Neshei Ubnos Chabad, May 1963; p. 18.

13. Mrs. Tema Gurary, "Guest Speaker." Ibid., p. 26.

14. Among other provisions, Jewish law is quite forthright about *onah*, a woman's entitlement to sexual satisfaction within marriage.

15. Mrs. Tema Gurary, ibid.

16. Rabbi M. Feller, "Guest Speaker." *Souvenir Journal* of the Eighth Annual Convention of Neshei Ubnos Chabad, p. 13.

17. Ibid.

18. "An Historical Conference." *Souvenir Journal* of the Fifth Mid-Winter Convention of Neshei Ubnos Chabad, February 1967; p. 11.

19. Mrs. Burton Chandler, "Opening Address." Ibid., p. 7.

20. Ibid.

21. Rachel Altein, "Preserving the Integrity of the Jewish family Today." *Souvenir Journal* of the Sixteenth Annual Convention of Neshei Ubnos Chabad, May 1971; pp. 18–20.

22. Ibid.

23. "Western Union Telegram." Ibid., p. 30.

24. Ibid.

25. The *Souvenir Journals* from the 1968, 1971, and 1983 Conventions are those with the greatest emphasis on Israeli issues.

26. "Neshei Chabad Candlelighting Campaign." *Souvenir Journal*, the Twentieth Annual Convention of Neshei Ubnos Chabad, April 1975; pp. 19–21.

27. Nechama Greisman, "Victory on the I.R.T." Ibid., pp. 48–51.

28. Sarah Baron, "A Child's Spark." Ibid., pp. 52–54.

29. S. B. Gitlin, "Neshek Workshop." *Souvenir Journal* of the Twenty-first Annual Convention of Neshei Ubnos Chabad, May 1976; pp. 26–28.

30. Ibid.

31. The interaction between guests and hosts is a complex ritual deserving further study. When Lubavitcher children assist adult guests in observing religious practices, they not only develop outreach and proselytizing skills. Their own pride and status is reinforced as they perceive their ability to perform rituals far more correctly than mature visitors from the outside world. Even more significantly, the child or adult Lubavitcher who receives many guests over time often hears a continuum of personal stories confirming Lubavitcher contempt for secular society and its conditions.

32. Devorah Kroll, "Dear Friend." *Souvenir Journal* of the Twenty-Third Annual Convention of Neshei Ubnos Chabad, June 1978; pp. 18–19.

33. "Meaning of Neshei." *Souvenir Journal* of the Twenty-Fifth Annual Convention of Neshei Ubnos Chabad, May 1980; p. 7.

34. Introduction (n/a), *Letters to N'Shei Ubnos Chabad 1956–80* (Brooklyn: Kehot Publication Society, 1980), p. ix.

35. Ibid., p. 4—from the Rebbe's letter to the 1957 Annual Convention.

36. Ibid., p. 9

37. Ibid., pp. 33–34.

38. "Letter by the Lubavitcher Rebbe," in *Di Yiddishe Heim*, v. 11, n.2, Winter 1970; p. 1.

39. *Letters by the Lubavitcher Rebbe—Neshei Ubnos Chabad Mid-Winter Conventions 1963-1987*. Brooklyn: Kehot Publication Society, 1987; pp. 18–19.

40. Ibid., p. 27.

41. The early, stapled *Souvenir Journals* have been replaced with thick, perfect-bound booklets. Their attractive layout and design is due in large part to the efforts of Hensha Gansbourg, the celebrated *baalas teshuveh* made famous as "Shaina Konigsberg" in Lis Harris's *Holy Days: The World of a Hasidic Family*. Gansbourg designed Convention programs from 1981 on; her contributions are one example of the benefits Neshei Chabad gleaned from college-educated newcomers.

Chapter Four

1. *Di Yiddishe Heim*, v. 1, n.1, Fall 1958; pp. 16–17.

2. The price of *Di Yiddishe Heim* was fifty cents from the fall of 1958 until the summer of 1973. With the publication of v. 15, n. 1, the price rose to seventy-five cents. In the fall of 1977, v. 19, n. 2 cost one dollar, but the price of the very next issue returned to seventy-five cents, for reasons that are unclear. By v. 19. n. 4, in the spring of 1978, the price of *Di Yiddishe Heim* was fixed at one dollar, and remained there until the one hundredth anniversary issue of 1987, which cost two dollars.

3. *Di Yiddishe Heim*, v. 1, n. 1, Fall 1958; p. 1.

4. Personal correspondence with Rachel Altein, September 1988.

5. The first two volumes used the months of the Jewish calendar as each issue's date. "Fall," "Spring," etc. were adapted as standard from Volume 3 onward. However, each issue continued to be oriented thematically toward the next upcoming Jewish holiday. Fall issues revolved around Rosh Hashana, Yom Kippur, Succos and Simchas Torah; Spring issues addressed Passover, and so on.

6. It is fair to note that Lubavitcher men, too, often embraced a passive role of awaiting instructions from the Rebbe, rather than making their own decisions. This was particularly true in personal decisions such as marriage, education, and employment. Before the Rebbe's death in 1994, a joke in Crown Heights asked "How many Lubavitchers does it take to change a light bulb? Two. One to change the bulb and the other to write to the Rebbe about it." See Lis Harris, *Holy Days*, p. 120.

7. Two articles in particular scoffed at the involvement of some American Jewish youth in protest movements. See Rabbi Elkanah Schwartz, "The Need for a Struggle," in v.9, n. 3, Winter 1968; and Rabbi David Wichnin, "Towards More Productive Encounters," in v. 10, n.4, Spring 1969.

8. Rachel Altein, "The Social Life of Teenagers." *Di Yiddishe Heim*, v. 2, n. 1, Spring 1960; p. 11.

9. Ibid., p. 12.

10. At the 1960 Annual Convention, Neshei Ubnos Chabad passed a resolution dealing with "modesty and decent dress." It read, "Whereas the moral standards of our youth, and the restoration of the high standards of modesty of Jewish womanhood, are two of our chief concerns, the convention therefore DIRECTS the attention of all Jewish women to the sorry state of modesty in our present society, and particularly to the immodest dress that is so common, with its consequent demoralizing effect on our youth."

11. Rabbi Zalman I. Posner, "On Our Anniversary." *Di Yiddishe Heim*, v. 6, n. 3, Winter 1965; p. 3.

12. Ibid., p. 5.

13. Posner concluded by declaring "Unexpected delights come from this doughty little magazine. My own favorite is the art work." Art, *Di Yiddishe Heim*'s least prominent feature, was provided only by male contributors until the 1970s. Ibid., p. 6.

14. William Brickman, Graduate School of Education at the University of Pennsylvania, "Recent Supreme Court Decisions on Church-State-School Relations." *Di Yiddishe Heim*, v. 10, n, 2, Fall 1968. Also see Aaron Twerski, Duquesne University Law School, "Reflections on State Aid to Parochial Schools." *Di Yiddishe Heim*, v. 11, n. 2, Fall 1969.

15. Again, this sex-role distinction is not limited to Lubavitch but is a hallmark of Hasidism. In *Educated and Ignorant*, Israeli anthropologist Tamar El-Or describes a study group for women of the Gur Hasidim. The Rebetzin (in this case called a *Rabbanit*) explains that women do not need to speak words of Torah learning: "And women? Should they speak of the Torah? Women can always find something to talk about. About bringing up the children, to exchange recipes, to speak of matters of health and the like." El-Or, pp. 101–102.

16. Sarah Yarmush, "How Fortunate We Are." *Di Yiddishe Heim*, v. 10, n. 2, Fall 1968; p. 20.

17. Ibid., p. 21.

18. Judith Mendelsohn, "On College." *Di Yiddishe Heim*, v. 13, n. 3, Winter 1972; p. 3.

19. Rachel Altein, "My Heroines." *Di Yiddishe Heim*, v. 9, n. 1, Summer 1967; p. 22.

20. See E. Mah, "School Days." *Di Yiddishe Heim*, v. 24, n. 3, Fall 1984. "E. Mah" is probably a psuedonym, a play on the Hebrew word *ima*, which means "mother." Could this clever writer be editor Rachel Altein, tactfully masking her identity in a critique of the Lubavitcher school system?

21. Several women wrote articles based on their summer studies. These articles always began with a disclaimer, noting that the essay was a "free" translation of a rabbi's lecture, or a condensation of notes taking during a tutorial.

22. Esther Stern, "A Rock of Strength." *Di Yiddishe Heim*, v. 13, n. 4, spring 1972; p. 22.

23. Ibid.

24. Ibid., p. 6.

25. Debra Kaufman, *Rachel's Daughters*, p. 28.

26. *Pirkei Avot* 1:17, 3:12, 3:22.

27. See "Lubavitcher Rebbe's Letter," in *Di Yiddishe Heim*, v. 6, n. 4, Spring 1965; pp. 2–3.

28. Esther Stern, "Changing For the Better." *Di Yiddishe Heim*, v. 15, n. 3, Winter 1974; p. 12.

29. Ibid.

30. Eshter Stern, "What Might Have Been." *Di Yiddishe Heim*, v. 16, n. 1, summer 1974; pp. 21–22.

31. Esther Stern, "Yossie Goes to Yeshiva." *Di Yiddishe Heim*, v. 17, n. 1, Summer 1975; p. 15.

32. Ibid., p. 16.

33. Ibid.

34. Ibid., p. 17.

35. Esther Stern, "Becoming Frum." *Di Yiddishe Heim*, v. 19, n. 3, Spring 1979; p. 24.

36. Occasionally, articles in *Di Yiddishe Heim* expressed a blanket contempt for all non-Jews. One 1979 essay by Yitla Mandel, a classic

example of Hasidic racism, told the story of a Lubavitcher woman who discovered that her maid was stealing from the family. Mandel bristled, "An Orthodox Jew's sense of temptation is weakened from childhood through the wonderful laws of the Torah . . . Now, what do we expect from a non-believer who has never been taught self-control or been trained to give much charity, who denies a hereafter and makes silver and gold his very ideals? Aren't we a little optimistic to trust in his good nature?" Yitla Mandel, "Protection from Burglars." *Di Yiddishe Heim*, v. 20, n. 3, Spring 1979; p. 18.

37. Personal correspondence from Rachel Altein, September 1988.

38. Felice Blau, "Is the Aishes Chayil Disappearing?" *Di Yiddishe Heim*, v. 8, n. 1, Summer 1966; pp. 22–23. *Aishes chayil* is the Hebrew term for "woman of valor," and a reference to the idealized Jewish wife described in Proverbs 31.

39. Ibid., p. 23.

40. It is difficult to break down the socioeconomic range of *Di Yiddishe Heim*'s readers. The global Lubavitcher community includes both wealthy and impoverished families, but the percentage of female readers who *had* to work was never articulated. Had class distinctions not been such a delicate subject in the Lubavitcher community, the feminist agenda of fair wages for female breadwinners might have enjoyed more commentary.

41. Felice Blau, "Women's Lib. Oration." *Di Yiddishe Heim*, v. 12, n. 2, Fall 1970; p. 23.

42. This trend also occurred in Lubavitcher literature aimed at college youth. Campus Chabad House newsletters, and *Wellsprings* magazine (published by the Lubavitch Youth Organization), featured interviews with actresses, designers, doctors, scientists, and other high-status professionals who had embraced Orthodoxy.

Chapter Five

1. Letter to the Editor, *Di Yiddishe Heim*, v. 17, n. 3, Winter 1975; p. 19.

2. Introduction, *The Modern Jewish Woman*. Brooklyn: The Lubavitch Educational Foundation for Jewish Marriage Enrichment, 1981; p. x.

3. The Lubavitcher Rebbe, "Equal Rights." Speech translation distributed by Sichos In English, Brooklyn, New York, 1984; p. 5.

4. See Lis Harris, *Holy Days: The World of a Hasidic Family*, pp. 60–61, 126, and 158.

5. R. Hodacov, "Spiritual Maladies of Our Age." *Di Yiddishe Heim*, v. 1, n. 3, Summer 1959; p. 18. See also Jerome Mintz, *Legends of the Hasidim*, p. 86.

6. Anzia Yezierska, *The Bread Givers*. New York: Persea Books, 1975; p. 10.

7. Letter to the Editor entitled "The Chassidic Woman: A Modern Problem." *Di Yiddishe Heim*, v. 12, n. 4, Spring 1971; p. 17.

8. Ibid., pp. 17–18.

9. Rabbi Israel Altein, ibid., p. 19.

10. Felice Blau, "Is the Aishes Chayil Disappearing?" *Di Yiddishe Heim*, v. 8, n.1, Summer 1966.

11. Rivka Shusterman, "Forum." *Di Yiddishe Heim*, v. 17, n. 2, Fall 1975; continued in v. 17, n. 3, Winter 1976.

12. Ibid., v. 17, n. 2; p. 4.

13. Ibid., p. 5.

14. Ibid.

15. Ibid.

16. "Forum," Part II. *Di Yiddishe Heim*, v. 17, n. 3, Winter 1976; p. 18.

17. Ibid., p. 17.

18. "Forum," Part I. *Di Yiddishe Heim*, v. 17, n. 2, Fall 1975; p. 5.

19. Letter to the Editor. *Di Yiddishe Heim*, v. 17, n. 3, Winter 1976; p. 19.

20. Rabbi Uriel Zimmer, "Great Women in Jewish History." *Di Yiddishe Heim*, v. 2, n. 1, Spring 1960; p. 6.

21. A few contributions also came from girls who were clearly not Orthodox. One eight-year-old feminist wrote, "I wish my name was Ms. Shabbos." Jenny Tenenholtz, *A Candle of My Own* (Brooklyn: The Lubavitch Women's Organization, 1979), p. 18.

22. *A Candle of My Own*, p. 21.

23. Introduction, *The Modern Jewish Woman*, p. x.

24. Ibid.

25. Grace Davidson, "The Man-Woman Relationship: Judaism Versus Western Culture." *The Modern Jewish Woman*, pp. 49–53.

26. Davidson, ibid. See also Shaina Sara Handelman, "On Being Single and Jewish," in *The Modern Jewish Woman*, pp. 3–10.

27. Handelman, ibid., p. 6.

28. The Lubavitcher Rebbe, addressing the 1980 Annual Convention of Neshei Ubnos Chabad. This translation appears in *The Modern Jewish Woman*, p. 81.

29. "Rachel," interviewed by Hilda Langer. "An Interview," *The Modern Jewish Woman*, p. 71.

30. Kate Loewenthal, "Be Fruitful and Multiply." *AURA: A Reader in Jewish Womanhood*; pp. 35–39.

31. Shaina Sara Handelman, "The Jewish Woman: Three Steps Behind? Judaism and Feminism," in *Di Yiddishe Heim*, v. 18. n. 4, Spring 1977; p. 8.

32. Ibid.

33. Ibid.

34. Ibid., p. 9.

35. Ibid., pp. 9–10. Note that Handelman wrote these words in the same year of the summer forum at which Jewish women expressed fear of "coming to grief" if they did not cater to the male ego in the home.

36. Lynn Davidman, *Tradition in a Rootless World*, pp. 131–135.

37. Handelman, pp. 10–11.

38. The Lubavitcher Youth Organization offers a series of weekend seminars, conferences, and holiday gatherings in Crown Heights for young Jewish students and couples interested in experiencing Lubavitch. These programs are often advertised as "An Encounter With Chabad," and their organizers refer to them casually as "Encounters."

39. Shaina Sara Handelman, "The Search For Truth." *Di Yiddishe Heim*, v. 19, n. 4, Spring 1978; p. 14.

40. Shaina Sara Handelman, "Judaism and Feminism." *Di Yiddishe Heim*, v. 19, n. 3, Winter 1978; p. 13.

41. Ibid.

42. A. Yerushalmi, "Has It Gone Too Far?" *Di Yiddishe Heim*, v. 19, n. 4, Spring 1978; p. 18.

43. Ibid., p. 21.

44. Shaina Sara Handelman, "Modesty and the Jewish Woman." In *The Modern Jewish Woman*, p. 25.

45. Beatrice Siegal Commack, "The Jew in Suburban Long Island." *Di Yiddishe Heim*, v. 23, n. 1, Spring 1982; p. 17.

46. Bas Chana, "Beating the Blahs." *Di Yiddishe Heim*, v. 23, n. 1, Spring 1982; p. 19.

Chapter Six

1. Cornel West, Foreword to *Fires in the Mirror* by Anna Deavere Smith (New York: Doubleday, 1993); p. xvii.

2. "Hasidic Group Expands Amid Debate on Future." *The New York Times*, September 5, 1988.

3. Ibid.

4. Personal correspondence from Rachel Altein, 23 Elul 5748 (September 5, 1988).

5. The Lubavitch Women's Organization defines *akeres habayis* as "The foundation of the home. A term used for a wife, indicating that she creates, establishes, and sustains the home, i.e. it is she who makes the home a home." Glossary, *The Modern Jewish Woman*; p. 170. Another revealing quote comes from the Rabbi Yosei: "Never have I called my wife 'my wife,' but always 'my home.'" Babylonian Talmud Shabbat 118b, Mishna Yoma I, 1.

6. See Mrs. Tema Gurary, "Guest Speaker," in the *Souvenir Journal* of the Eighth Annual Convention of Neshei Ubnos Chanad, May 1963; pp. 25–27.

7. See "The Key to Eternity," a pamphlet of the Lubavitch Educational Foundation for Jewish Marriage Enrichment, 1987; p. 4. See also the Lubavitcher Rebbe's essay "A Blessing for Mother and Child," in the *Neshei Chabad Newsletter*, v. 13, n. 1, September 1988; p. 15.

8. The issue of anti-Semitism in the feminist community led to the publication of numerous texts, including (but certainly not limited to) *Yours in Struggle* by Elly Bulkin, Minnie Bruce Pratt, and Barbara Smith (Long Haul Press, 1984). Interestingly, the Lubavitcher movement never addressed the problem of feminist anti-Semitism in publications intended to detract Jewish women from the feminist movement.

9. See Deborah Lipstadt, "Women and Power in the Federation," in *On Being a Jewish Feminist*, edited by Susannah Heschel (New York: Schocken, 1995).

10. Jewish feminist Phyllis Chesler has written several articles on the conflict surrounding women's prayer groups at the Wall. See "The Walls Came Tumbling Down," in *On the Issues*, fall 1989; and "A Song So Brave," in *On the Issues*, summer 1990.

11. The *mechitzah* is the barrier separating men and women in Orthodox synagogues. It may take the form of a wall, curtain, or movable screen. In synagogues such as the main Lubavitcher shul at 770 Eastern Parkway, women sit in a gallery above the main floor where men pray. Regardless of these variations in structure, women in Orthodox synagogues are separated from the area where the Torah is taken out and read.

12. *New Directions for Women*, December 1986; p. 13.

13. Ibid.

14. Ibid.

15. Ibid.

16. Ibid.

17. Rabbi Avi Shafran, "Prayer Meetings and Midnight Feedings," in *The Jewish Woman's Outlook*, v. 5, n. 2, August-September 1986; p. 14.

18. Ibid., pp. 14–15.

19. See Rabbi David Novak, "Women in the Rabbinate?," in *Judaism*, Winter 1984, p. 41.

20. The controversy continues. Recently *The New York Times* reported that "an Orthodox rabbinic board in Queens ruled that women's prayer groups violated Jewish tradition." The *New York Times*, May 1, 1997; p. A20.

21. "When my rabbi says, 'A Jew is called to the Torah,' he never means me or any other living Jewish woman.... My own synagogue is the only place in the world where I am not named Jew." Cynthia Ozick, "Notes Toward Finding the Right Question," in *On Being a Jewish Feminist*; p. 125.

22. The Rebbe Menachem M. Schneerson, "A Blessing for Mother and Child," ibid.

23. The difference in attitude that Lubavitcher girls bring to classes taught by women, as opposed to classes taught by male rabbis, has its parallel in the restlessness and lack of discipline some Lubavitcher boys show during English classes as opposed to Talmud lessons.

24. Personal correspondence from Rachel Altein, September 1988.

25. See the Introduction to *Letters by the Lubavitcher Rebbe to Neshei Ubnos Chabad, 1956–1980*; pp. vii–x. It is interesting to note that because Jewish women are considered more spiritual than their male counterparts, they may attend performances and lectures by men. But male Lubavitchers are forbidden to hear women sing, and women may not sing with men even at a holiday meal table, due to the assumption that the males might become aroused. The entire rationale behind the separate seating arrangement in the Lubavitcher synagogue is to prevent men from being "distracted" by the view of women during the service. Women, seated in the upstairs gallery, presumably gaze down on their menfolk without risk of spiritual distraction. Further explanations of these issues may be found in Dov Eisenberg's *Guide for the Jewish Woman and Girl* (Brooklyn: Z. Berman), 1981.

26. See Nancy Cott, *The Bonds of Womanhood* (New Haven: Yale University Press), 1977.

27. See Aileen Kraditor, *The Ideas of the Woman Suffrage Movement* (New York: W.W. Norton), 1981.

28. The Rebbe's birthday, April 18, was designated as "Education Day U.S.A" in 1978. President Carter signed this proclamation into law after a joint resolution passed both the Senate and the House of Representatives. See Daniel Goldberg, "The Lubavitcher Rebbe: Eighty Years," in *The Rebbe: Changing the Tide of Education*, p. 52.

HASIDIC HISTORIOGRAPHY

The primary sources for this study include the Lubavitcher women's periodicals (*Di Yiddishe Heim* and *The Neshei Chabad Newsletter*), Convention programs and resolutions, Lubavitcher outreach education materials and pamphlets, religious instructional kits, and Lubavitcher children's periodicals. The bulk of these sources, and additional volumes of correspondence and speeches by the current and previous Rebbe, are located in the Levi Yitzchok Library of the Lubavitcher Youth Organization in Crown Heights, Brooklyn. The Library also possesses a collection of book-length works and translations by the Lubavitcher Women's Organization (Neshei Chabad), the Kehot Publication Society, and the Lubavitcher Youth Organization. Sources on female education and curriculum materials are located in the libraries and administrative offices of the Beth Rivkah High School and the Machon Chana Institute in Crown Heights. Additional sources on women's activism, organization, and observance came from the offices of the Lubavitcher Women's Organization, the National Committee for the Furtherance of Jewish Education, the Crown Heights women's *mikveh*, and the central Lubavitcher synagogue complex at 770 Eastern Parkway in Crown Heights.

Prior to the Nazi Holocaust, students of Hasidism were almost exclusively other male Hasidim or Orthodox Jews: religious scholars seeking to study Hasidic philosophy or to preserve the response of outstanding Rebbes. The surprising survival and even revival of Hasidism in the post-Holocaust era, however, attracted

historians, sociologists, and cultural anthropologists, whose backgrounds and perspectives were secular and grounded in the secular academy rather than in the yeshiva.

The extant sources pertinent to Hasidism fall into roughly three categories. First, of course, are the sacred texts of Judaism itself. The basis for all Jewish scholarship, including Hasidic education, is Jewish law and commentary: the Torah, or first five books of the Bible; the Mishnah, or Oral Law, a series of legal interpretations and commentaries compiled in the third century C.E.; and, most central of all, the Talmud. The Talmud contains both the Mishnah and the two Gemara, or commentary on the Mishnah. These commentaries incorporate arguments, legal decisions, and guidelines from the Babylonian and Palestinian academies of the third, fourth, and fifth centuries. The Hasidim, as well as many other observant Jews, believe the Torah and Mishnah were handed down to Moses at Sinai and transmitted orally from Jew to Jew throughout subsequent generations until committed to paper. All of Jewish law, or *halacha*, therefore retains the character of divine origin, which is why Hasidic and Orthodox legal experts are reluctant to criticize or modify the laws. The extensive spectrum of commentaries on aspects of *halacha* does testify to religious scholars' interest in making ancient law continually meaningful, applicable, and enlightening to the practitioners and the faithful.

A second category of sources relevant to Hasidic scholarship are the texts by the Hasidim themselves. For the Lubavitcher sect, the most important of these works is the *Likutei Amarim*, or *Tanya*, the philosophical work written by the Alter Rebbe, Shneur Zalman, in the late eighteenth century. This text outlines the Chabad ideology later popularized as an interactive ethic by the Lubavitcher movement. In addition to the *Tanya*, other Hasidic works include the correspondence and memoirs of Rebbes from each dynasty, biographies and commentaries on the works of these Rebbes (usually written by devoted followers or secretaries), Hasidic folktales and ethical treatises, and mystical works. Hasidim have also written histories of their own sects.

A third form of sources on Hasidism are those texts written by "outsiders"—sociologists and secular scholars, academic historians affiliated with non-Hasidic or non-Jewish institutions. The general problems affiliated with infiltration of the Hasidic community have been bypassed by those scholars whose works involve biography or the editing and translation of primary sources.

Perhaps the best-known student and promoter of Hasidic folk-

lore and cultural origins was Martin Buber, the German philosopher and Zionist activist. By the time of his death in 1965, his works included such well-acclaimed texts as *Hasidism and Modern Man, The Origin and Meaning of Hasidism, Tales of the Hasidim,* and *The Tales of Rabbi Nachman.* Buber focused on the origins of faith and folk custom in the Hasidic realm and the significance of the appearance of Hasidism in the modern era. The more esoteric aspects of Hasidic mysticism and kabbalism were left to be explored by Gershom Scholem, author of *Kabbalah, Zohar,* and *Major Trends in Jewish Mysticism;* Scholem is noted as well for his attack on Buber's Hasidic scholarship. Other authors chose particular aspects of Hasidism for their texts: the role of the *tzaddik*, or leader, as a symbolic and historical construct is explored in Samuel Dresner's *Zaddik,* Arthur Green's *Tormented Master,* and Jerome Mintz's *Legends of the Hasidim.*

Texts that directly examine issues in contemporary Hasidic communities are rarer. Two studies of Hasidim in urban New York remain outstanding: *The Hasidic Community of Williamsburg,* by Solomon Poll (1962) and *Satmar: An Island in the City,* by Israel Rubin (1972). Poll, studying the postwar transplantation of European Hasidim to Brooklyn, provided a general sociology of Hasidic roles and status symbols in neighborhood economy, rather than focusing on a narrower demarcation of sects. In his book's appendix, "Some Problems in Studying the Hasidic Community," Poll described the difficulty of winning his subjects' trust, despite his status as a Jewish male, his fluent Yiddish and Hungarian, and his rabbinical education in a European Hasidic *yeshiva*. Poll's research was both informed and shaped by the transitory and fearful character of those sects still recovering from World War II.

Israel Rubin deliberately elected to write of the contemporary Satmar Hasidim, who remain the most insular and controversial Hasidic group today. The Satmar are virulently anti-Zionist, and for decades were affiliated with the ultra-right-wing activist group Neturei Karta in Jerusalem. Satmarer Hasidim severely limit their contact with other Hasidim, non-Hasidic Jews, and non-Jews in general, although they occupy a multiethnic section of Brooklyn. The Zionist stance of the Lubvitcher Rebbe and his followers in postwar America led to innumerable Satmar-Lubavitcher conflicts during the 1970s. Rubin's book was not intended to be a vehicle for blanket condemnation of Satmar policy; rather, he expressed concern for the future and longevity of such an extremist community, and proposed that the limitations on educational opportunity for

Satmar Hasidim and resultant low income levels might produce malcontents.

These particular conditions of modern non-European Hasidism—the Satmar-Lubavitcher conflict, the immense power generated by Rebbes over followers, and the problems of dialogue between Hasid and Hasid or Hasid and secular authority—proved to be popular topics for other authors of secondary studies on Hasidic politics. *Perpetual Dilemma* by S. Z. Abramov (1976), *Hasidism and the State of Israel* by Harry Rabinowicz (1982), *For the Land and the Lord* by Ian Lustick (1988), and *Defenders of the Faith*, by Samuel Heilman (1992) all address the problems of Orthodox Judaism in Israeli policy and the political function of anti-Zionist Hasidim in Israel.

The Satmar-Lubavitcher conflict is also addressed in *Dimensions of Orthodox Judaism*, an anthology edited by Reuven Bulka (1983). In this anthology, Jerome Mintz's article "Ethnic Activism: The Hasidic Example" compares the Satmar-Lubavitcher rift to similarly strained relations between Hasidim and other minority groups within Brooklyn. Mintz recently updated this research, including astute analysis of racial conflict in Crown Heights, with the publication of his 1992 work *Hasidic People*. He remains best known for his 1968 study *Legends of the Hasidim*, which provided a dual perspective on the new Hasidic communities then flourishing in America. In that text, Mintz gave a detailed history of the various Hasidic sects in New York, and then allowed each community to speak for itself through legends, folk tales, and personal anecdotes about the attributed powers of disparate Rebbes. The bulk of the stories centered on the hardship of prewar life in Eastern Europe, the function of Hasidic faith in overcoming both hardship and temptation, and the miraculous in everyday life.

Finally, there is a popular genre of novels and investigative studies that capture the essence of Hasidic life for readers unfamiliar with Hasidism. The photoessays by George Krantzler and Philip Garvin give glimpses into the yearly and daily cycles of Hasidic followers; these works familiarize the reader with the appearance and style of Hasidic followers at work, study, and worship. Chaim Potok's novels *The Chosen, The Promise, In the Beginning, My Name Is Asher Lev,* and *The Gift of Asher Lev* brought images of Hasidic history, philosophy, tragedy, and joy into millions of Jewish and non-Jewish homes. These novels are particularly evocative of the fear and faith among those Hasidim struggling to perpetuate their sects in the atmosphere of liberal American thought and educational institutions. And, of

course, Lis Harris's *Holy Days: The World of a Hasidic Family* is the most recent and direct account of an outsider's encounter with the Lubavitcher community of Crown Heights. Harris's personal and journalistic reporting introduced the reality of Lubavitcher belief and politics to readers in a sympathetic and candid style.

At the time of this writing, the emergence of scholarly literature on Hasidic thought and community published by academic *women* is challenging the prior canon of criticism and secondary sources. Two works on the *baalot teshuvah* community, Debra Kaufman's *Rachel's Daughters* and Lynn Davidman's *Tradition In A Rootless World* (both 1991), examine the phenomenon of the newly observant woman, effectively fusing *baalot teshuvah* narrative, sociological analysis, and women's studies. Israeli scholars such as Tamar El-Or (*Educated and Ignorant*, 1994) and Rachel Elior (*The Paradoxical Ascent to God*, 1993) have published U.S. translations of their monographs on the Gur Hasidism and Chabad theosophy respectively. Ethnomusicologist Ellen Koskoff has also explored the function of gender segregation in Lubavitch singing and vocal performance (*Women and Music in Cross-Cultural Perspective*, 1987).

Not surprisingly, works seeking to explore and reconcile Orthodoxy and feminism are now written for mainstream publishers by observant women themselves, such as Tamar Frankiel in *The Voice of Sarah* (1990). The establishment of academic women's studies, combined with political questions of gender and ethnic identity today, permits a continuing focus on the Jewish woman's role in such dissimilar Judaica journals as *Moment, Tikkun, Bridges, Polin, Midstream, Judaism,* and *Jewish Observer.* However, the new availability of sources on ultra-Orthodox women does not guarantee the use of such sources by those presently seeking to understand the Hasidic community in America. A case in point is the relative invisibility of the Hasidic woman in mainstream investigations of racial tension between Lubavitch sources and black residents in Crown Heights. The urban rivalry and subsequent political views of black and Hasidic *women* remain, in news journalism, conveniently assumed as identical to the views of corresponding male community leaders. This is a prime example of the need for ongoing research on women in Hasidism, and indeed, for research on women in other ethnic subcultures.

The following bibliography lists those secondary sources that have influenced and informed my study and other studies of modern Hasidism and Jewish women's history. These works supplement the primary sources on Lubavitcher women from the Levi Yitzchok Library and the Lubavitcher Woman's Organization in Crown Heights.

BIBLIOGRAPHY

Abramov, S. Z. *Perpetual Dilemma: Jewish Religion in the Jewish State.* New Jersey: Associated University Presses, 1976.

Aron, Milton. *Ideas and Ideals of the Hasidim.* New York: Citadel Press, 1969.

Atkinson, Clarissa, Constance Buchanan, and Margaret Miles, eds. *Immaculate and Powerful: The Female in Sacred Image and Social Reality.* Boston: Beacon Press, 1985.

Aviad, Janet. *Return to Judaism.* Chicago: University of Chicago Press, 1983.

Baal Shem Tov. *Baal Shem Tov on Pirkei Avot.* New York: Feldheim Publishers, 1974.

Balka, Christie and Andy Rose, eds. *Twice Blessed: On Being Lesbian, Gay, and Jewish.* Boston: Beacon Press, 1989.

Baum, Charlotte, Paula Hyman, and Sonya Michel. *The Jewish Woman in America.* New York: New American Library, 1975.

Beck, Evelyn Torton, ed. *Nice Jewish Girls: A Lesbian Anthology* Boston: Beacon Press, 1989.

Bernstein, Saul. *The Renaissance of the Torah Jew.* New York: Ktav, 1985.

Biale, David. *Gershom Scholem: Kabbalah and Counter-History.* Cambridge, MA: Harvard University Press, 1979.

Biale, Rachel. *Women and Jewish Law*. New York: Schocken Books, 1984.

Bokser, Ben Zion. *Jewish Mystical Tradition*. New York: Pilgrim Press, 1981.

Braude, Ann. *Radical Spirits*. Boston: Beacon Press, 1989.

Brewer, Joan Scherer, ed. *Sex and the Modern Jewish Woman*. Fresh Meadows, NY: Biblio Press, 1986.

Brooten, Bernadette. *Women Leaders in the Ancient Synagogue*. Brown University Judaic Studies Series 36. Chico, California: Scholars Press, 1982.

Buber, Martin. *Hasidism*. New York: Philosophical Library, 1948.

―――. *Hasidism and Modern Man*. New York: Horizon Press, 1958.

―――. *The Origin and Meaning of Hasidism*. New York: Horizon Press, 1960.

―――. *Tales of Angels, Spirits and Demons*. New York: Hawk's Well, 1958.

―――. *Tales of the Hasidim*. New York: Schocken Books, 1948.

―――. *The Tales of Rabbi Nachman*. New York: Horizon Press, 1956.

―――. *Ten Rungs: Hasidic Sayings*. New York: Schocken Books, 1962.

Bulka, Reuven. *Dimensions of Orthodox Judaism*. New York: Ktav Publishing House, 1983.

Cantor, Aviva. *The Jewish Woman, 1900–1980: A Bibliography*. Fresh Meadows, New York: Biblio Press, 1981.

Chmielewski, Wendy, Louis J. Kern, and Marlyn Klcc-Hartzell. *Women in Spiritual and Communitarian Societies in the United States*. Syracuse University Press, 1993.

Christ, Carol. *Laughter of Aphrodite*. San Francisco: Harper and Row, 1987.

Christ, Carol, and Judith Plaskow, eds. *Womanspirit Rising*. San Francisco: Harper and Row, 1979.

Danzger, M. Herbert. *Returning to Tradition: The Contemporary Revival of Orthodox Judaism*. New Haven, Conn: Yale University Press, 1989.

Davidman, Lynn. *A Strength of Tradition in A Chaotic World: Women Turn to Orthodox Judaism*. Dissertation, Brandeis University, 1986.

———. *Tradition in a Rootless World: Women Turn to Orthodox Judaism.* Berkeley: University of California Press, 1991.

Dov Baer ben Samuel. *In Praise of Baal Shem Tov.* Bloomington, Indiana: Indiana University Press, 1970.

Dresner, Samuel. *The Zaddik.* New York: Schocken Books, 1974

Dubnow, Simon. *History of the Jews in Russia and Poland.* trans. I. Friedlaender, 3 vols. Philadelphia, 1916–1920.

———. *Toledot Ha-Hasidut.* Tel Aviv, 1960.

Eisenberg, Dov. *A Guide for the Jewish Woman and Girl.* Brooklyn: Z. Berman, 1981.

Eliach, Yaffa, ed. *Hasidic Tales of the Holocaust.* New York: Avon Books, 1982.

———. *Jewish Hasidim, Russian Sectarians: Nonconformists in the Ukraine, 1700–1760.* Dissertation: City University of New York, 1970.

Elior, Rachel. *The Paradoxical Ascent to God: The Kabbalistic Theory of Habad Hasidism.* Albany: SUNY Press, 1993.

El-Or, Tamar. *Educated and Ignorant: Ultraorthodox Jewish Women and Their World.* Boulder, CO: Lynne Rienner, 1994.

Elwell, Ellen. *Jewish Women's Studies Guide.* Fresh Meadows, New York: Biblio Press, 1982.

Feinstein, Moshe. *A Joyful Mother of Children.* New York: Feldheim, 1982.

Feldman, David. *Marital Relations, Birth Control and Abortion in Jewish Law.* New York: Schocken Books, 1974.

Fleer, Gedaliah. *Rabbi Nachman's Fire.* New York: Herman Press, 1975.

———. *Rabbi Nachman's Foundation.* New York: Sepher-Hermon, 1976.

Frankiel, Tamar. *The Voice of Sarah.* San Francisco: HarperCollins, 1990.

Freedman. Marcia. *Exile in the Promised Land.* Ithaca: Firebrand, 1990.

Garvin, Philip. *A People Apart.* New York: Dutton, 1970.

Glanz, Rudolf. *Jewish Women in America: Two Female Immigrant Generations.* New York: Ktav Publishing House, 1976.

Gluckel of Hameln. *The Memoirs of Gluckel of Hameln*, trans. Marvin Lowenthal. New York: Schocken, 1977.

Goldenberg, Naomi. *Changing of the Gods: Feminism and the End of Traditional Religions.* Boston: Beacon, 1979.

Green, Arthur. *Jewish Spirituality.* New York: Crossroad, 1987.

———. *Tormented Master.* University, AL: University of Alabama Press, 1978.

Greenberg, Blu. *How to Run a Traditional Jewish Household.* New York: Simon and Schuster, 1983.

———. *On Women and Judaism.* Philadelphia: Jewish Publication Society, 1981.

Grossman, Susan, and Rivka Haut, eds. *Daughters of the King: Women and the Synagogue.* Philadelphia: Jewish Publication Society, 1992.

Haddad, Yvonne Hazbeck, and Ellison Banks Findly, eds. *Women, Religion and Social Change.* Albany: SUNY Press, 1985.

Hagerman, Alice, with the Women's Caucus of Harvard Divinity School. *Sexist Religion and Women in the Church.* New York: Association, 1974.

Hamelsdorf, Ora. *Jewish Women and Jewish Law Bibliography.* Fresh Meadows, New York: Biblio Press, 1980.

Handler, Andrew. *Rabbi Eizik: Hasidic Stories About the Zaddik of Kallo.* Rutherford, NJ: Fairleigh Dickinson University Press, 1978.

Harris, Lis. *Holy Days: The World of a Hasidic Family.* New York: Macmillan, 1985.

Hazleton, Lesley. *Jerusalem Jerusalem.* Boston: Atlantic Monthly Press, 1986.

Heilman, Samuel. *Defenders of the Faith.* New York: Schocken, 1992.

———. *The People of the Book.* Chicago: University of Chicago Press, 1983.

Heilman, Samuel, and Steven M. Cohen. *Cosmopolitans and Parochials: Modern Orthodox Jews in America.* Chicago: University of CHicago Press, 1989.

Helmreich, William. *The World of the Yeshiva.* New York: The Free Press, 1982.

Henry, Sondra, and Emily Taitz. *Written Out of History: Our Jewish Foremothers.* Fresh Meadows, New York: Biblio Press, 1983.

Hertzman, Chuna, and Shmuel Elchonen Brog. *One: The Essence of A Jewish Home.* New York: Moriah Offset, 1978.

Heschel, Abraham. *Circle of the Baal Shem Tov: Studies in Hasidism.* Chicago: University of Chicago Press, 1985.

Heschel, Susannah, ed. *On Being a Jewish Feminist.* New York: Schocken Books, 1983.

Hoffman, Edward. *The Way of Splendor: Jewish Mysticism and Modern Psychology.* Boulder, CO: Shambhala Publishing, 1981.

Horodezky, Samuel. *Leaders of Hassidism.* London: Hasefer, 1928.

Idel, Moshe. *The Kabbalah: New Perspectives.* New Haven: Yale University Press, 1988.

Jacobs, Louis. *Hasidic Prayer.* London: Routledge and Kenan Paul, 1972.

———. *Hasidic Thought.* New York: Behrman House, 1976.

Joselit, Jenna Weissman. *New York's Jewish Jews.* Bloomington: Indiana University Press, 1990.

Jungreis, Esther. *The Jewish Soul on Fire.* New York: William Morrow, 1982.

Kahana, Kalman (trans. Leonard Oschvy). *Daughter of Israel: Laws of Family Purity.* New York: Feldheim Publishers, 1977.

Kamen, Robert Mark. *Growing Up Hasidic: Education and Socialization in the Bobover Hasidic Community.* New York: AMS Press, 1985.

Kaplan, Aryeh. *Light Beyond: Adventures in Hasidic Thought.* New York: Maznaim, 1981.

Kaufman, Debra Renee. *Rachel's Daughters: Newly Orthodox Jewish Women.* New Brunswick, NJ: Rutgers University Press, 1991.

Kaye, Evelyn. *The Hole in the Sheet.* Seacaucus, New Jersey: Lyle Stuart, 1987.

Kaye-Kantrowitz, Melanie, and Irena Klepfisz, eds. *The Tribe of Dina: A Jewish Women's Anthology.* Montpelier, Vermont: Sinister Wisdom, 1986.

Kaye-Kantrowitz, Melanie. *My Jewish Face and Other Stories.* San Francisco: Spinsters/Aunt Lute, 1990.

Klepfisz, Heszel. *Culture of Compassion: The Spirit of Polish Jewry from Hasidism to the Holocaust.* New York: Ktav, 1983.

Klepfisz, Irena. *Dreams of an Insomniac.* Portland, OR: Eighth Mountain Press, 1990.

Koltun, Elizabeth, ed. *The Jewish Woman*. New York: Schocken Books, 1976.

Koskoff, Ellen, ed. *Women and Music in Cross-Cultural Perspective*. New York: Greenwood Press, 1987.

Krantzler, George. *The Face of Faith*. Baltimore: Baltimore Hebrew College, 1972.

———. *Williamsburg: A Jewish Community in Transition*. New York: Feldheim, 1961.

Lacks, Roslyn. *Women and Judaism*. New York: Doubleday, 1980.

Langer, Mordecai. *Nine Gates to the Chasidic Mysteries*. New York: D. McKay, 1961.

Levin, Meyer. *The Golden Mountain: Marvelous Tales of the Baal Shem*. New York: Behrman House, 1951.

Liebman, Charles. *Aspects of the Religious Behavior of American Jews*. New York: Ktav, 1974.

Lipshitz, Max. *The Faith of a Hasid*. New York: Jonathan David Publishers, 1967.

Lowenkopf, Anne N. *The Hasidim: Mystical Adventurers and Ecstatics*. Los Angeles: Sherbourne Press, 1973.

Lubavitch Educational Foundation for Jewish Marriage Enrichment. *The Modern Jewish Woman: A Unique Perspective*. Brooklyn, 1981.

Lubavitch Foundation of Great Britain. *Challenge: An Encounter with Lubavitch/Chabad*. London, 1970.

———. *Challenge: An Encounter with Lubavitch-Chabad in Israel*. London, 1973.

———. *A Woman of Valor: Anthology for the Thinking Jewess*. London, 1976.

Lubavitch Women's Organization. *AURA: A Reader on Jewish Womanhood*. Brooklyn, 1984.

Lubavitch Youth Organization. *The Tzach Directory*. Brooklyn: Lubavitch Youth Organization, 1987.

Lustick, Ian. *For the Land and the Lord*. New York: Council on Foreign Relations, 1988.

Mahler, Raphael (trans. Eugene Orenstein). *Hasidism and the Jewish Enlightenment: Their Confrontation in Galicia*. Philadelphia: Jewish Publication Society, 1985.

Mann, Denise Berg. *The Woman in Judaism*. Hartford: Jonathan Publications, 1979.

Marcus, Jacob. *The American Jewish Woman: A Documentary History*. New York: Ktav Publishing House, 1981.

Meiselman, Moshe. *Jewish Woman in Jewish Law*. New York: Ktav Publishing House, 1978.

Miller, Yisroel. *In Search of the Jewish Woman*. New York: Feldheim Publishers, 1984.

Mindel, Nissan. *Rabbi Shneur Zalman*. Brooklyn: Chabad Research Center and Kehot Publication Society, 1980.

Minkin, Jacob. *The Romance of Hassidism*. New York: Macmillan, 1935.

Mintz, Jerome. *Hasidic People*. Cambridge, MA: Harvard University Press, 1992.

———. *Legends of the Hasidim*. Chicago: University of Chicago Press, 1968.

Mirsky, Mark Jay. *My Search for the Messiah*. New York: Macmillan, 1977.

Mirsky, Norman. *Unorthodox Judaism*. Columbus: Ohio State University Press, 1978.

Mollenkott, Virginia, ed. *Women of Faith in Dialogue*. New York: Crossroad, 1987.

Moonan, Willard. *Martin Buber and His Critics*. New York: Garland Publishers, 1981.

Morgan, Moshe. *A Guide to the Laws of Niddah*. New York: By the Author, 1983.

Moskowitz, Ira. *The Hasidim*. New York: Crown Publishers, 1973.

Nachman ben Simah of Bratslav. *Tales*. New York: Paulist Press, 1978.

Nahum ben Zevi of Chernobyl. *Upright Practices: The Light of Eyes*. New York: Paulist Press, 1982.

Newman, Louis. *The Hasidic Anthology*. New York: Schocken Books, 1963.

———. *Maggidim and Hasidim: Their Wisdom*. New York: Bloch Publishers, 1962.

Plaskow, Judith. *Standing Again At Sinai*. San Francisco: Harper/Collins, 1990.

Poll, Solomon. *The Hasidic Community of Williamsburg.* New York: Schocken Books, 1962.

Priesand, Sally. *Judaism and the New Woman.* New York: Behrman House, 1975.

Rabinowicz, Harry. *Hasidism: The Movement and Its Masters.* London: Jason Aronson, 1988.

———. *Hasidism and the State of Israel.* New Jersey: Associated University Presses, 1982.

———. *The World of Hasidism.* London: Vallentine Mitchell, 1970.

Rabinowitsch, Wolf Zeev. *Lithuanian Hasidism.* New York: Schocken Books, 1971.

Rapoport-Albert, Adah, and S. Zipperstein, eds. *Jewish History: Essays in Honour of Chimen Abramsky.* London: Peter Halban, 1988.

Remy, Nehida (trans. Louise Mannheimer). *The Jewish Woman.* New York: Bloch Publishing Company, 1916.

Rivkin, Mayer S., ed. *The Rebbe: Changing the Tide of Education.* Brooklyn: Lubavitcher Youth Organization, 1982.

Rogow, Faith. *Gone to Another Meeting.* University of Alabama, 1993.

Roiphe, Anne. *A Generation Without Memory.* New York: Simon and Schuster, 1981.

Rosenthal, Gilbert. *Contemporary Judaism: Patterns of Survival,* 2d ed. New York: Human Sciences Press, 1986.

Rotenberg, Mordechai. *Dialogue with Deviance: The Hasidic Ethnic.* Philadelphia: Institute for the Study of Human Issues, 1973.

Roth, Cecil. *The Concise Jewish Encyclopedia.* New York: New American Library, 1980.

Rubin, Israel. *Satmar: An Island in the City.* Chicago: Quadrangle Books, 1972.

Rubinstein, Aryeh. *Hasidism.* Jerusalem: Keter Publishing House, 1975.

Rudavsky, David. *Modern Jewish Religious Movements.* New York: Behrman House, 1979.

Ruether, Rosemary Radford. *Religion and Sexism.* New York: Simon and Schuster, 1974.

———. *Women of Spirit.* New York: Simon and Schuster, 1979.

———. *Womanguides: Readings Toward a Feminist Theology.* Boston: Beacon, 1985.

Sachar, Howard Morley. *The Course of Modern Jewish History.* New York: Dell, 1977.

Safran, Bezalel, ed. *Hasidism: Continuity or Innovation?* Cambridge: Harvard University Press, 1988.

Schacter-Shalomi, Zalman. *Sparks of Light: Counseling in the Hasidic Tradition.* New York: Random House, 1983.

Schneider, Susan. *Jewish and Female.* New York: Simon and Schuster, 1984.

Schneerson, Joseph Isaac (trans. Nissan Mindel). *Lubavitcher Rabbi's Memoirs.* Brooklyn: Kehot Publication Society, 1960.

Schneerson, Menachem Mendel. *Letters by the Lubavitcher Rebbe.* Brooklyn: Kehot Publication Society, 1979.

———. *Letters by the Lubavitcher Rebbe to Neshei Ubnos Chabad 1956–1980.* Brooklyn: Kehot Publication Society, 1981.

———. *Letters by the Lubavitcher Rebbe to Neshei Ubnos Chabad Midwinter Conventions, 1963–1987.* Brooklyn: Kehot Publication Society, 1987.

Schneur Zalman of Liadi. *Likutei Amarim* (Tanya) (trans. Zalman Posner) (bilingual ed.). Brooklyn: Kehot Publication Society, 1982.

Schochet, J. Immanuel. *Who Is a Jew?* New York: Shofar Association, 1987.

Scholem, Gershom. *Kabbalah.* Jerusalem: Keter Publishing House, 1974.

———. *Major Trends in Jewish Mysticism.* New York: Schocken Books, 1941.

———. *Origins of the Kabbalah.* Philidelphia: The Jewish Publication Society, 1987.

———. *Sabbatai Sevi: The Mystical Messiah, 1626–1676.* Princeton, NJ: Princeton University Press, 1973.

———. *Zohar: The Book of Splendor.* New York: Schocken Books, 1949.

Schwartz, Howard. *Captive Soul of the Messiah: New Tales About Reb Nachman.* New York: Schocken Books, 1983.

Shaffir, William. *Life in a Religious Community: The Lubavitcher Chassidim in Montreal.* Toronto: Holt, Rinehart and Winston, 1974.

Sharot, S. *Messianism, Mysticism and Magic.* Chapel Hill: University of North Carolina Press, 1982.

Smith, Anna Deavere. *Fires in the Mirror.* New York: Doubleday, 1993.

Spelman, Elizabeth. *Inessential Woman.* Boston: Beacon Press, 1988.

Steinmann, Eliezer. *Garden of Hasidism.* Jerusalem: Department of Education and Culture, World Zionist Organization, 1961.

Steinsalz, Adin. *Beggars and Prayers: Adin Steinsalz Retells the Tales of Rabbi Nachman.* New York: Basic Books, 1979.

Teubal, Savina. *Sarah the Priestess.* Athens, Ohio: Ohio University Press, 1984.

Uffenheimer, Rivka Schatz. *Hasidism as Mysticism.* Princeton, NJ: Princeton University Press, 1993.

Unterman, Alan. *Wisdom of the Jewish Mystics.* New York: New Directions, 1976.

Vishniac, Roman. *A Vanished World.* New York: Farrar, Strauss and Giroux, 1983.

Warshaw, Max. *Tradition: Ortrhodox Jewish Life in America.* New York: Schocken Books, 1976.

Weinberg, Sidney Stahl. *The World of Our Mothers.* Chapel Hill: University of North Carolina Press, 1988.

Weiner, Herbert. *9 1/2 Mystics.* New York, 1969.

———. "The Lubavitcher Movement I." *Commentary* 23, n. 3, 1957, pp. 231–241.

———. "The Lubavitcher Movement II." *Commentary* 24, n. 4., 1957, pp. 316–27.

Weiss, Joseph. *Studies in Eastern European Jewish Mysticism.* Oxford: Oxford University Press, 1985.

Weiss Rosmarin, Trude. *Jewish Women Through the Ages.* Jewish Book Club Press, 1940.

Welch, Susan and Fred Ulrich. *The Political Life of American Jewish Women.* Fresh Meadows, NY: Biblio Press, 1984.

Wenkart, Henny, ed. *Sarah's Daughters Sing.* New York: Ktav, 1990

Wiesel, Elie. *Four Hasidic Masters and Their Struggle Against Melancholy.* Notre Dame: University of Notre Dame Press, 1987.

———. *Somewhere a Master: Further Hasidic Portraits and Legends.* New York: Summit Books, 1982.

———. *Souls on Fire.* New York: Vintage Books, 1973.

INDEX

A

A Candle of My Own, 110–11
Achos Tmimim, 37–38
aishes chayil (woman of valor), 24–25, 62, 79, 95, 137
Altein, Rachel, 44, 65–66, 80, 85, 87–88, 95–97, 107, 125, 134
AURA: A Reader on Jewish Womanhood, 114–15

B

baalei teshuvah (men returning to Orthodoxy), 11, 45–46, 93
baalot teshuvah (women returning to Orthodoxy) 5, 6, 9, 20, 28, 30, 45–46, 48–49, 128, 138; as authors, 47, 69–70, 89–94, 97–98, 114–20, 128; estranged from family, 47, 49
Bais Chana, 52–53, 116
Bais Yaakov, 35–38, 41, 48
Belzer Hasidism, 17, 21, 35
BESHT (Baal Shem Tov), 15, 17, 21
Beth Rivkah: elementary school, 30, 38–40, 42, 48, 86; high school, 41–43, 45, 53–54, 61, 130, 133; Teachers Seminary, 40, 42, 47–48
Biale, Rachel, 19, 34
birth control and abortion, 65–66, 76, 87, 112–13, 115, 126
Blau, Felice, 94–98, 105
Bnos Chabad (daughters of Chabad), 74
Bobover Hasidim, 14, 17

C

candlelighting. *See neshek*
Chabad Hasidism: philosophy of, 17–18, 26, 135; activism in Russia and Eastern Europe, 21, 23, 56, 83
Chabad Houses, 30, 45, 60, 115
Chafetz Hayyim, 35
Cheifetz, Mordecai, 37–38
Commack, Beatrice S., 120–21

Crown Heights, Brooklyn: as Lubavitcher headquarters, 5, 6, 14, 27, 40, 47, 56–58, 91, 98, 117; racial tension, 5, 8, 13, 91–92, 123–24

D

Daly, Mary, 18–19
Davidman, Lynn, 3, 19–20, 91, 116
Di Yiddishe Heim (*The Jewish Home*), 8, 26, 39, 41–42; *baalot teshuvah* authors, 89–94, 115–20; history of, 78–99; female education concerns, 41–42, 44, 47, 54; format, 80–84; male authors, 80–83, 86–87, 99, 103–105, 118–19, 134; Neshei Chabad use of, 56, 60–63, 109, 134

E

economic roles, female, 23, 102–103, 106–107; male, 31, 102–103, 106–107, 132
education, *baal teshuvah*, 30, 45–54, 120, 125, 127, 133; female, 30–54, 88; in Europe, 30, 34–38; hostility to secular curricula, 87, 92–93, 117–18; male, 30, 31–32, 35, 41, 45–46, 51, 93; women's exemption from study, 32–34, 132
Eidele, 21
Eliach, Yaffa, 25–26
Eliezer, Rabbi, 33
El-Or, Tamar, 3, 20, 39, 80

F

farbrengen, 25, 49, 59
Feller, Rabbi, 63
The Feminine Mystique, 55, 62

feminism, critique of religion, 18–19, 63, 102, 112–13, 127–28; hostility toward, 4, 27, 62–63, 70, 95–97, 100–22; in Eastern Europe, 36–37; in the United States, 27, 44, 52, 100, 105, 126, 128–29
Flatbush Women's Davening Group, 129–33

G

Greisman, Nechama, 48–49, 68
Gur Hasidim, 20, 36, 38, 80
Gurary, Tema, 62, 80

H

Handelman, Shaina Sara, 115–20
Hannah Havah, 21
Hannah Rachel, 21–22, 30
Harris, Lis, 3, 18–19
Hasidic movement, 15–18
Haut, Rivka, 129–30
Heilbrun, Chana, 41–42
Holocaust, 15, 29, 37, 40, 113, 127
Horodetzky, S.A., 21–22, 59

J

Jacobson, Rabbi Israel, 38–39, 83
The Jewish Press, 129
The Jewish Women's Outlook, 130
Joselit, Jenna Weissman, 3

K

Kabbalism, 16, 37
Kaufman, Debra, 3, 19–20, 91
Klaczko, M., 22
Koskoff, Ellen, 3
Krinsky, Rabbi Yehuda, 124–25

L

Labkowsky, Sara, 48
Leib Sarah, 21
Levi Yitzchok Library, 8–11, 137
Lowenkopf, Anne, 48
Lubavitcher Rebbe (Menachem Mendel Schneerson), 1, 6, 10–11, 14, 26, 28, 30; appearances before female audiences, 58–59, 76; as the Messiah, 126–27; attitudes toward birth control and feminism, 113; education philosophy, 44, 47, 50, 53–54, 137–39; female audience; letters to the Neshei Chabad Conventions, 60, 71–75; on Israeli policy, 66; support of Neshei Chabad activities, 55–56, 11, 133–34
Lubavitch Women's Organization. *See* Neshei Chabad

M

Machon Chana, 11, 45, 49–53, 127, 130
Maid of Ludmir. *See* Hannah Rachel
Maimonides, 33
matchmaking, 9, 11
Meir, Golda, 66
Meiselman, Moshe, 19
Mendy and the Golem (comic book series), 53–54
mikveh, 8, 24, 50, 57, 67, 76, 120, 127
mitnagdim, 16, 23
The Modern Jewish Woman, 112–15
Moshiach/Messiah, 16, 26–27, 72, 92, 97, 104, 114, 124–25, 134; Lubavitcher Rebbe as, 126–27, 139
Muchnik, Tzippora, 29

N

Neshei Chabad (The Lubavitch Women's Organization), conventions, 49, 55–77; Mid-Winter regional conventions, 56, 60, 64–65, 69, 71–72, 74–75; *Newsletter*, 10, 43; publications, 8, 109–15; souvenir convention journals, 60–70
neshek project (candlelighting), 67–70, 110–11, 114
New Directions for Women, 129–30
niddah (menstruating women), 8, 28, 112–14

P

Plaskow, Judith, 20
Poll, Solomon, 25
Posner, Zalman, 85–86

R

Rabinowicz, Harry, 21
Rapoport-Albert, Ada, 22–23, 59
Rashi, 33
Rebbe, Lubavitcher. *See* Lubavitcher Rebbe
rebbes, role of in Hasidism. *See* *tzaddik*
rebbetzin, role of, 20–21, 23, 35, 51, 91, 97, 105
Rebbetzin Chana, 35, 49
Rosengarten, Sudy, 39–40

S

Satmar Hasidim, 6, 14, 17
Schenierer, Sarah, 35–38
Schneersohn, Rebbe Joseph Yitzhak (the sixth Lubavitcher Rebbe), 18, 37–41, 75, 85

Schneerson, Menachem Mendel (the seventh Lubavitcher Rebbe). *See* Lubavitcher Rebbe
Sefer Abudraham, 34
Shafran, Rabbi Avi, 13–32
sheitel, 24, 129
shluchim (missionaries), 30, 72, 76, 98, 126, 136
Shusterman, Rivka, 106–108
Silver, Arthur, 34, 38
Six-Day War, 45, 63
Smith, Anna Deavere, 124
Soviet Union, 23, 42, 68, 73, 83, 85, 102
Stern, Esther, 89–93, 97, 133

T

taharas hamishpocha (laws of family purity), 62, 70, 113
Tanya (Likutei Amarim), 17
tikkun (repair, redemption), 16
Twersky, Rabbi Mordecai, 21
tzaddik, role of, 16, 20, 59
tzedaka (charity), 24, 54, 58
Tzivos Hashem (Army of God children's organization), 7
tznius (modesty), 6, 8, 20, 28, 61, 69–70, 74, 85–86, 109, 113, 131

U

uforatzto (outreach), 55, 61, 78

V

Vishniac, Roman, 29

W

Weissman, Deborah, 36–37
women's prayer groups, 129–33
women's studies, 2, 100–101, 135–37

Y

Yeshiva Hadar Hatorah, 45, 48
Yeshiva Tiferes Bachurim, 46
Yeshiva University, 130–32
Yezierska, Anzia, 104
Yiddish language, 7, 58, 75, 78–79

Z

Zalman, Shneur (the Alter Rebbe), 17–18, 84

Made in the USA
Lexington, KY
25 April 2014